DUANE

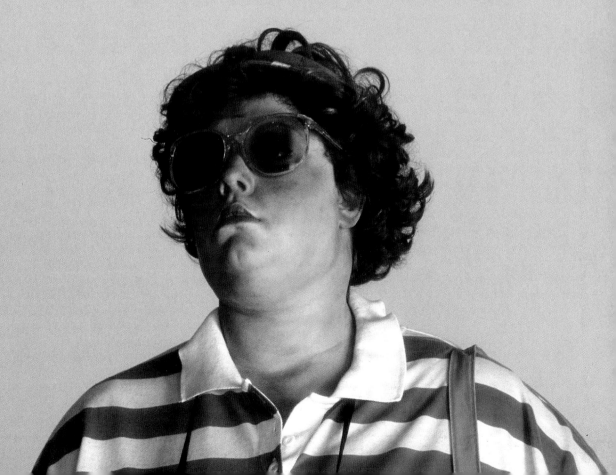

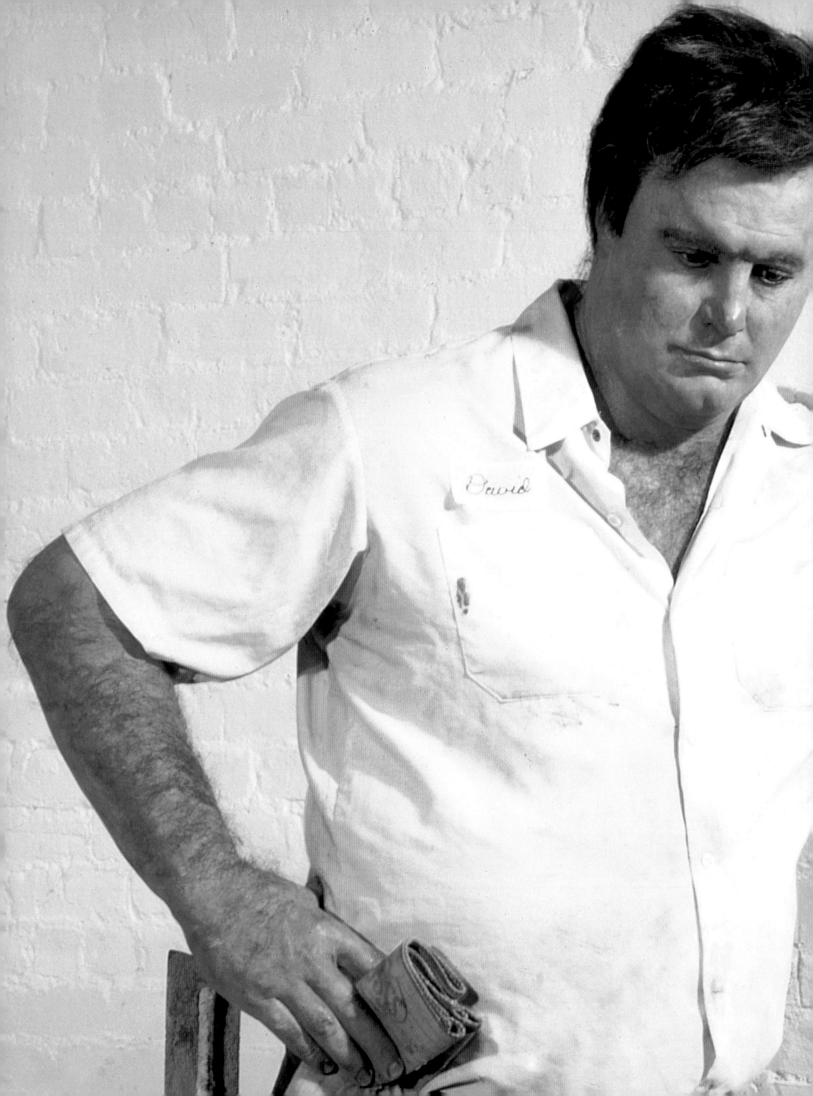

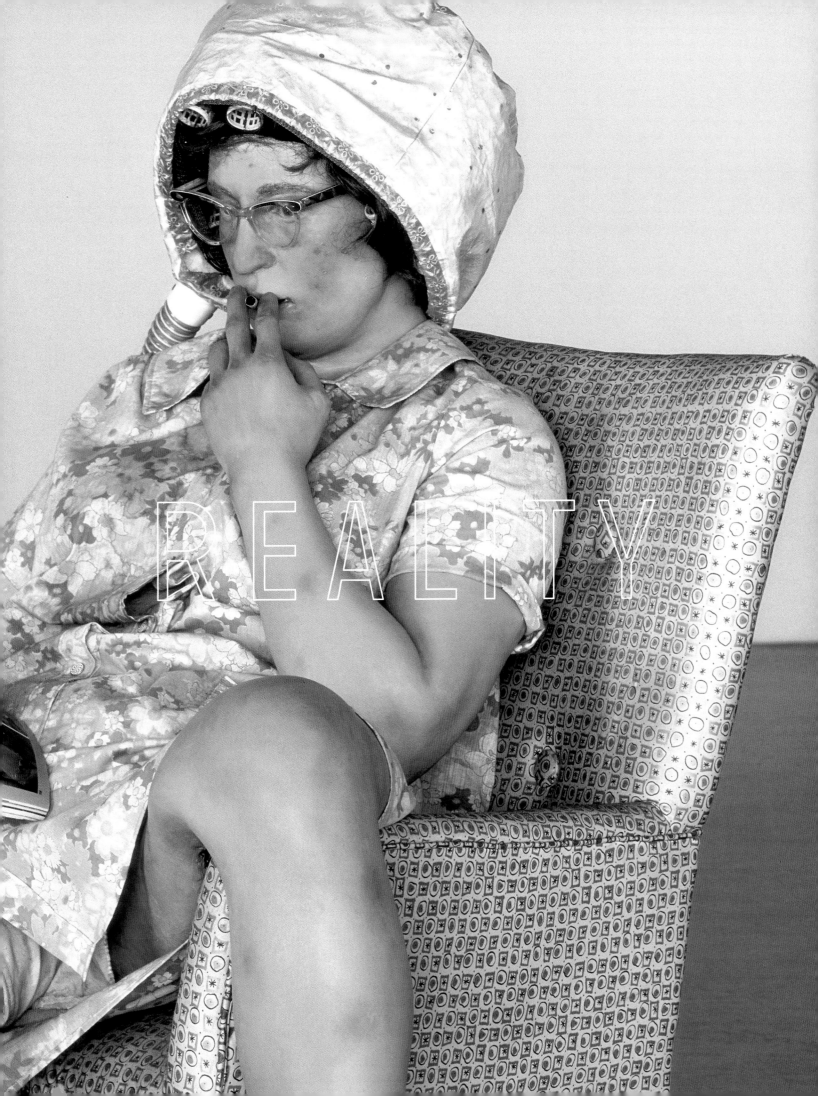

DUANE HANSON
MORE THAN REALITY

EDITED BY THOMAS BUCHSTEINER AND OTTO LETZE

HATJE CANTZ PUBLISHERS

Anyone who encounters photographs by Philip-Lorca diCorcia today and looks at his inconspicuous individuals standing around idly at intersections or hurrying with a fixed stare through the lobbies of insurance companies will notice his unsentimental view of those strangers who are the masses. Michel Houellebecq comes involuntarily to mind, and the dull centre in which the figures of his visionary society novels move, of their loneliness, their terrible isolation and despair, which he dissects mercilessly and describes with deeply sorrowful humour. We now know that the world is of "average" size, and we remember that Duane Hanson's fibreglass people have been "alive" in this world for more than thirty years. Starting in the 1960s, he found these people in American everyday life, people who were all somewhat closer to the trauma of life, somewhat closer to the surface of the earth, and somewhat more forgotten on the edge of the masses. He replicated these people in polyester resin or bronze and placed them in the museums of this world, people who in their artificial perfection, in their artificial lifelikeness brought forth bewilderment, astonishment, and dismay in all viewers. His figures show that life does not satisfy the needs which it awakens.

Exhibitions of the work of Duane Hanson are especially important because his art allows us to reflect on our experiences in a world which is becoming increasingly impersonal. His sculptures show us life and do not permit us to view them coolly from a distance. Instead, they invite us to discover in the details the similarities and differences between the sculptures and the real individuals, and to follow the confusion of illusion and art world in the situation in which they are perceived.

For this reason we thank all the museums that agreed to participate in this large European tour for their great interest to show Duane Hanson's heroes of everyday life, to bring his works and his world of motifs to the attention of the public, and to put it up once again for discussion. We thank everybody who contributed to pushing this project ahead, gave moral and practical support, contributed texts, and loaned artwork. We would especially like to thank Wesla Hanson, Maja, and Duane Jr. Without their great dedication, this exhibition – the largest retrospective which has been shown anywhere in the world since the death of this great artist, their husband and father, in 1996 – would not have been possible.

Thomas Buchsteiner and Otto Letze

* = Exhibition piece

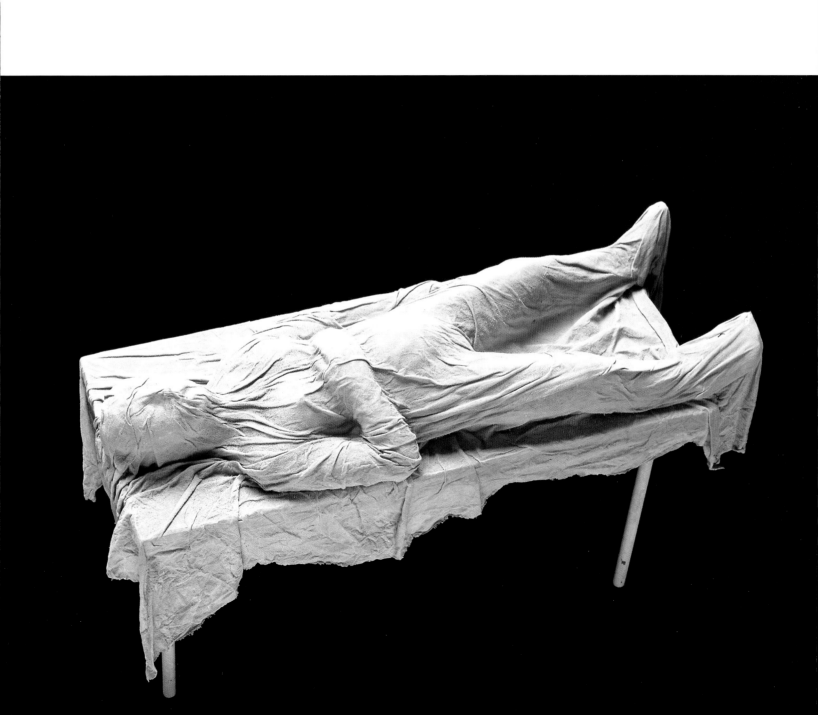

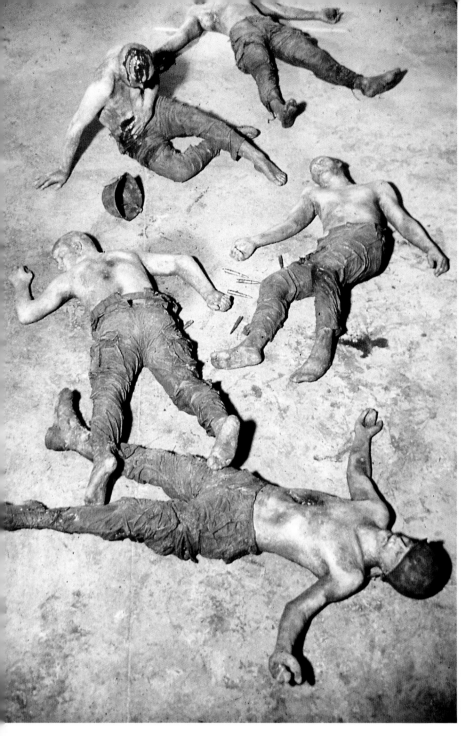

2 War, 1967

3 Motorcycle Accident, 1967 *

16

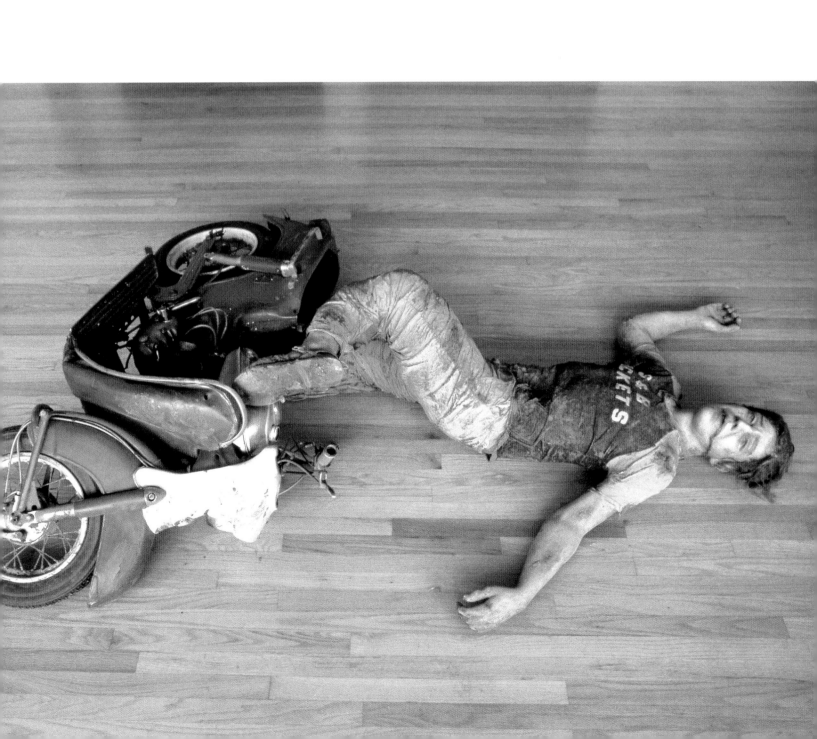

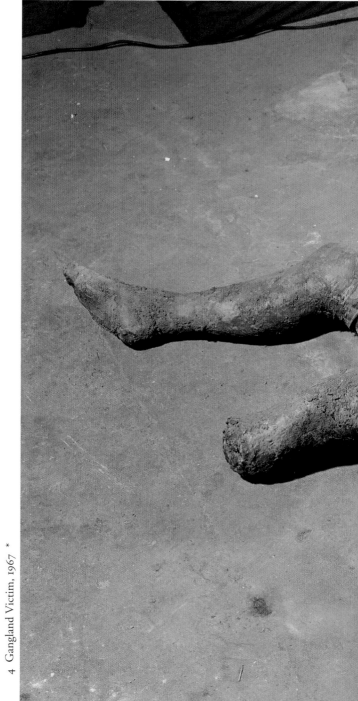

4 Gangland Victim, 1967 *

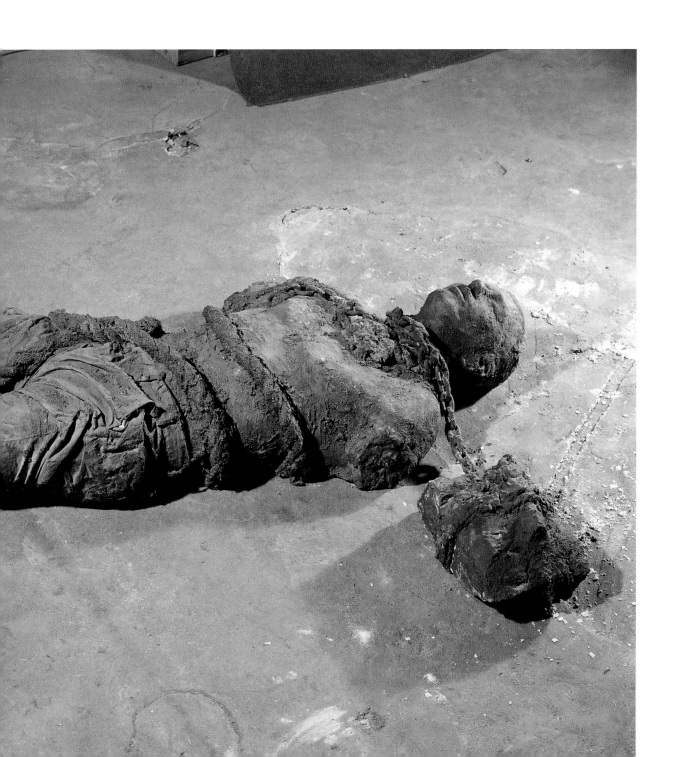

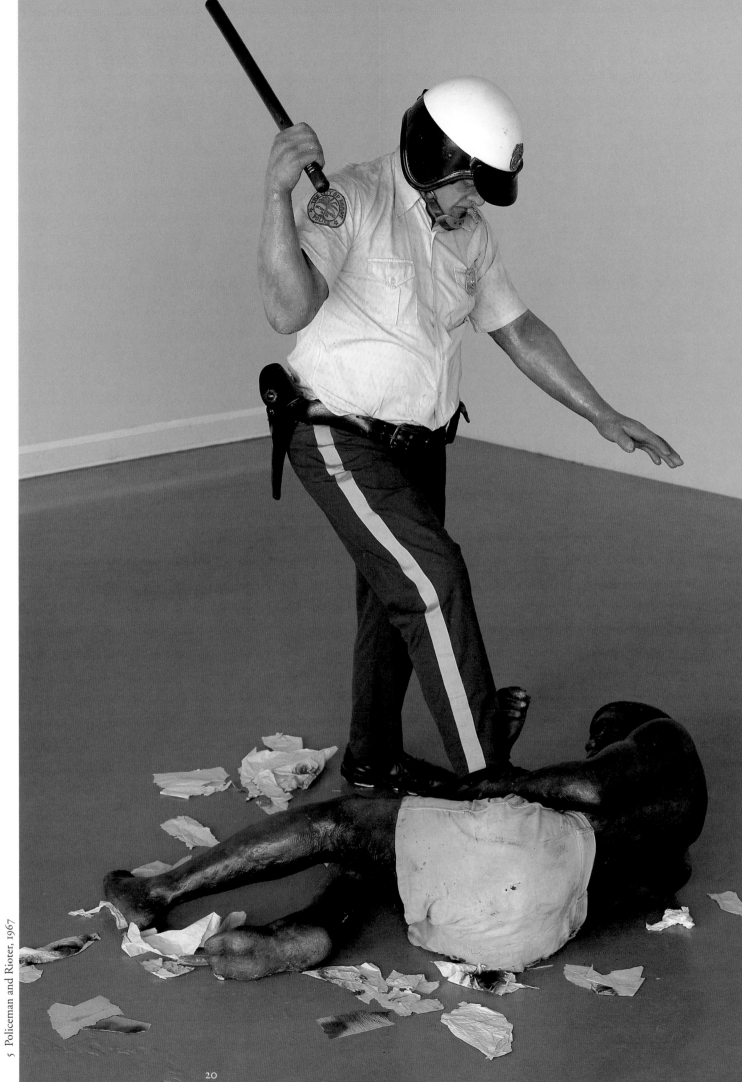

5 Policeman and Rioter, 1967

6 Trash, 1967 *

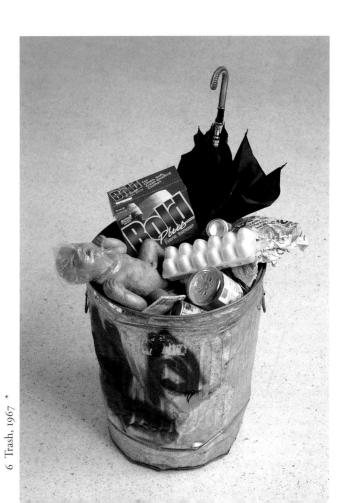

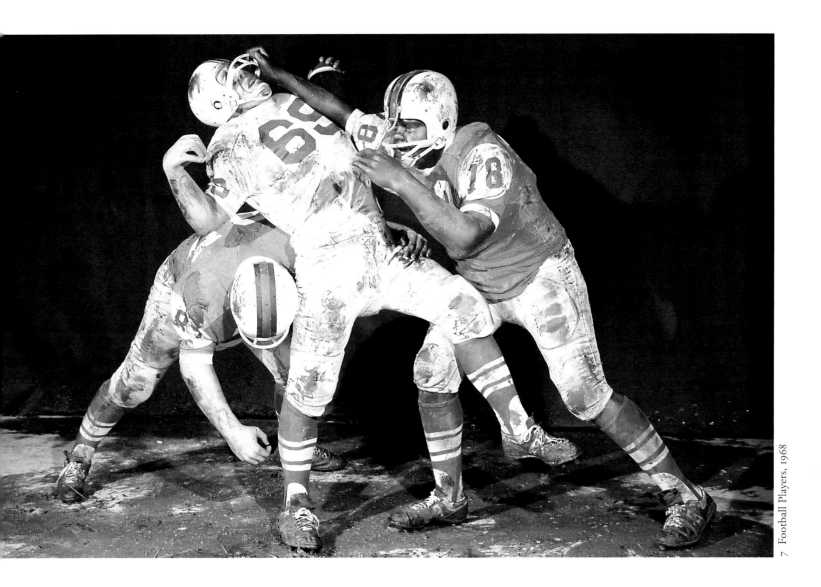

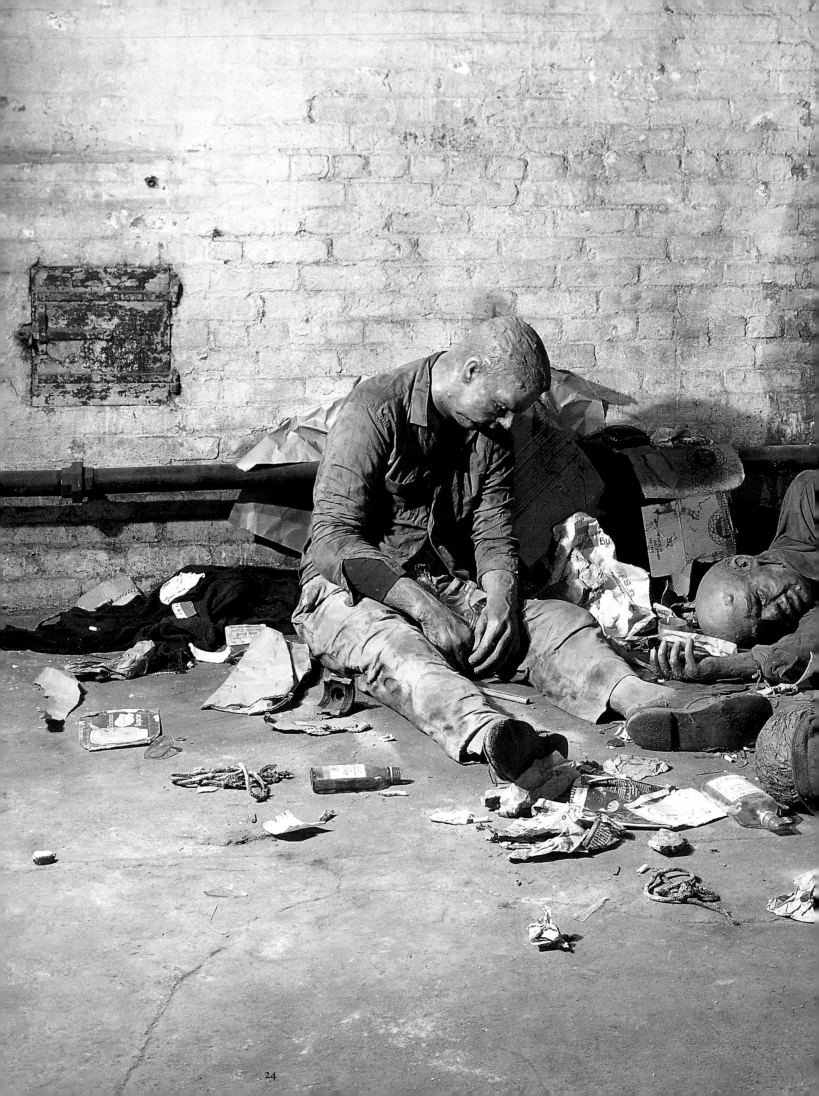

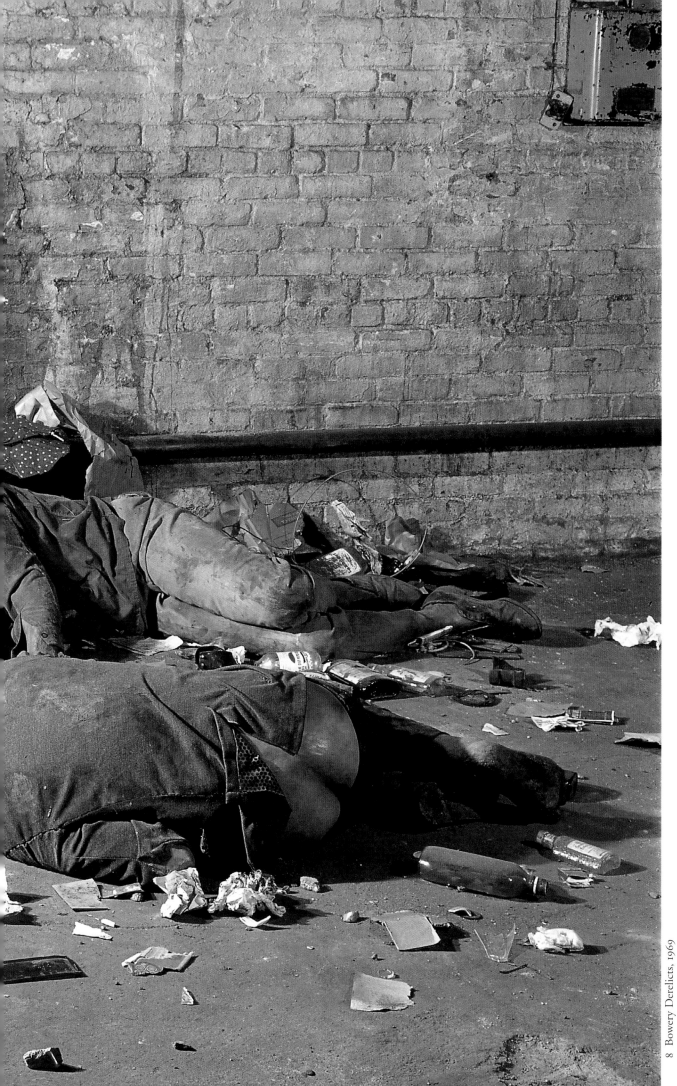

8 Bowery Derelicts, 1969

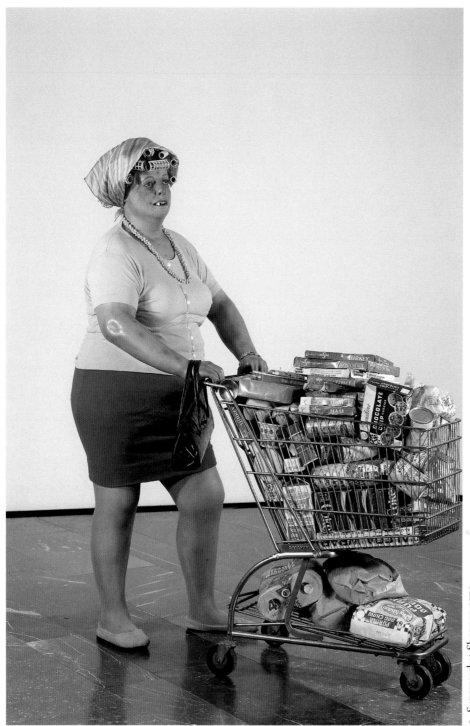

9 Supermarket Shopper, 1970

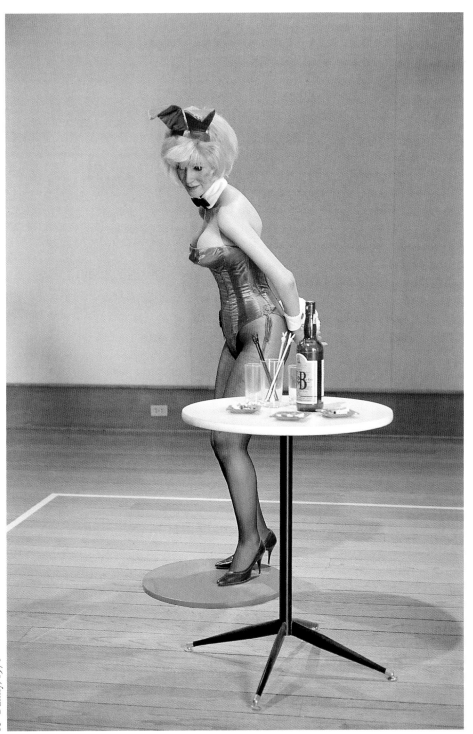

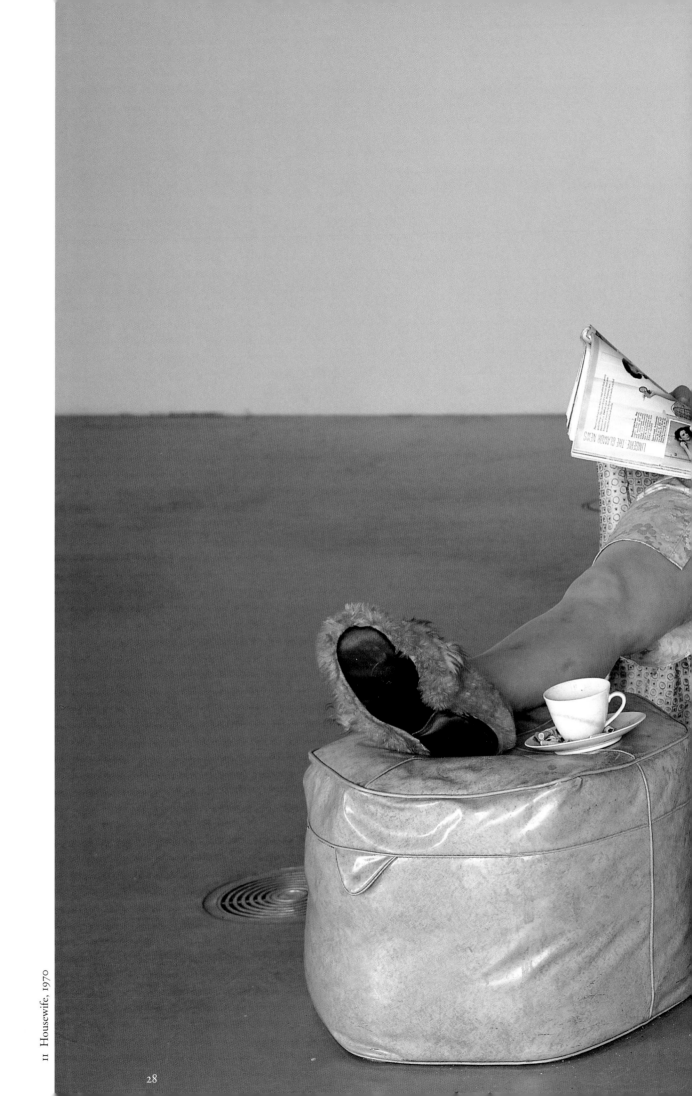

11 Housewife, 1970

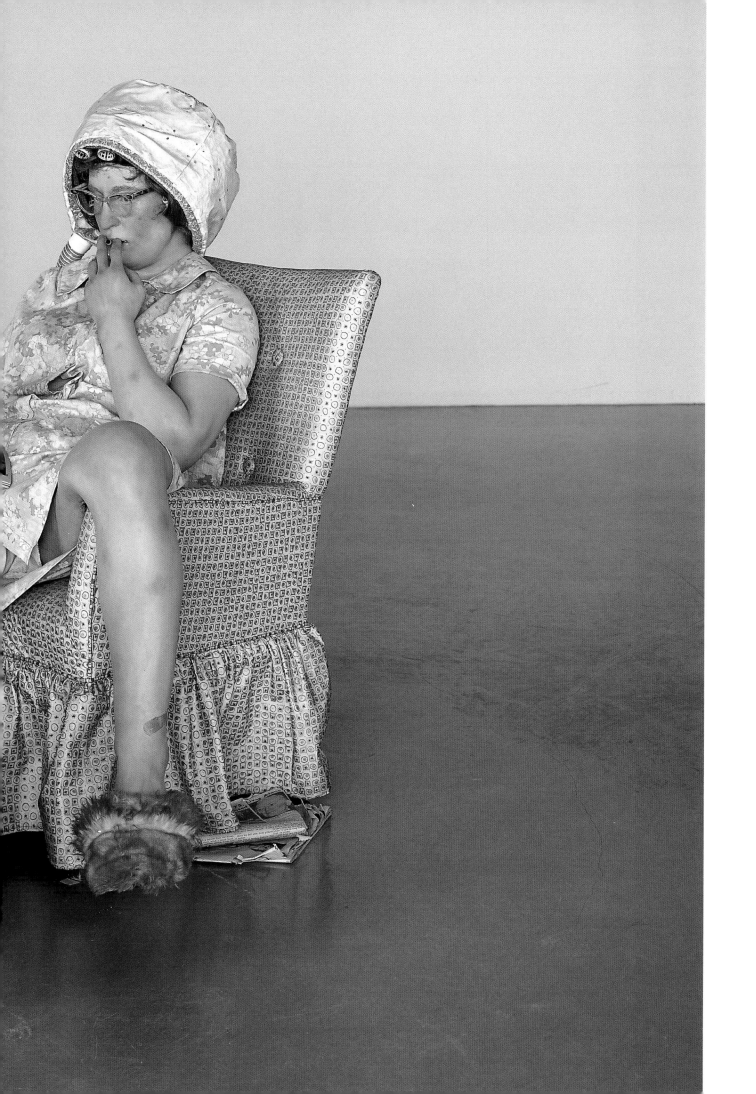

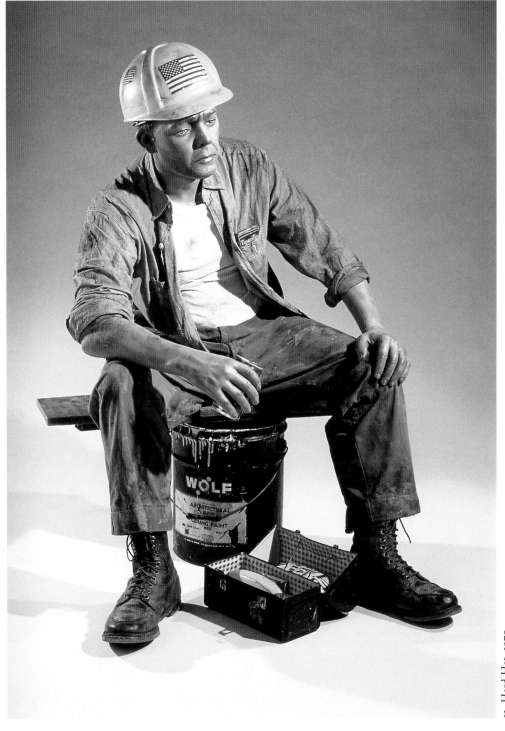

13 Hard Hat, 1970

12 Tourists, 1970

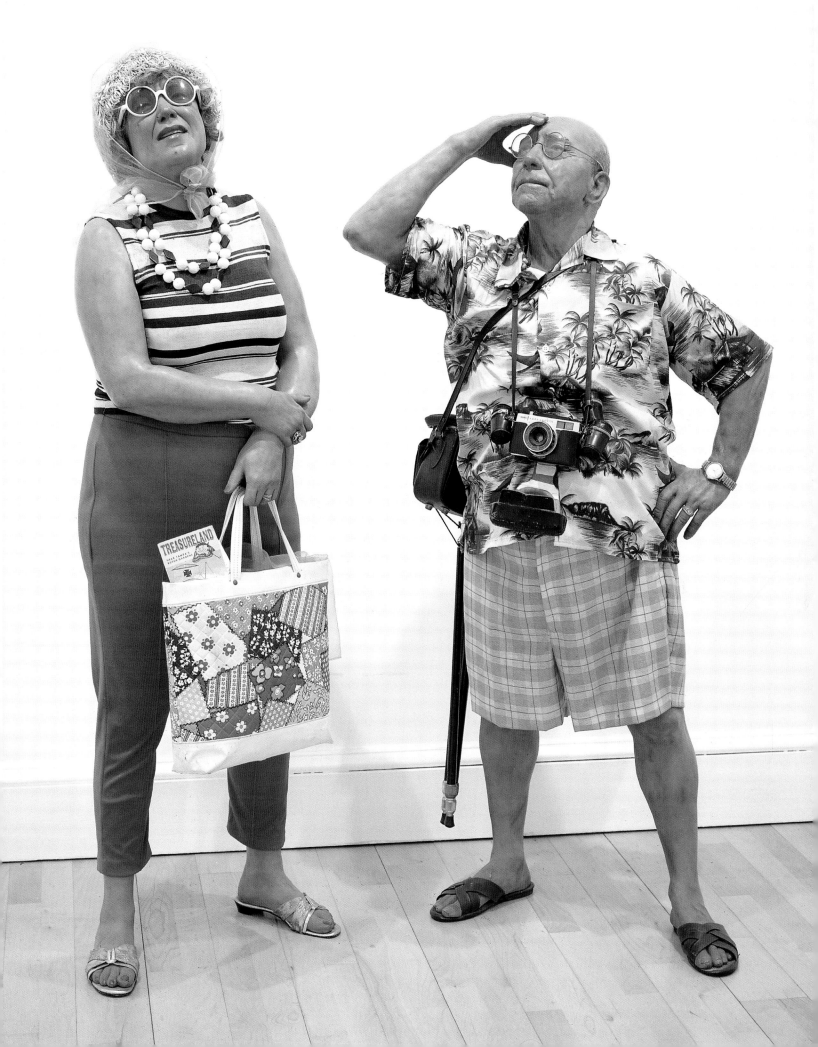

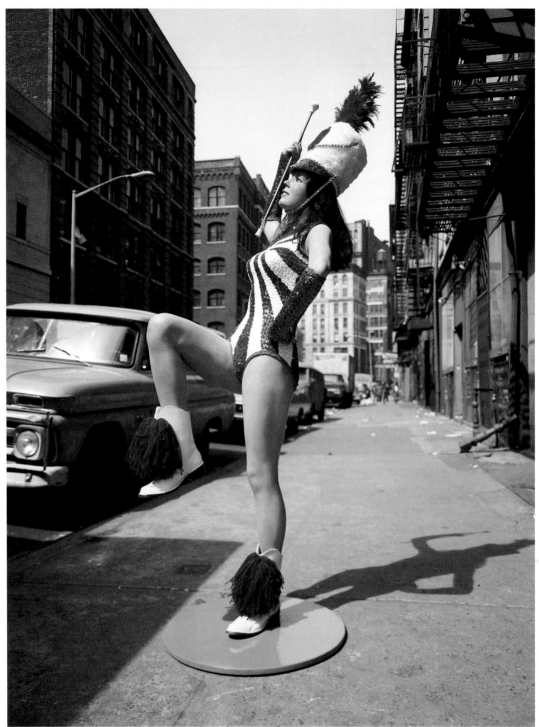

14 Baton Twirler, 1971

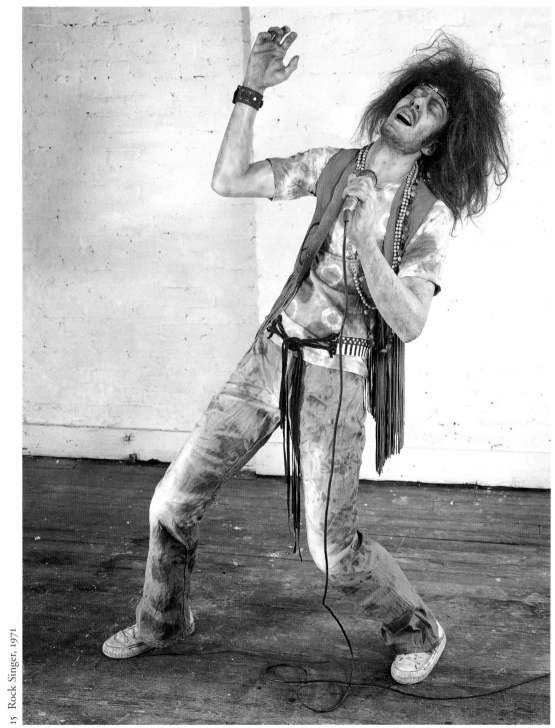

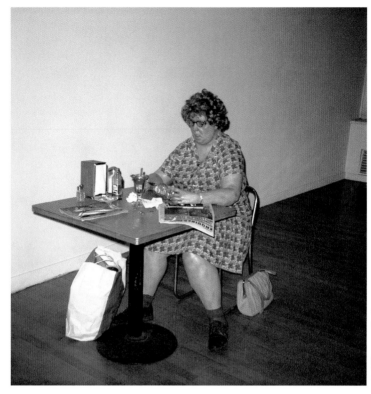

16 Woman Eating, 1971

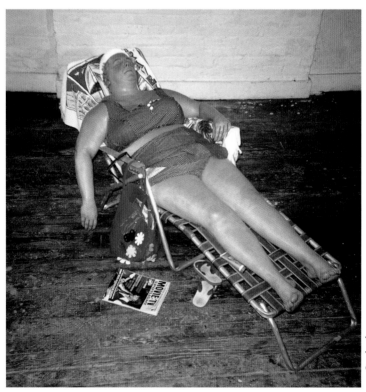

17 Sunbather, 1971

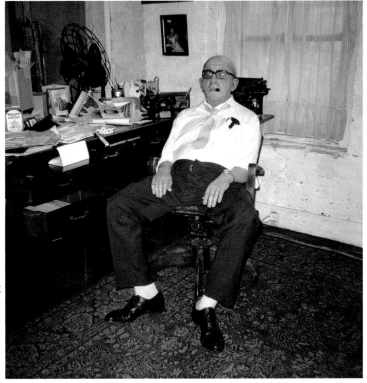

18 Businessman, 1971

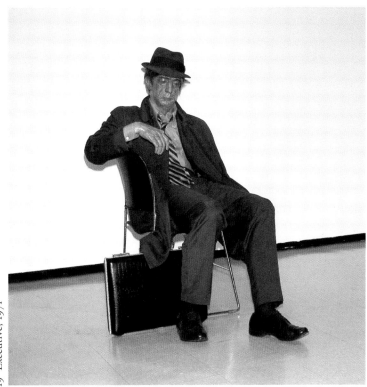

19 Executive, 1971

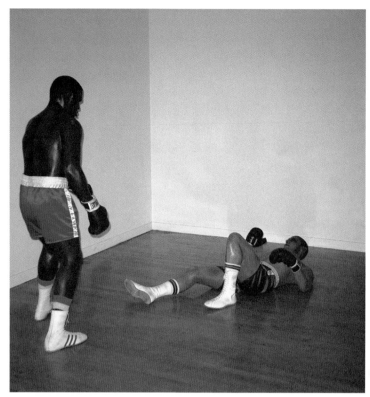

21 Boxers, 1971

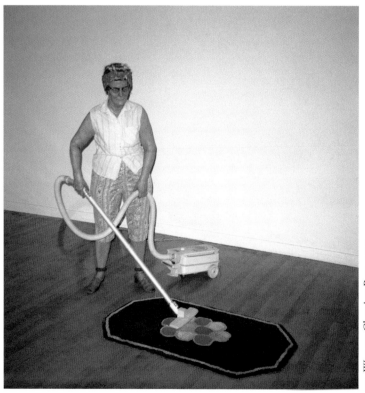

20 Woman Cleaning Rug, 1971

36

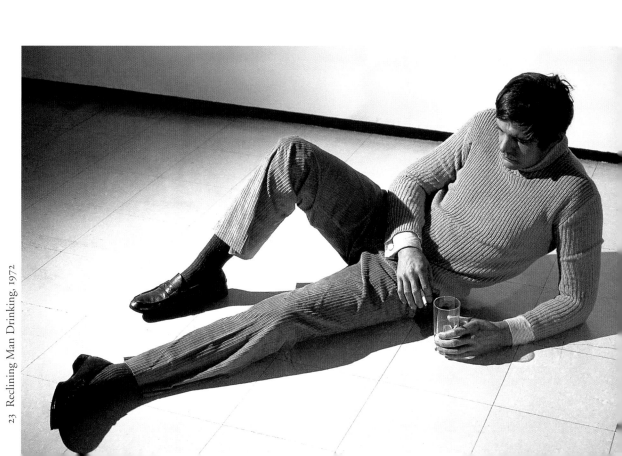

23 Reclining Man Drinking, 1972

22 Seated Artist, 1971

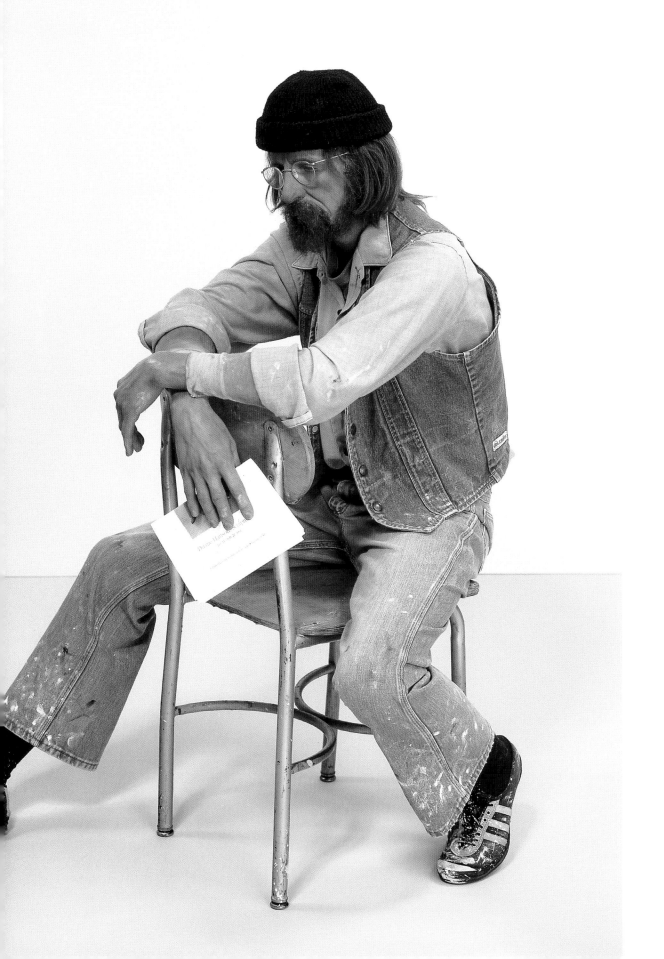

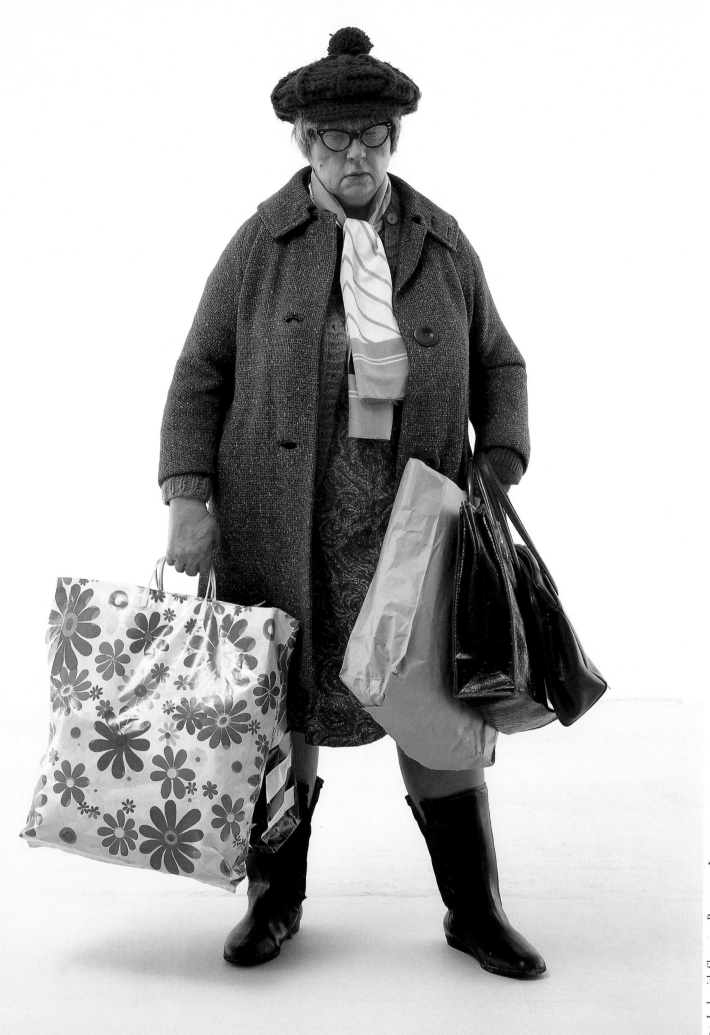

24 Lady with Shopping Bags, 1972 *

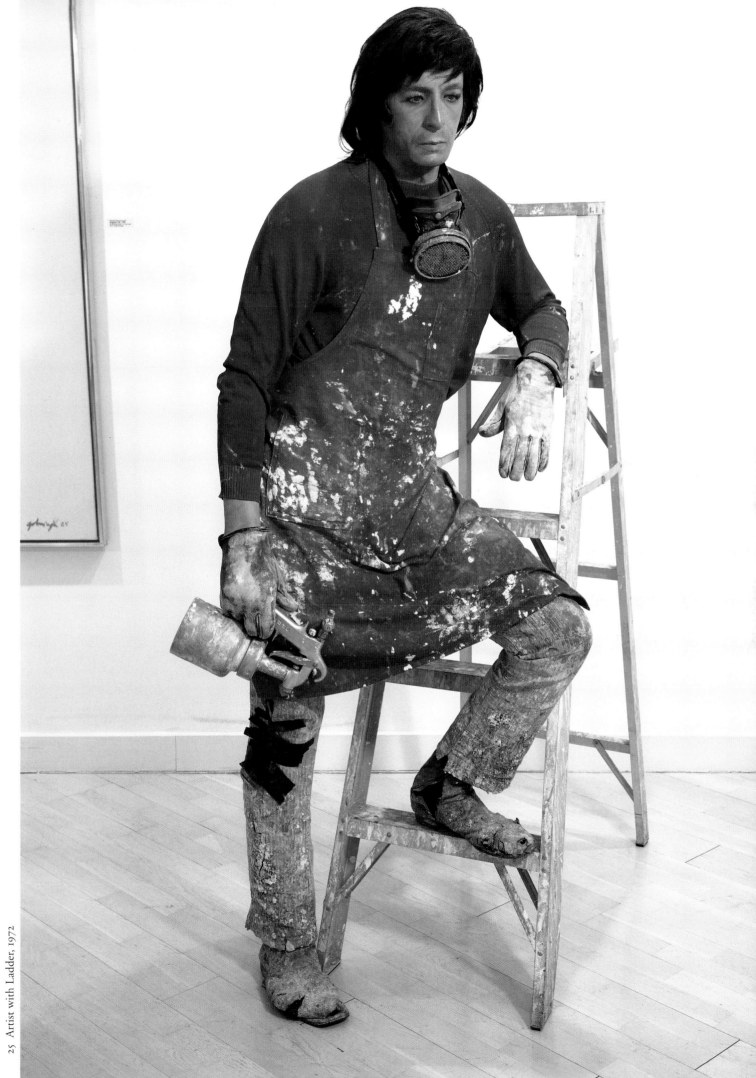

27 Putzfrau, 1972

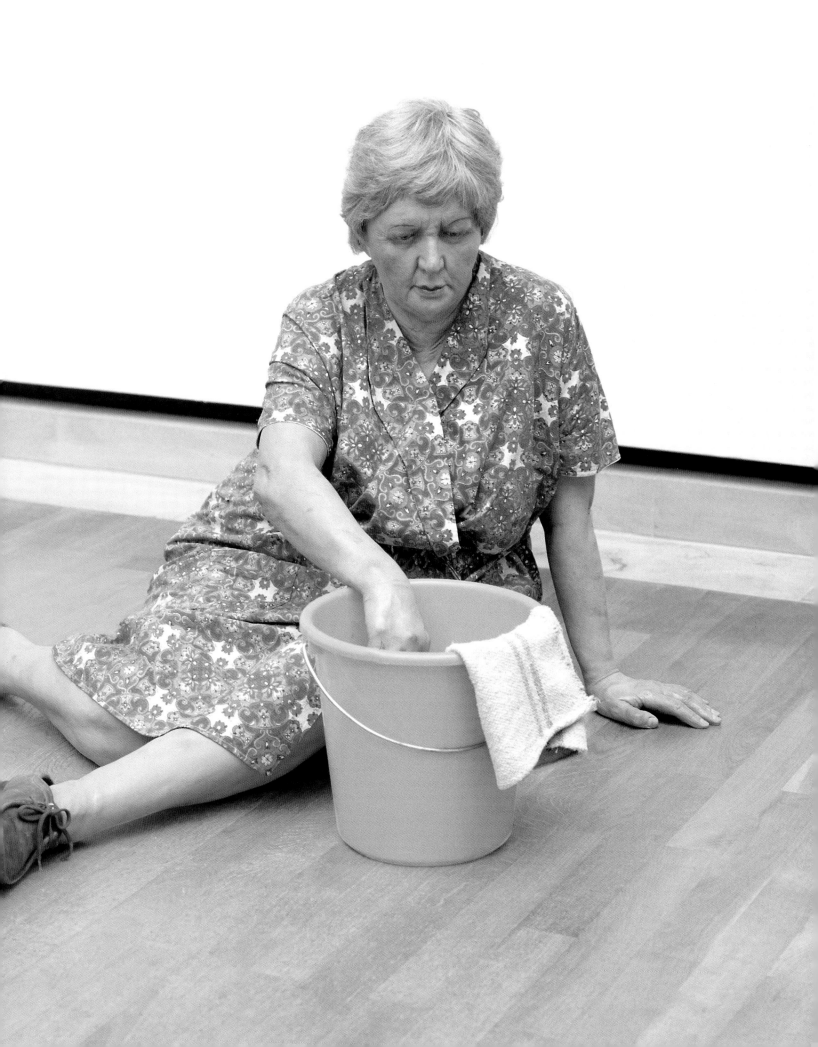

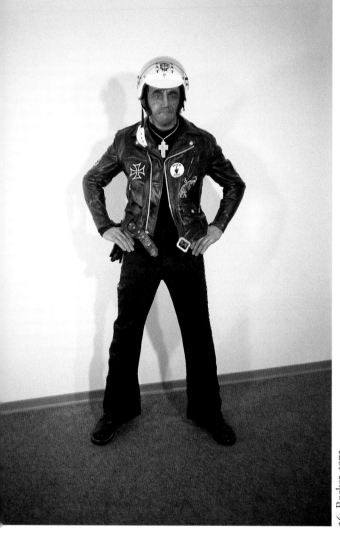

26 Rocker, 1972

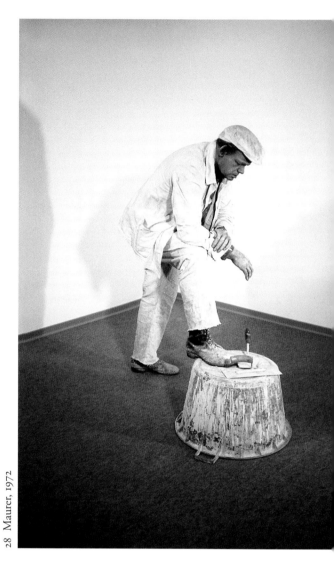

28 Maurer, 1972

44

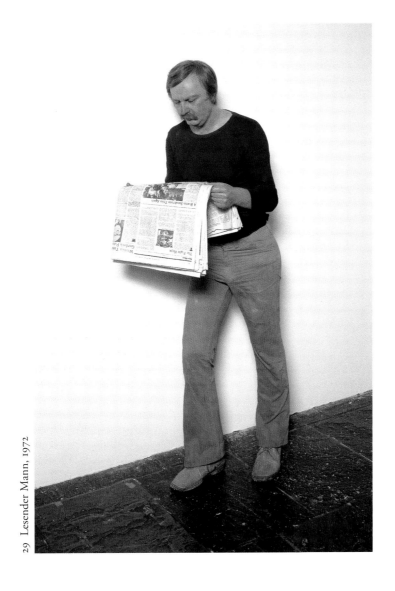

29 Lesender Mann, 1972

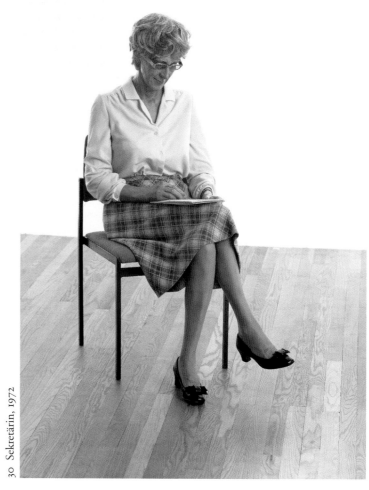

30 Sekretärin, 1972

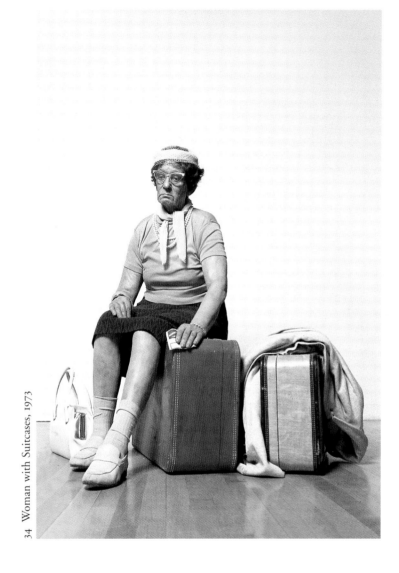

34 Woman with Suitcases, 1973

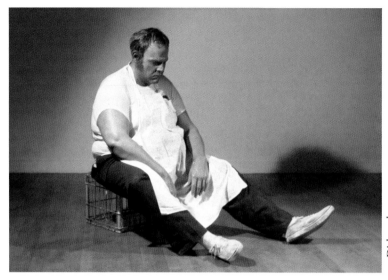

31 Dishwasher, 1973

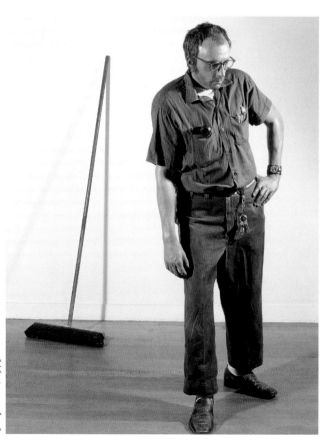

32 Janitor, 1973

48

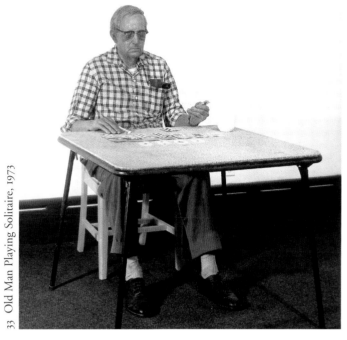

33 Old Man Playing Solitaire, 1973

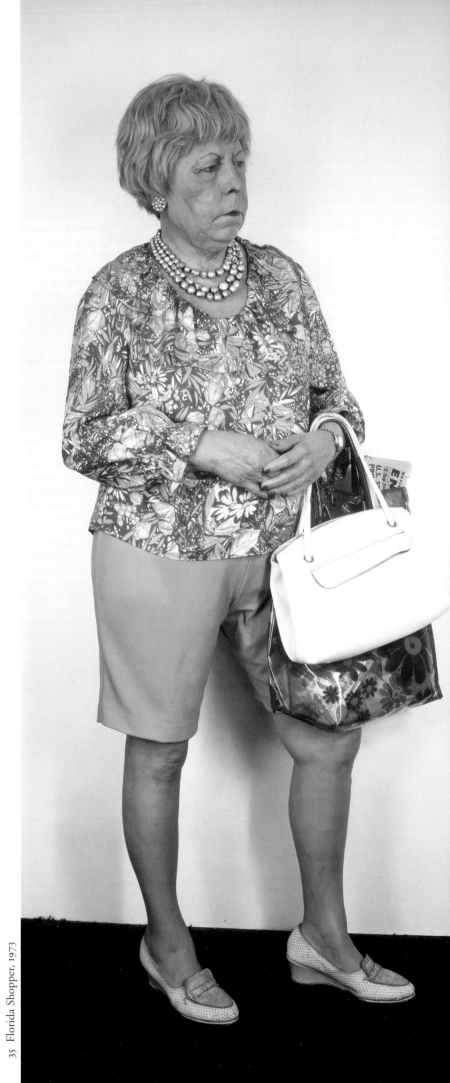

35 Florida Shopper, 1973

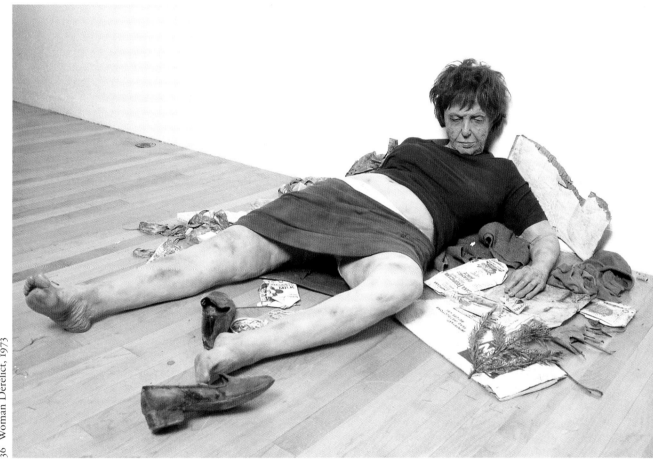

36 Woman Derelict, 1973

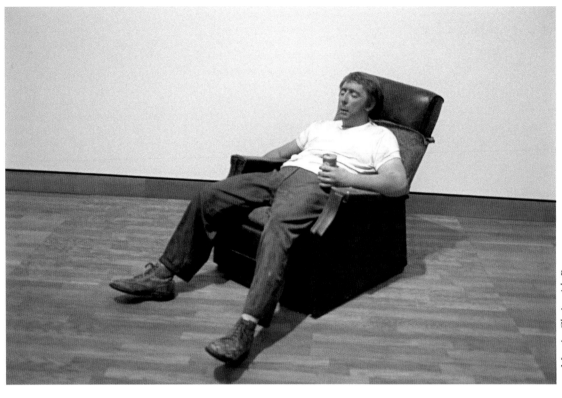

37 Man in Chair with Beer, 1973

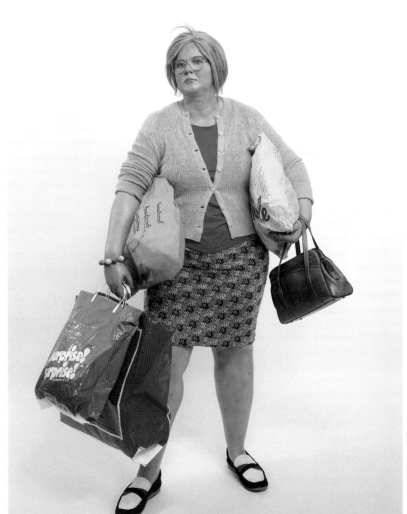

38 Young Shopper, 1973

52

40 Drug Addict, 1974

39 Man Leaning against Wall, 1974

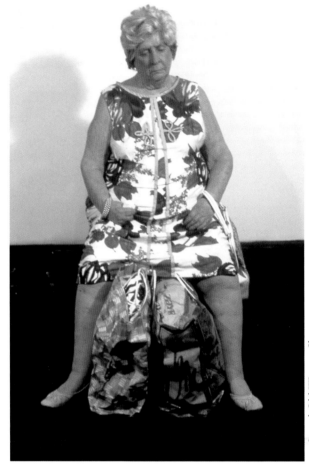

41 Seated Old Woman Shopper, 1974

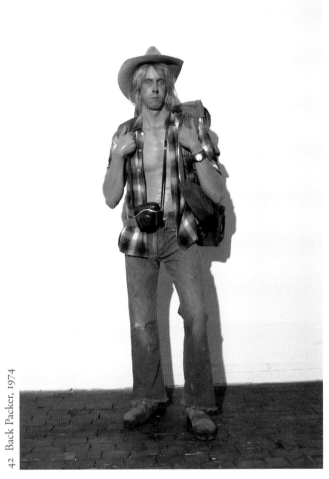

42 Back Packer, 1974

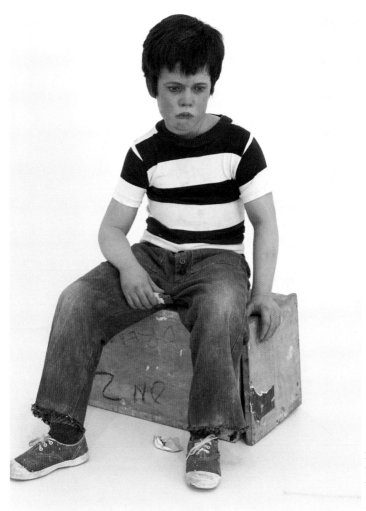

44 Seated Child, 1974

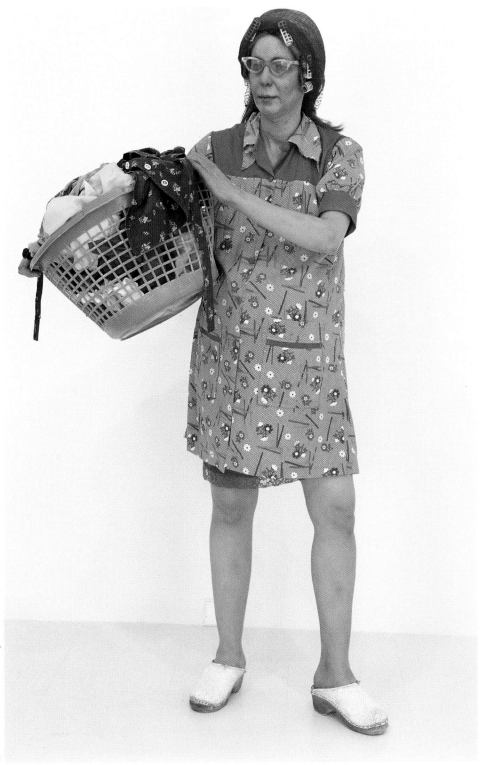

43 Woman with Laundry Basket, 1974

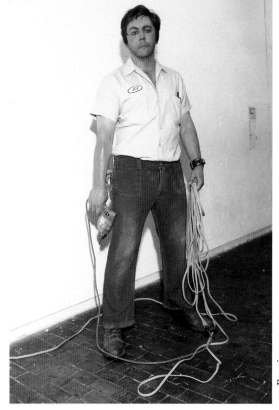

45 Repairman, 1974

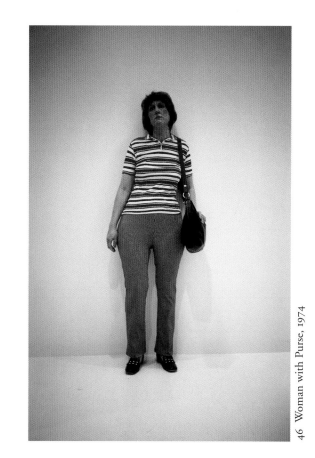

46 Woman with Purse, 1974

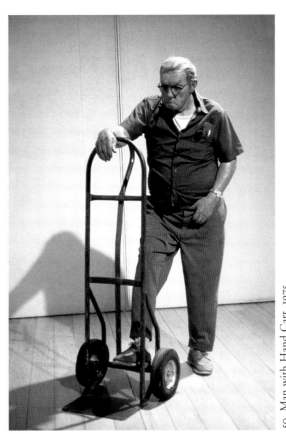

50 Man with Hand Cart, 1975

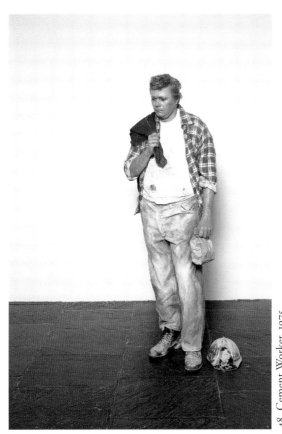

48 Cement Worker, 1975

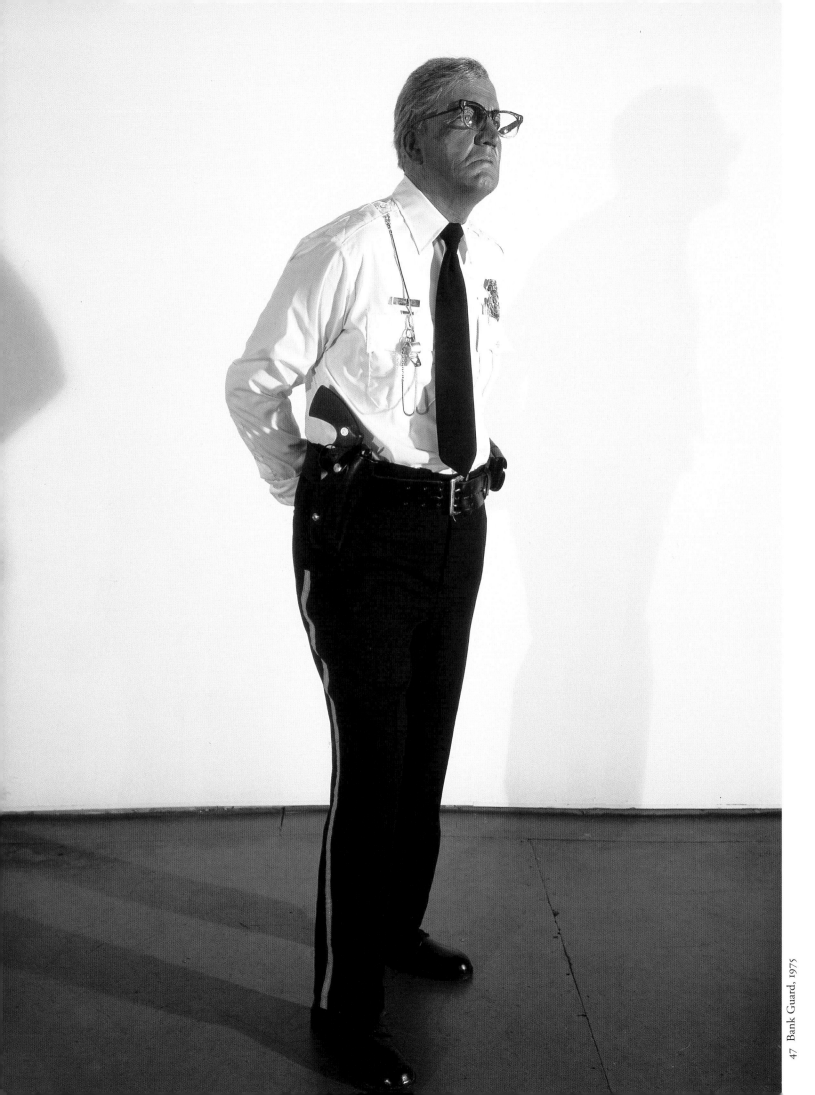

47 Bank Guard, 1975

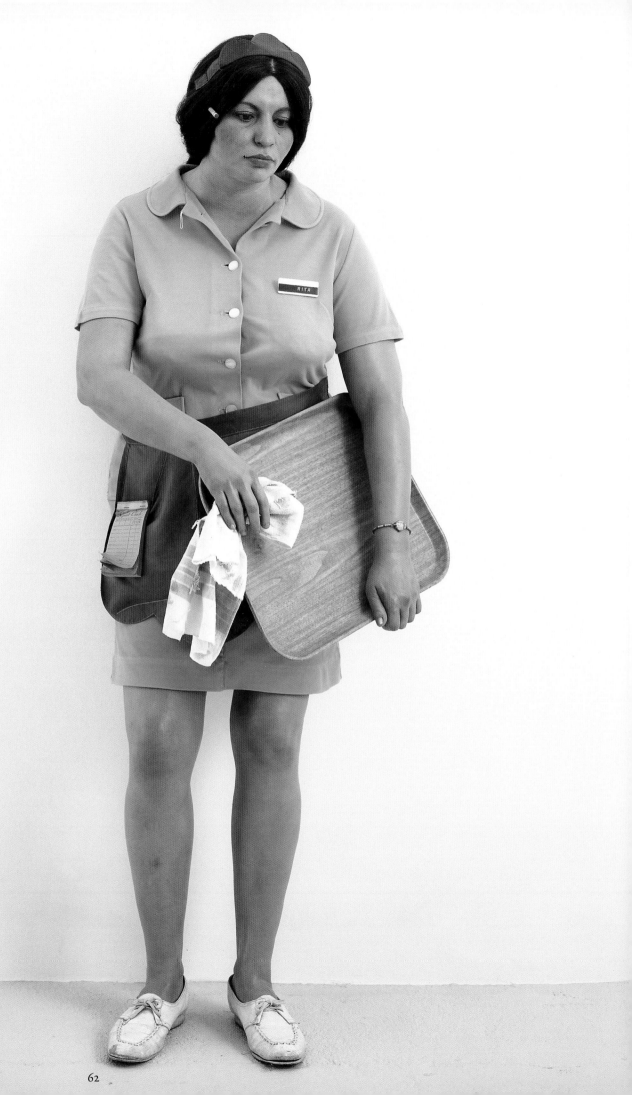

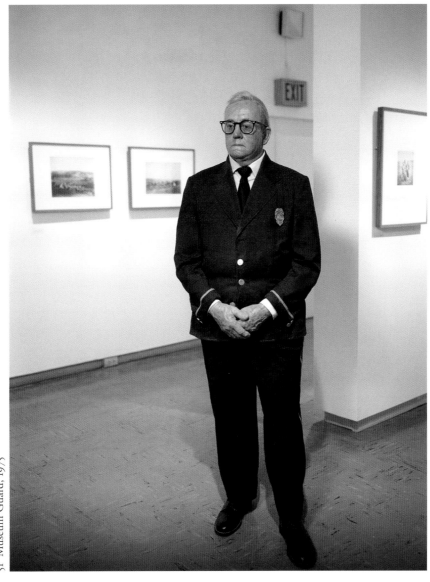

51 Museum Guard, 1975

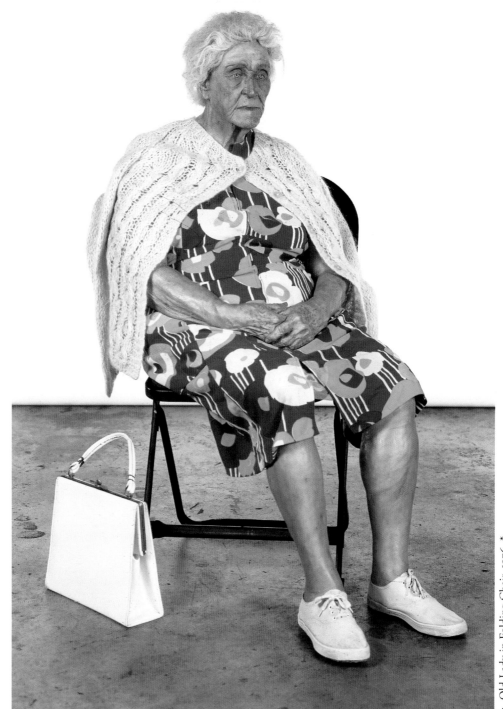

52 Old Lady in Folding Chair, 1976 *

ESSAYS

ESSAYS

ART IS LIFE,
AND LIFE IS REALISTIC
THOMAS BUCHSTEINER

THE HUMAN FIGURE
IN DUANE HANSON'S ART
KEITH HARTLEY

DUANE HANSON AND OTTO DIX
JOHANN-KARL SCHMIDT

HOW TO LOOK AT...
CHRISTINE BREYHAN

ART IS LIFE,
AND LIFE IS REALISTIC
THOMAS BUCHSTEINER

"I'm not duplicating life, I'm making a statement about human values. My work deals with people who lead lives of quiet desperation. I show the empty-headedness, the fatigue, the aging, the frustration. These people can't keep up with the competition. They're left out, psychologically handicapped." [1]

People are Duane Hanson's main subject. His art-people are the medium of his message. They are very specific people. They are not special characters, and not at all conspicuous, since they come from the masses. All his life Duane Hanson noticed them, and his trained eye often picked them out on the edge of the crowd, because even the masses left these people no room in their centres – mentally or physically.

These losers in life and heroes of everyday life determined Duane Hanson's artistic work for more than thirty years. A total of 114 "sculptures of life" are still in existence today, some in a number of variations and many of them so lifelike that anyone familiar with Ovid's story of Pygmalion would try to breathe life into them. Others are beautifully perplexed by what they see and are filled with a mixture of profound emotion and admiration.

In an age in which computer simulation and electronic magic have confused our belief in reality and likeness, in reality and virtual reality, Duane Hanson's message seems even more urgent, even stronger and more persistent, since the three-dimensional presence of his people evokes an emotional response that surpasses by far our usual reactions to two-dimensional, flat images. His human images do not react to overly intense staring, and you would like to touch their rather disconcerting, almost obscene realness, to smell their closeness, or to even just have eye contact. You can point at these strange, dressed people with your naked finger, you can talk about them as long and even as loud as you please, and they just don't react – a state between attraction and unease which in terms of dramatic effects goes much deeper than interaction with a Play Station. But there is communication. Deep within ourselves we feel Duane Hanson's message, which he has transported with this incarnated material from the outside world to the inner world of the museum and which we – since we cannot evade this dialogue – consciously or subconsciously take out with us into the outside world. We see that Duane Hanson's fibreglass people also live in our world, and that we come across them every day. Sometimes early in the morning at the mailbox, or later at the gas station, in the office, at the checkout in the supermarket, or at the latest in the evening on the way to the theatre or while ordering in a restaurant. We see the same resignation, emptiness, and aloneness, the same boredom and hopelessness which Duane Hanson also captured in his works about the American way of life, and his world of motifs from the American lower and middle classes still perfectly identify the clichés and prejudices which Europeans have about American life.

Duane Hanson transforms the reality of life into the realism of art. His artificial real world once again becomes everyday in the real art world of the museum, sharpening our view of the future, the world, our fellow human beings, and also our own lives.

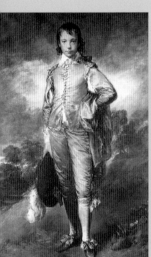

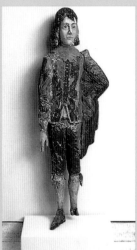

Thomas Gainsborough,
The Blue Boy, c. 1770,
Library and Art Gallery
San Marino, California

Duane Hanson,
Blue Boy, 1938

Duane Hanson was born on 17 January 1925 in Alexandria, Minnesota, in the American Midwest. His parents, Agnes Nelson and Dewey O. Hanson, were Swedish immigrants. They ran a rural dairy, bringing Duane up in a protective, understanding, and loving way with an American system of values. When Duane was five, the family moved to Parkers Prairie, a small town of seven hundred inhabitants, none of whom had any interest in art whatsoever – with the exception of Duane. "I guess I was the only oddball around", he remembered later.[2] He painted, carved, and modelled constantly, and his friends and fellow pupils in the small village school profited from his many interests and obvious talents. He played the piano and violin, wrote plays, poems, short stories, and liked acting. It is said that there was only one art book in the whole place and that he especially liked the illustrations of the paintings by the English portraitist Thomas Gainsborough and Sir Joshua Reynolds, the English court painter and leading portraitist of 18th-century aristocracy. He repeatedly borrowed this book from the local library, and his first artwork was based on a famous painting by Gainsborough.

Duane carved Gainsborough's portrait *The Blue Boy* of 1770 in wood. He translated the two-dimensional image into a three-dimensional sculpture and then painted it like the illustration, and initially he placed a hat in its right hand. Duane was thirteen at the time. Five years later – at the height of World War II in 1943 when everybody was joining the army – nobody was really very surprised when he decided to study art, since he was not eligible for service due to his allergies. He initially enrolled at Luthor College in Decorah, Iowa, switching after one year to the art department at the University of Washington in Seattle. He enjoyed discussions with the old sculptor Dudley Carter, who carved with an axe, learning from him even though he did not favour his rough style.

Seattle was far away from home, however, and travelling during the war was not easy. After a year and a half he returned to Minnesota, enrolling at Macalester College in St Paul. In June 1946 he graduated with a Bachelor of Arts. This period in Minnesota was particularly exciting for Duane Hanson since he met Alonzo Hauser and John Rood, two sculptors who were quite well known in America at that time; their acquaintanceship was to grow into a lasting friendship. The discussions with Rood, whose figural works impressed Hanson, were especially important to him. He profited from the inspiring theoretical discussions, and his friends' positive feedback concerning his work motivated him to enrol in the famous Cranbrook Academy of Art in Bloomfield Hills, Michigan, in order to concentrate on sculpture. Bloomfield Hills was a small town, located about twenty miles from Detroit, but its art academy had an extraordinary reputation. Most of the buildings had been built by Eliel Saarinen, who was known both for his historicising forms and for his successful integration of buildings and landscape – as well as being the father of the even more famous Finnish architect and designer Eero Saarinen. The designers Charles Eames and Harry Bertoia also taught at Cranbrook Academy in the late 1930s. They and other artists lent a very distinctive character to this mixture of academy, research centre, artists' colony, and museum. The teaching system did without classes and grades, which guaranteed direct contact with the professors – the "master artists" – and maximum freedom, which left its mark on the few, carefully chosen students.

At Cranbrook, Hanson also met the Swedish sculptor Carl Milles, whose artwork, especially his monumental bronzes, had by then earned him international renown. Milles was responsible for sculpture at Cranbrook; he spent much time with Hanson, and the two appreciated each

other. "Good words from Milles meant a lot to me, I loved his work. I still like it, but I think it really wasn't for me."[3] Although abstraction was in fashion at the time, the few works by Hanson which still exist from this period have figural subjects, but seem to be searching for a style, trying out everything from abstract to realistic. He said himself, "I would try to do abstract work, but I always put a bit of an arm or nose in it. I never could do just non-figurative work."[4]

In 1951 Hanson received his Masters of Fine Art at Cranbrook. He married the young and ambitious opera singer Janice Roche and taught art briefly at Edgewood High School in Greenwich, Connecticut, and then at Wilton Junior High School in Wilton. Hanson's first one-man show was held at the Wilton Gallery as early as 1952, but he was extremely unhappy with his artistic work and development. On one hand, he was searching for his own, unique style, but on the other hand he, too, wanted as soon as possible to conquer the galleries of New York as an exponent of Abstract Expressionism, which was current at that time. This was a feasible goal from Connecticut, but in artistic terms depressing and frustrating because all his attempts ended in failure. He simply did not have a chance with his art, although he did have the vague idea that maybe he could find an artistic direction in Europe. He reckoned that he could work as a teacher in American schools, in places where American soldiers were stationed. This idea became reality in 1953. He found work in Munich and taught there for the next four years at schools affiliated with the American army. "I did some formalistic pieces, making some pretty aesthetic statements in stone, wood, and clay – even some welded works and paintings. But I never stuck with anything or tried to develop my work. It always ended up as decoration."[5] Artistically he was still stagnating, but he did discover the museums of Germany, which were either being rebuilt or, like the Haus der Kunst in Munich, had survived the war.

At this point chance intervened and changed Hanson's life. He was transferred to Bremerhaven in 1957 to teach at the army school for three years. In 1958 he showed several new works in the Galerie Netzel in Worpswede, and in this period he must have also met George Grygo. Grygo was a sculptor, not very well known, but good enough to have just been commissioned to make public sculptures for several cities in destroyed post-war Germany. Duane Hanson was impressed. Not by the commission, or the way that Grygo dealt with it, but by the materials he worked with: polyester resin and fibreglass. Duane Hanson was fascinated by the possibilities offered by these materials.

When Hanson returned to the United States in 1961 to teach at Oglethorpe College in Atlanta, Georgia, he began experimenting with polyester resin. He did not know anyone at the time who was making art with this medium, but he sensed that he could bring a certain liveliness into his work with it, only he did not know exactly what subject would present the energy and strength of expression that he wanted so desperately to achieve. Everything he did, even in collaboration with various architects, he judged self-critically as stylistic routine work; a relief, which he produced for a building, he considered mere decoration.

Duane stayed in Georgia for five years. It was no easy time for him artistically, nor was life easy. The civil rights movement of the sixties, the political tension, the riots, the general discontent, and the brutal violence in the streets of America, some of it in the open, were felt even more strongly in the South, and Hanson, as a Northerner, felt it even more. His personal conflict was that as an artist he wanted to do something about this atmosphere, to break down the monstrous hypocrisy and the segregation which was still strongly anchored in society, but he didn't know how and was unable to express his sense of justice. In several pieces from this period, which for the most part no longer exist, it was possible to see what moved him and to feel that he would succeed in overcoming this inner conflict. He was awarded the Ella Lyman

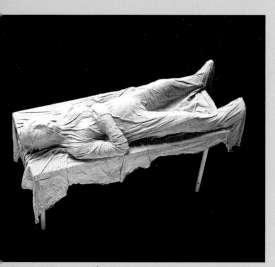

Duane Hanson, *Abortion*, 1965

Cabot Trust Award in 1963 for his sculptural work, and he also received two thousand dollars to continue experimenting with polyester resin, but the years in Atlanta ended for him with disappointment, frustration, divorce from Janice Roche, and separation from his son. Duane Hanson was now forty, and his move to Miami in 1965 represented a new beginning. His teaching engagement at Miami Dade College proved to be more challenging academically than he expected. Perhaps it was due to this necessary adjustment that he perceived the beginning development of Pop Art and the shift from Abstract Expressionism with curiosity. Artists such as George Segal and Edward Kienholz, or also Jasper Johns and Robert Rauschenberg especially interested and occupied him. They had begun to view the banalities and trivialities of everyday life as iconographic material, treating it as their subjects in loud and energetic ways, and arranging it in unambiguous and understandable statements and also responding to it. "Pop certainly spurred me on, especially the work of George Segal."[6]

George Segal, who was only one year younger than Hanson, had already begun at the end of the 1950s to produce crude human figures from wire mesh, jute, and plaster. In the early 1960s he made the first body casts of living models, which were mounted in a bandage process with the "skin" of the cast facing the outside. Still impressionistically uneven and coarse, they were arranged in installations to show the habits, banalities, and monotonies of American life at the movie house ticket booth, in the bathroom, at the gas station, or even on the bus or in the act of painting fingernails.

Duane Hanson considered Edward Kienholz and also Robert Rauschenberg to be too surreal and divorced from reality, while Jasper Johns and other artists, who were quite interesting to Hanson, worked only with individual body parts or torsi. Nevertheless they and others like Paul Thek, with *Death of a Hippie* of 1967, or even Marcel Duchamp's *Etants Donnés*, which Hanson could not have seen before the summer of 1969 in the Philadelphia Museum of Art, influenced him, guided him, gave him strength, and ultimately offered confirmation again and again.

Hanson made his artistic breakthrough in 1965 with a sculpture he called *Abortion*. He found the idea for the material, the technical inspiration and methods in George Segal's work; a debate in Florida on the question of abortion provided the subject. Cuban doctors had performed illegal, incompetent abortions on young, despairing girls, some of whom died or were badly injured. Hanson was in favour of legalising abortions and wanted to document his position as well as his frustration over the lack of government action. The sculpted figure, about sixty centimetres in length, represents a young, pregnant girl on a table, but is covered by a linen sheet. "I wanted to make a statement about why our society would force them to risk an illegal operation. Something had to be done to awaken the public."[7]

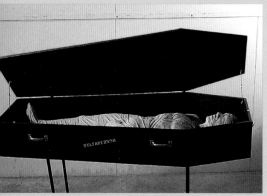

Duane Hanson, *Welfare-2598*, 1967

He shaped the girl's body in clay which he covered with fibreglass and polyester resin in order to create a sculpturally exact, but light form under the cloth. This ghostly sculpture so unambiguously represented an illegal, fatal abortion that it did not fail to have an effect. Friends persuaded Hanson to enter this work in the annual Sculptors of Florida exhibition. After heated, controversial debate, *Abortion* and one other work by him were chosen by the jury for the exhibition. But the real confrontation occurred when the show opened. The reaction of local critics was similar to that of Doris Reno of the *Miami Herald* on 20 October 1966: "This we do not consider a work of art,

since we inevitably consider all such objects and such treatments as outside the categories of art. We find the subject objectionable, and continue to wish that such works which merely attempt to express experience in the raw could be referred to by some other name. This, of course, is the newest thing in 'sculpture', but that doesn't invalidate our contention that it is non-art."[8]

The waves of indignation were as high as those of acknowledgement, and discussions were so heated that Hanson was forbidden by the college board to produce his sculptures in the sculpture studio at the college. Some time later he said, "Here at last was something I deeply wanted to say about life around us today. But, more important, after years of uncomfortable ventures into abstract, nonobjective and conventional representative work ... I had embraced realism as my mode of expression."[9] Rejection and agreement motivated him equally to formulate his social and political views as sculpture. He was a sculptor, a visual artist. Art for him was life, and life was realistic. That now became clear to him.

In the following years, still very much in the spirit of the protest movement, he created sculptures treating the subjects of social misery, suicide, rape, murder, racism, and violence. In *Welfare-2598* Hanson used fibreglass and polyester resin, the same materials with which the sculptor George Grygo had impressed him in Germany. Now the full-size figure of a man lay in an old-fashioned black coffin which Hanson's father and uncle had built. "The sculpture dealt with a poor person dying and no one giving a damn about it. There his body is, but it's just another number.... That's wrong. Maybe it was a dumb idea. But the idea of death was very important to me, and I wanted to share my feelings with others. Why shouldn't we protest the crazy, dumb things people do, particularly the bureaucrats."[10]

This work, too, caused debates and fundamental discussions about what art is and how far an artist can go. Duane Hanson's reputation and his interest in the morbid began to establish themselves in the public consciousness.

In this year, 1967, he made his first casts from living models. One sculpture represented a man who had committed suicide, wearing shorts and hanging from a beam with his head drooping to the side. Another work showed a half-naked girl, murdered and covered with blood, lying on a bed with the murder instrument still stuck in her body. A third work was a rape victim, half naked and tied to a tree. A scene of raw violence, one of many crimes committed by a number of motorcycle gangs which often came up in the media at that time. This work with living models and his first attempts to make casts directly from the model were especially exciting for Hanson. He now had countless opportunities to try out a staging until the drama of the expression really did reflect the reality. In addition, the casting technique, the assembling of body parts, and dressing the figures enabled him to create an almost hyperreal sculpture. He felt that by improving his technique he could heighten the effect of his work. But for him these works were simply experiments, studies which were never exhibited, and he was not especially annoyed when all three of these sculptures were destroyed in a fire at his friend's house, where he had stored them when he moved to New York.

In 1967 he was moved by the very divided attitudes of his contemporaries to American involvement in the Vietnam War to produce *War*, a group of sculptures which for him was also a statement against war and violence in general, in support of all those who had to directly or indirectly suffer because of war. *War* presents five uniformed dead or wounded soldiers, who could "serve" in any army of the world and now lie on a battlefield somewhere, covered in dirt and blood. Another work made in 1967, again a direct cast, has pure violence on the street as its subject. In *Race Riot* Hanson articulated taking the law into your own hands, criminality, racial unrest, and the direct, brutal attacks of representatives of a so-called democracy against minorities and weak citizens. Seven figures are involved in a violent, armed struggle.

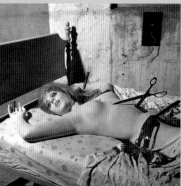
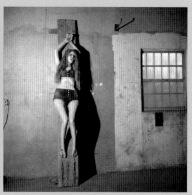

Duane Hanson, *Untitled,* c. 1967

A burly policeman, surrounded by aggressive citizens who are ready to take the law into their own hands, strikes a black man on the head with his club. It is an image which was hardly exceptional in those days in America; critic David L. Shirey chose this work, on the occasion of a 1969 exhibition in the Whitney Museum in New York in which Hanson participated, as one of the strongest presentations. But Hanson later considered the figures to be too "wooden", and he destroyed five of them, leaving only the standing figure of the policeman with his club and the cowering black man on the ground.

That same year, in a somewhat larger atelier in Opa-Locka, he also created *Gangland Victim* (1967): the chained-up body of a drowned person, already starting to decompose, some of whose limbs had been cut off and who was attached to a cinder block which was to have kept it at the bottom of some American body of water – a cry out against organised crime. One year later Hanson received the Florida State Fair Award of Merit for this work – and nobody less than the jury-member George Segal put in a good word for him. In *Motorcycle Accident* of 1967 Hanson also wanted to say something about death. "I had a model drape himself around the crushed motorcycle for casting, and I broke the arms and legs of the cast. I wasn't concerned with the piece looking refined and finished. I was more interested in the symbolism of death and violence."[11] *Motorcycle Accident* also received a prize and caused a sensation because it was demanded that this work, along with *Gangland Victim,* be removed from an exhibition in the Bicardi Museum in Miami. There were civic protests, the media intervened, critics and the Florida art scene got involved, until the director of the Miami Art Museum, a supporter of Hanson, volunteered to show the works in his museum. "On the day we installed the pieces, I was married and left for ten days on my honeymoon. When we returned, a stack of newspapers was waiting."[12] *Trash* (1967), a dead baby in a garbage can, and *Pietà* of 1968, which shows a dead black man in the arms of a young woman, quoting historical devotional images in its composition – Hanson later destroyed this piece – drawing to a close his socio-critical political period. His deeply rooted, critical view, his social awareness, his age, but certainly also the spirit of the 1960s, the protest movement, the Vietnam War, and the general discontent had all fed into his work during that period.

Duane Hanson now began to concentrate more and more on individual people, on their typical, almost satirical and comical

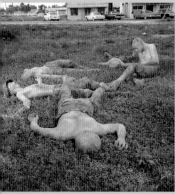

Duane Hanson, *War,* 1967

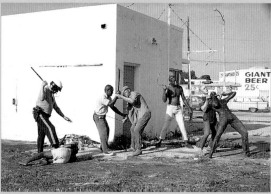

Duane Hanson, *Race Riot,* 1968

appearance, and their visible attitude and stance, which were often representative of the entire nation. At the same time he tried to give his figures more drama through the effect of "instantaneous motion". A first attempt at this effect can be seen in *Race Riot*; this was then followed in 1968 by *Football Players*, in which three athletes are wildly and almost theatrically piled around the ball, almost as in a tableau.

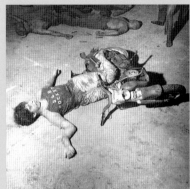
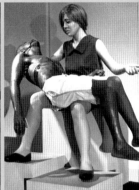

Duane Hanson, *Motorcycle Accident*, 1967

Duane Hanson, *Pietà*, 1968

The shock effect of his sculptures, the controversies they sparked off in the media, and the resulting publicity made Duane Hanson known in Florida, but in other states he was still a nobody. Friends pleaded with him to approach important galleries in New York, telling him to send slides of his sculptures, for great artists were made in New York. After long thought, Hanson sent some material to the Leo Castelli Gallery. Leo Castelli and Ivan Karp had made important contributions to the success of Pop Art with their promotion of Roy Lichtenstein, Robert Rauschenberg, Jasper Johns, Tom Wesselmann, Andy Warhol, James Rosenquist, and Mel Ramos. Ivan Karp's response to Hanson's letter was especially positive: he wrote him encouraging, positive letters, arranged Hanson's participation in an exhibition in the Whitney Museum in 1969, and finally persuaded him to move to New York so that he could better look after him. Duane Hanson moved into a large studio at 17 Bleeker Street in 1969 with his young, beautiful wife, Wesla Host, a Danish woman he had met in Miami. The future was full of hope, New York was exciting and full of contrasts. His building was located across the street from a Catholic church where the homeless could get a hot meal every day. "I would look out the window and see them, they would get soaked with alcohol during the day and lie around the sidewalk in front of our doorway... It's shocking to be confronted by these people living in the streets... I had to do something." [13]

This resulted in *Bowery Derelicts* (1969), his last socio-critical installation group and one of his most important works. Three drunk, unkempt homeless men lie in the midst of trash and empty bottles, in an environment which is so realistic that you can almost smell it. It is noteworthy that he modelled the heads of the figures, while the bodies were cast from live models. In comparison with other sculptures, the placement and gestures of these figures are kept quite simple. In this work it finally became clear to Hanson that when he represented shortcomings of society like violence, criminality, or suffering and misery, and complained about them with the expressive directness which is so typical of his early works, then it would always be the subjects themselves which were at the centre of the discussion and not their artistic handling and transformation into a three-dimensional sculpture.

In the following four years in New York, until 1973, he produced over twenty-five sculptures, which in their subject matter for the most part represent "typical" Americans with completely normal American everyday lives. "Why not look at this guy sitting right next to me, what's going on, what I see on the TV and in the newspaper." [14]

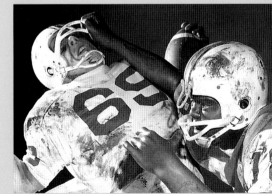

Duane Hanson, *Football Players*, 1968

The poses and gestures of his people made of plastic were initially sometimes still staged with the effect of "instantaneous motion", like in the marching figure of the *Baton Twirler* (1971), the bent-over *Rock Singer* (1971), or even the *Boxers* (1971). But Hanson realised that the halted movement seemed too controlled, as in his *Woman Cleaning Rug* (1971), reducing the realism and convincingness, while pieces such as *Seated Artist* (1971) had undiminished energy and stronger expression.

His new motifs varied now in their range from comical caricatures – as in *Bunny* (1970), a satire of the American Playboy fever, the first *Tourists* (1970), *Supermarket Shopper* (1970), *Housewife* (1970), or also in *Sunbather* (1971) – to *Reclining Man Drinking* (1972): a wholly serious response to the problem of alcohol. In-between were sculptures such as *Hard Hat* (1970), *Businessman* (1971), and *Lady with Shopping Bags* (1972), works which would later make Hanson famous and were typical for him.

The large, colourful canvases of the Photorealists of these years certainly also inspired, stimulated, and encouraged him in his New York years. Artists like Richard Estes, Malcolm Morley, Robert Bechtle, and others made paintings of gas stations, window displays, streets, and living rooms which looked like photographs. Others, like Chuck Close, painted portraits which were as realistic as biographies, and Duane Hanson translated these art trends into three-dimensionality. But his sculptures were more magnetic, more emotional, and much more penetrating and remarkable than any Photorealist painting. Since Photorealism was also a subject of the international art exhibition documenta 5 in Kassel in 1972, Hanson was invited to show *Bowery Derelicts* (1969) and *Seated Artist* (1971). Both sculptures caused a sensation at this important, always trail-blazing show, bringing Hanson great recognition in Europe, several gallery shows, and the prospect of a touring show in 1974. He spent the summer in Germany, making contacts and working on the sculptures *Maurer (Brick Layer,* 1972), *Putzfrau (Cleaning Woman,* 1972), and *Lesender Mann (Man Reading,* 1972). He was dissatisfied with the works, however, and on his return to the United States, he realised that American characters were much more familiar to him and that this familiarity was essential to his sculptures.

In 1973 Hanson returned with his wife and three-year-old daughter, Maja, to Florida, set-tling in Davie, close to Fort Lauderdale. "New York is more of a synthetic world; this is more the real world." [15] He was now back somewhat closer to the dull banality and the gloom in America's suburbs, in which you can see the thin line between comedy and tragedy somewhat more quickly than in the city. Back in Florida he perfected his working method. The poses and gestures of his figures became calmer, the body language less ambiguous, clearer, the faces technically more polished, and the clothing and accessories more pronounced in their existential characteristics, choice, and wornness.

His son Duane was born in 1973, and in 1974 Hanson went to Germany with a grant from the German Academic Exchange Service (DAAD) to live and work in Berlin for six months. In October 1974 his show began its tour through the museums of Stuttgart, Aachen, Berlin, and Humlebæk in Denmark. Twenty works were to have been shown, several of which still had to be finished. But he had learned from his experiences of 1972 and the realisation that it was absolutely necessary to be totally familiar with the character of his artificial people, and he transported several "spare parts" like arms, legs, heads, and also used pieces of clothing and accessories to Germany. The travelling show was a retrospective and showed *War* (1967), *Motorcycle Accident* (1967), *Gangland Victim* (1967), and *Bowery Derelicts* (1969) from his socio-critical period; *Supermarket Shopper* (1970), *Tourists* (1970), *Bunny* (1970), and *Baton Twirler* (1971) from his satirical, observing period; and *Hard Hat* (1970), *Seated Artist* (1971), *Lady with Shopping Bags* (1972), *Artist with Ladder* (1972), *Putzfrau* (1972), *Dishwasher* (1973), *Woman with Suitcases* (1973), *Man in Chair with Beer* (1973), *Man Leaning against Wall* (1974), *Repairman* (1974), and *Woman with a Purse* (1974) from his illusionistic period.

The tour was a great success. Crowds poured into the museums, and nobody, not even the media, could find an explanation for the great interest. Duane Hanson's name was now also established in Europe, but the artist himself was happy to be back in Florida so that he could develop his ideas and perfect his technique. He knew that the illusion had to be absolute.

The closer to life the figures were and the more they corresponded to the reality of the American everyday life, the more natural they would also look in their environment, be it museums or galleries. He chose his models with the greatest care. "The subject matter that I like best deals with the familiar lower and middle class American types of today. To me, the resignation, emptiness, and loneliness of their existence captures the true reality of life for these people... I want to achieve a certain tough realism which speaks of the fascinating idiosyncrasies of our times."[16]

Hanson created a connection between his artworks and the viewer. The relationship between sender and receiver becomes non-verbal communication, and the confusion of reality, fiction, and perfect mirroring bores its way into our consciousness. An example of this is *Rita the Waitress* (1975), who true to life leans against the museum wall with the tray under her arm, forcing the visitor to reflect on his or her own human experiences in our impersonal society, and especially in a restaurant. The way *Photographer* (1978) works is even simpler: nobody ever looks at him frontally because they think he will take a photograph of them, nor does anybody ever "walk into his picture" because the camera could click at any moment.

Starting in 1976, Hanson's works went on a major tour of American museums in several states, and these were followed by many one-man shows in increasingly better museums. They were all great successes with the public: in 1978 a large show was held in the Corcoran Gallery in Washington and in 1979 in the Whitney Museum of American Art in New York. The University of Miami in Florida named him Adjunct Professor of Art, and the University of Fort Lauderdale made him a Doctor of Humane Letters – social acknowledgement for the artist.

Hanson's special interest in people who work with their hands is clearly visible in his oeuvre. "Visually they tend to be more descriptive and fascinating. You can describe with a construction worker what kind of person he is, what he does for a living. The soiled hands, the clothes spotted with grease, greasy hair, sweaty jaw. It's very down-to-earth."[17] You can tell from the appearance of *Repairman* (1974), *Man with Hard Cart* (1975), *Slab Man* (1976), the three workers in *Lunchbreak* (1989), or *Man on a Mower* (1995), and the many painters, janitors, bricklayers, window washers, and plumbers done in the years in-between, what party they vote for, what they think about abortion, minorities, and tax increases, that their favourite dish is not necessarily vegetarian, and where they like to go after work. He was fascinated just as much by the older ones, the shapeless ones, by those whom life had marked in a very special way and not necessarily in a dreadful way. "You read their physical presence: their size, their age and shape and colouration and all that. There are some really upsetting visual things that you see in people. My images don't get near what you see in real life. The world is so remarkable and astonishing and surprising that you don't need to exaggerate. What exists out there is just mind-boggling."[18] At some American airport he discovered a *Traveller* (1985), somewhere, maybe in Disney World, a pair of colourful, fat *Tourists* (1988), or somewhere in a city hall *Queenie* (1988), and sitting outside it *Old Couple on a Bench* (1994). The likeness had to correspond to the human original; the end product had to look like life. He worked on his models with almost impertinent attention to detail, made the casts more precise by sometimes correcting noses, smoothing chins, or even switching entire heads, arms, or legs and assembling them to create his likeness-body, painted it skin-colour, added hair, and dressed it in clothing chosen in an equally pedantic manner.

Family members and friends were the models for some of his sculptures. His father was the model for *Old Man Playing Solitaire* (1973) and *Old Man Dozing* (1976), his son from his first marriage for *Medical Doctor* (1992) and *Policeman* (1992), his wife Wesla was *Bunny* (1970), his children Maja and Duane helped out with *Children Playing Game* (1979), *Child with Puzzle*

(1978), *Cheerleader* (1988), *High School Student* (1990), and *Surfer* (1987), while the family dog was the model for *Beagle in a Basket* (1979) – the first of the many sculptures which Hanson had cast in bronze. *Janitor* (1973) was a friend who was a professor of literature, the *Flea Market Lady* (1990) was a teacher at an art school, and *Seated Artist* (1971) the painter Mike Bakaty, a friend from New York who also was happy to help out with authentic requisites for the costumes of the sculpture. Even when he used family members or friends as models, he sometimes corrected facial features or body parts. For example, *Museum Guard* (1975) has the head of his wife's uncle. He was not concerned here with portraits, but almost always the maximum closeness to the figure as a type. (The six real portraits – William Weisman, Larry Tobe, Martin Bush, Mary Weisman, Heidi and Kim – made by Hanson were, strangely enough, sculpted by him as he could not make casts of his patrons.) He wanted to create the desired emotional effects, to reach his artistic goals, and thus had no problems with all the possible changes to the bodies and the figures: "With the figure, it's a wonderful thing to see that every body, every face is different. Out of millions of people, there are no two alike, except perhaps for some identical twins. How did that happen? We all have nose, ears and lips, and they are all different. There are millions and billions of combinations like that." [19]

Hanson made collages of realistic forms as long as they looked real. When he was no longer happy with the effect of the painting of his figures, he eventually asked the Photorealist Richard Estes what gave his paintings their tremendous luminosity. Estes confided the secret of priming his canvases to him, and Hanson successfully used this formula on his sculptures until he switched to a new, even better acrylic paint in 1989. He passed Estes' formula on to John de Andrea, one of the successful artists who used the same technique as Hanson to create mostly naked and posing figures.

In the 1980s Duane Hanson had successful shows all over the United States, in four large Japanese museums, then somewhat later six works were shown in the World Design Exposition in Nagoya, Japan, and he was honoured by the King of Sweden on the occasion of an exhibition in Sweden. In 1983 the State of Florida gave him the Ambassador of the Arts Award, and in 1985 he received the Florida Prize for his outstanding artistic work.

The 1990s began for him with a large retrospective which was shown in six important museums in Germany and Austria. There were always long lines, and both the public and the media expressed their enthusiasm. In the United States he was entered in the Florida Artists Hall of Fame in 1992, and in 1995 he received the title Doctor of Fine Arts from Luther College in Decorah, Iowa, where he had studied for a short time in 1943, and from Macalester College in St Paul, Minnesota, where he had studied in 1945. A large exhibition in the Montreal Museum of Fine Arts in 1994 was also shown in Texas one year later, followed by three exhibits in Japan. His first figure in painted bronze was *Man on a Mower* (1995), a work that could also be shown outside in rain or shine.

As early as 1971 Duane Hanson had been diagnosed with cancer, as a result of his often careless, unprotected contact with polyester resin and fibreglass. He had renewed health problems in 1974 and a serious relapse in 1995. This time he could not fight against it. Duane Hanson died on 6 January 1996, at the age of 70. He showed the reality of life with the realism of his art.

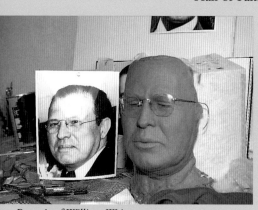

Portrait of William Weisman,
modelled after a photograph, c. 1988

Thomas Buchsteiner, Institut für Kulturaustausch, Tübingen

1 Martin Bush, *Sculptures by Duane Hanson,* Wichita 1985, p. 15.
2 Ibid., p. 25.
3 Ibid., p. 27.
4 Ibid., p. 27.
5 Ibid., p. 28.
6 Ibid., p. 31.
7 Ibid., p. 31.
8 Doris Reno, "Taste Marks Sculptors of Florida Annual",
 Miami Herald, 30 October 1966, p. 10.
9 Duane Hanson, "Presenting Duane Hanson",
 Art in America, vol. 58, September 1970, p. 86.

10 Bush 1985 (see note 1), p. 34.
11 Ibid., p. 36.
12 Ibid., p. 37.
13 Ibid., p. 41.
14 Marco Livingstone, *Duane Hanson,* Montreal 1994, p. 17.
15 Ibid., p. 88.
16 Christine Lindey, *Superrealist Painting and Sculpture,*
 New York 1980, p. 130.
17 Livingstone 1994 (see note 14), p. 78.
18 Ibid., p. 48.
19 Ibid., p. 66.

THE HUMAN FIGURE
IN DUANE HANSON'S ART
KEITH HARTLEY

In art as in philosophy, humanism has suffered a sustained attack since the 1950s right up to today. Not only has it been criticised for placing the human being centre stage and for interpreting the world according to the principles of a unified, rational (and usually male) subject, it was also deemed to be uncritical and too accepting of traditional values. For many it was simply old-fashioned. In art, humanism has often gone hand in hand with realism or at least with those types of figurative art that emphasise content and more specifically human content. In the eyes of much of the post-war art establishment this was doubly suspect: it offended against the view that the "subject" was dead, but also against the modernist opposition to depicting reality. Despite such theoretical strictures, however, artists have continued to be drawn towards realism and, more specifically, towards a realist depiction of the human body. In part this has been a reaction against the dominant formalist, abstract aesthetic (particularly in America), but it also forms part of a recurring, universal urge. Artists have always wanted to test their skill in deceiving the eye, they have always wanted to use their depictions to persuade others of their viewpoint, and above all, they have been so deeply in love with visible and tangible life, in all its complexities and subtleties, that they wanted to recreate it with their own hands.

Duane Hanson's work is part of this age-old tradition. His uncannily lifelike sculptures depicting the *dramatis personae* of Middle America have their equivalents in the 19th-century novels of Balzac, Zola, and Dickens, in the marble portrait busts of Republican Rome, and in the photographs of August Sander that together give us a typological portrait of the Weimar Republic. Before attempting to position Hanson more exactly in his historical context, it is worth spending some time analysing his art a little more closely. So often it is dismissed as "not art", "shallow", "merely waxworks" that one begins to wonder whether his critics have actually looked at his work, let alone thought about it.

The first thing to say is that they are cast from life. This sounds straightforward, but the process and its implications are anything but so. First, Hanson had to select his models. This was by no means arbitrary. He wanted certain types: in general, people who had seen a lot of the tougher things that life can throw at you; careworn, tired, often overweight and neglectful of their personal appearance. He chose them from the lower rungs of society in keeping with his own sympathies for the disadvantaged and the downtrodden. Over the years he built up a range of characters from housewife to shopper, derelict, cleaner, janitor, security guard, waitress, and tourist. Together they form a vivid, if depressing, picture of late 20th-century Middle America. Hanson's work should really be viewed in its totality to appreciate the breadth and depth of his vision. It is a melancholy world of passive acceptance, resignation, one might almost go so far as to say nihilism, if one were not aware of Hanson's angry, socially critical early work, such as *Abortion* (1965), *Gangland Victim, Race Riot,* and *War* (all of 1967). Although there is an element of satirical humour, even caricature, in some of the pieces from around 1970, such as *Housewife* and *Tourists* (both of 1970), Hanson aimed primarily to elicit our understanding and compassion. To achieve this Hanson was very careful in his choice of person. They are not distinctive-looking although they might be overweight; they are neither beautiful nor ugly. Ordinariness is their very soul. The sort of people one would never remember. The sort of people, in fact, who make up most of society.

After selecting his models, Hanson thought long and hard about how to pose them. Their poses had to be natural and typical. In the same way as the models typified a certain kind of person, so their poses had to capture their typical activities or job. Hanson had learnt from early mistakes that if he wanted his figures to be as near life as possible they could not be represented in mid-movement. That might be alright in paintings or photographs which could never pretend that they were anything more than flat, two-dimensional representations of reality.

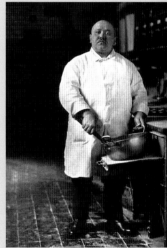

August Sander,
Pastry Cook, c. 1928,
Münchner Stadtmuseum

Sculpture, on the other hand, occupied the same space as ourselves, as our own bodies, and if it wanted to look lifelike it had to be natural – over a period of time, the time, in fact, that we take to look at it. In other words Hanson's sculptures occupied not only the same space as ourselves, but the same, real time. Hanson, therefore, chose static poses, when the body was resting, when the person was poised between activities. It is at such times that people naturally fall into reverie, introspection, or plain blankness. Hanson captures this inner absorption in the downcast gazes of his figures, in the vacancy of their facial expressions, all of which contributes to their general melancholy air.

The actual casting of the figures was done from life, but that does not mean to say it did not require artistic decisions. Sometimes, Hanson would cast parts from different models and would alter details after a cast had been taken. This shows to what extent Hanson's work differs from the ready-made aesthetic, of taking life as found, and how strong an inner vision he had of the effect he was trying to achieve.

One of the most skilful parts of the process was the painting of the figures in order to achieve maximum verisimilitude. Unlike painting figures in a picture where the artist controls the lighting, painting a sculpture is an entirely different matter. Here, the figure is in the round, is exposed to real and variable lighting, and the viewer can look at it from multiple vantage points. Hanson discovered by trial and error that he had to exaggerate the light and shade, particularly around such expressive features as the eyes. In other words he had to go beyond reality in order to achieve a realistic effect.

The final part of Hanson's creative process was to clothe his figures as authentically as possible and, if need be, to provide them with the appropriate props. Hanson went to some lengths to get old, lived-in clothes that would fit properly and, in many cases, they even had to be made to look dirty and stained. The props vary from the waitress's tray and cloth, the tourists' bags, cameras, and sunglasses, all the way to the chair, books, and paintings of the *Flea Market Lady* of 1990. Not only do these objects act as attributes signifying the particular job, activity, or identity of the figures, they also help give an insight into their way of life, their likes, and dislikes. They also act to create a tableau-like effect around the figures, which consequently lose some of their stand-alone, sculptural quality. What this does, particularly with the works that have extensive attributes, is to reinforce the feeling that, psychologically, Hanson's figures inhabit a separate space from our own. This is significant. Hanson certainly wanted to make his figures as lifelike as possible, but his central concern was not to deceive people into thinking they were real. His aim was to use their verisimilitude to engage the empathy and sympathy of the viewers. The figures had to be believable, but ultimately they had to be seen to be at one remove from reality and to inhabit the realm of the imagination. Only in the imagination could Hanson induce us to dream the same dreams, struggle with the same hopes, and experience the same blank despair of some of his figures.

It has been argued that, since they wear contemporary clothes, Hanson's figures will lose their immediacy and relevance to us today as they recede into the past, that they will inevitably give rise within us to the twin evils of curiosity and nostalgia. This is fundamentally to misconceive the nature of Hanson's work. It is not simply a question of *trompe l'œil*. By operating on the level of the imagination and engaging our powers of empathy, Hanson enables us to identify with his figures no matter how far removed in time they are from us. The question of contemporary costume in art is a hoary one and was used again and again by traditionalists to criticise the realist impulse of many artists.

If Hanson is to be seen as a humanist with a deeply felt concern for human values, and if he is to be seen as a realist who wants his art to move people and arouse sympathy, how does he fit

into the context of late 20th-century art? Who are his artistic predecessors and who are his heirs? When Hanson was training as an artist in the late 1940s and early 1950s and for most of the first fifteen years of his career, figurative art was out of critical favour and the reigning orthodoxy was formalist abstraction, expressionist or otherwise. However, by the mid-1950s images and objects from the real world were beginning to find their way back into advanced painting. In 1955, for example, Jasper Johns included a row of plaster casts taken from his own body in his painting *Target with Plaster Casts*, and Robert Rauschenberg was using stuffed animals – a rooster in *Odalisque* of 1955–58, a goat in *Monogram* of 1955–59 – in works at about the same time. There was more than an element of Dada iconoclasm in this, an

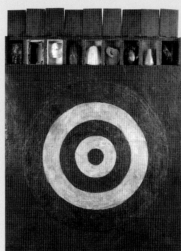

Jasper Johns,
Target with Plaster Casts, 1955,
David Geffen Collection,
Los Angeles

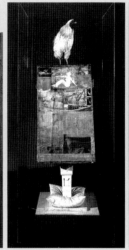

Robert
Rauschenberg,
Odalisque, 1955–1958,
Museum Ludwig,
Cologne

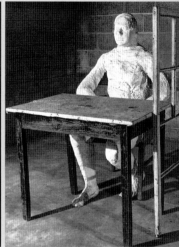

George Segal,
Man Sitting at Table, 1960,
Städtisches Museum
Abteiberg,
Mönchengladbach

attack on current formalist canons, but at the same time works such as these staked a claim for broadening the definitions of what painting in particular and art in general could encompass. No longer should artists be limited to the traditional and separate genres of two-dimensional painting and three-dimensional sculpture. Art had become more environmental with the artists feeling free to use and integrate into their work whatever they wanted from the world about them. Hanson may or may not have been aware of such works, but he did see and approve of the way that the next generation of Pop artists concentrated on figurative subject matter. He was especially drawn to the work of George Segal, who used plaster figures cast from life and placed with a few props to create an environment or tableau. However, Segal's plaster casts do not reproduce his models as perfect simulacra; they are rough, approximate, and left unpainted and white. They are like ghosts of a former presence, like frozen happenings, and do not engage the viewer on a realist level.

Nearer, in fact, to the spirit of Hanson's early "expressionist" work – sculptures such as *Motorcycle Accident* of 1967, *Gangland Victim* of 1967, *War* of 1967, and *Bowery Derelicts* of 1969 – are Ed Kienholz's tableaux from the 1960s. Although Kienholz was not concerned with verisimilitude, he did cast from life and he definitely used his art to attack the wrongs of society, to stand up for the weak and needy, and to move his public. *The Illegal Operation* of 1962 looks forward directly, at least in subject matter and power of expression, to Hanson's *Abortion* of 1965. The late 1960s in America saw the impact of the war in Vietnam, race riots, and student unrest; it is not surprising that artists felt the need to express some of this anger in their art and to do so in figurative terms. Even Warhol's "Death in America" paintings (riots, car crashes, electric chair), with their mechanically reproduced serial imagery, hold up a powerful mirror to a violent period in American history.

The environmental nature of Hanson's work with its emphasis on real objects in real space was very much part of the postmodern strain in 1960s art. In this respect (in this respect alone) it shares a concern with Minimal Art, with the bricks and metal plates of Carl Andre, the stacks and boxes of Donald Judd, and the geometrical constructions of Sol LeWitt. Ironically,

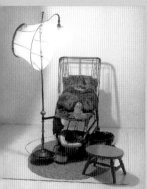

Edward Kienholz,
The Illegal Operation, 1962,
Betty and Monte Factor
Family Collection

Carl Andre, *Equivalent VIII*, 1966,
The Tate Gallery, London

Hanson's work has much less in common with Photo-realism which began in America around 1970. As its name implies, Photorealism was more concerned with creating the illusion of a large photograph than with engaging the sympathies of the viewer. Indeed, the subject matter was rarely of people.

The question as to whether Hanson has influenced subsequent generations of artists is more difficult to answer. Certainly with the ever increasing diversity of artistic strategies and media many artists have had recourse to producing lifelike figures, some cast from life, others not. In America the most notable have been Robert Gober and Charles Ray. Gober's truncated legs protruding from gallery walls are certainly modelled down to the last hair, but they could never be taken for real. Their wan colour looks like wax even from a distance, and they are often altered in some way with the addition of a plug-hole, a candle, or printed music. Likewise Ray's figures are recognisably dummies, some-times with the addition of lifelike genitals, sometimes altered in scale so that parents become as small as their children (and the other way round). What Gober's and Ray's works show is that the artists make use of the verist idiom made popular by Hanson, but that this is simply a starting point for various interventions and alienations which owe more to Surrealism.

Similar practices can be seen in British art of the 1990s. Jake and Dinos Chapman, Ron Mueck, Marc Quinn, and Gavin Turk have all made highly realistic sculptural figures but added a surrealist twist to them, producing a frisson of recognition and/or horror in the viewer. The Chapman brothers have created a brood of adolescent mutants, who sprout genitals in all the wrong places and are joined together like Siamese multiplets. But they are particularly disconcerting because in all other respects they look like the sort of kids that parents want to have – with well-proportioned limbs, shiny hair, and regular features. Mueck adopts a strategy similar to Charles Ray's, altering the scale of his figures so that the ordinary appears extraordinary. Babies become as big as grown-ups, and the naked figure of his dead father is reduced to the size of a child. The verism of Mueck's sculptures is quite riveting and rivals that of Hanson, but the intention is quite different. Marc Quinn in *Self* of 1991 has taken a life mask of his head and, instead of casting it in plaster, has cast it in his own, frozen, blood. The effect is highly unsettling, playing as it does with our own squeamishness about blood and with the philosophical implications of using a living product to make what looks like a live or dead mask. Gavin Turk takes the age-old practice of making self-portraits as famous individuals, but rather than painting them he makes lifelike models. Unlike Hanson's figures these works have the aura of wax-works about them.

It is doubtful if the practice of making highly realistic figures, and especially figures cast from life, would have been so common in the past decade if it had not been for Duane Hanson's example. Even the

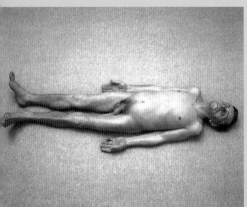

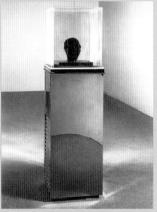

Ron Mueck, *Dead Dad*, 1996/97,
The Saatchi Collection

Marc Quinn, *Self*, 1991,
Courtesy of Jay Jopling/
White Cube, London

humanism that Hanson embraced so warmly seems to be reasserting itself if one is to judge by Harald Szeemann's exhibition, *Plateau of Mankind*, at the 2001 Venice Biennale. The tide of cynicism, of what Peter Sloterdijk called "cynical reason", seems to have turned, and a new more positive, though still knowing and not uncritical, relationship between the artist and the world about him can be observed. Utopian thought no longer seems to be quite so hopelessly naïve as it did to some even ten years ago.

Keith Hartley, Scottish National Gallery of Modern Art, Edinburgh

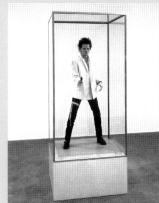

Gavin Turk, *Pop*, 1993,
Courtesy of Jay Jopling/
White Cube, London

Jake and Dinos Chapman,
*Zygotic Acceleration, Biogenetic,
De-Sublimated Libidinal Model*, 1995,
The Saatchi Collection

DUANE HANSON AND OTTO DIX
JOHANN-KARL SCHMIDT

Contrary to popular opinion, visual artists throughout the ages have only rarely been interested in producing faithful images of reality with the sole aim of providing posterity with a timeless reminder of how things used to be. Deceiving the eye by producing something that made natural appearance and the artefact indistinguishable was certainly seen as a major artistic achievement, and art literature has reported on the amazement this has caused from ancient times onwards: birds are said to have pecked at painted grapes or horses to have greeted their painted images with joyful neighing. But all in all, *trompe l'œil* as a genre had remained a marginal note in art history and verisimilitude the exception rather than the rule. It is no coincidence that the ancient Roman portraits that make the most impact because of their sense of reality probably go back to death masks from the ancestor cult. Certainly a sense of reality was the driving force behind art to a greater extent than usual in certain periods, as in the case of Netherlandish painting since 1400 or 15th-century Renaissance art. Precise depiction and a correct view of the way in which things were seen could then be a binding aim of any portrayal, and this went as far as detailed casts of living creatures in bronze. But art historians have shown that even when physical illusionism was developed to the extremes of technical perfection it was only a vehicle for portraying the intellectual dowry that was actually intended. Mere physiology as a formal vessel existed only to a certain extent in 19th-century French *plein-air* painting, and nowhere else; seen in this way, it is not surprising that the closest thing to today's popular taste in art is probably this French movement's vividness and clarity, which ends at the retina and is completely lacking in significance. It is probably necessary to point this out in the foreword to an exhibition of art that perceives itself as realistic, as many of the public still wrongly associate such art with being entirely true to nature.

Being faithful to reality is not restricted to the relationship of a portrayal to natural appearance. Other criteria can apply, like for example those of the world of social life or those of individual psychology. Artists with an educational bent have been concerning themselves with socio-critical approaches to lower echelons of society that have so far been excluded from the subjects addressed by art since the mid 18th century; before this ordinary people had usually only been objects of less than humane humour and satire. It is useful to keep these art-historical points in mind when two of the outstanding positions within the 20th century's sense of reality – a century that is still almost the present as far as we are concerned – are to be examined together: the central German Otto Dix, whose main work was produced above all in the third decade of the 20th century, and the Swedish-American Duane Hanson, who was fifty years younger. Both artists are comparable, despite the age difference of a generation and their distance apart in terms of space and culture, because of the similarity of their approaches. They are even kindred spirits as two special artistic phenomena standing alongside the avant-garde

Otto Dix, *Salon I,* 1922,
Galerie der Stadt Stuttgart

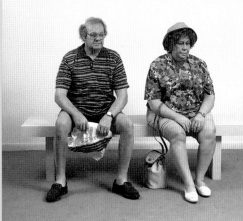

Duane Hanson,
Old Couple on a Bench, 1994

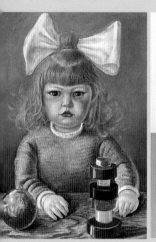

Otto Dix,
Nelly with Toys, 1925,
Otto-Dix-Stiftung,
Vaduz

Duane Hanson,
Child with Puzzle, 1978

formal breaks in the Modernism that dominated the 20th century. Both show the greatest possible objective and vivid closeness to reality, and both draw a picture of the human physical and mental condition in order to cast light on the moral and social conditions of the world they live in. They are close to each other here in terms of the compassion that informs their depictions of reality – unlike their contemporaries, who are ostensibly similar in terms of formal aspects. Otto Dix is as far removed from the cool realism of Neue Sachlichkeit as he is from post-1914 political agitprop art. He appeals to Friedrich Nietzsche and not to the left-wing *Weltanschauung* by cancelling the ideal approach of the art of his day and unleashing the destructive force of everyday truth. His work, dedicated without irony "An die Schönheit" – to (the) beauty – of the vivid and the real, tears through the aesthetic canon of bourgeois art like a storm and despises the physical internalisations of some of them just as much as the transcendental renunciations of others. Otto Dix casts aside any theoretical justification formulae of the kind used by his contemporaries' modern revolution, which tended towards freeing themselves from visual images and adopting intellectual approaches instead. He sets both his hand and his eye against the self-reflexive thought that avant-garde art's self-justification is increasingly committed to with the passage of time and relies on the evocative effect of reality as arranged by art, which has an emotional force that goes beyond any poetic vision as far as he is concerned.

Reality found itself again, ironically refracted in the main strands of Modernism, as in the case of Marcel Duchamp, or universally extended, as in the case of Piet Mondrian, but scarcely historically, socio-psychologically, or socio-critically and illustratively. Otto Dix's analytical and compassionate view of the circumstances of his day meant that he was rejected by Western art critics at first, and it kept him out of its institutions for a long time, accused of recapitulation. As social commentary, art was banished into the second-rate category of special cases. It was not until it became clear that his approach had not regressively underbid the Modern revolution, but progressively leaped over it, that his work took its place, far too late, in the imaginary museum of the 20th century. But Otto Dix had always expressly claimed this place by using quotations of style and painting technique to demonstrate historical continuity and thus claiming his candidacy for the museum.

When Duane Hanson completed his orientation phase with *Football Players* in 1968 and created the first main work of his scenic figure ensembles in the form of *Bowery Derelicts*, abstraction had been over for about a decade in terms of fine art. In the Neo-Realistic work of artists like Robert Rauschenberg, Richard Hamilton, or Arman, tautological treatment of banal, representational reality was broadening the riverbed of the early intellectual approach by Marcel Duchamp and adapting his ontological experiments on the theme of art and reality superficially for contemplation. George Segal had already developed his formal and realistic plaster casts into

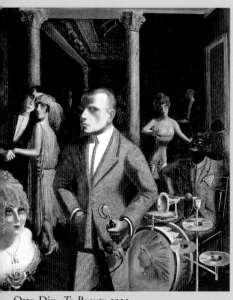

Otto Dix, *To Beauty,* 1922,
Von der Heydt-Museum,
Wuppertal

authentic body masks of human ready-mades. Duane Hanson was not satisfied with this approach, which made the object, fitted together into one with its image, into the sole sufficient element of cognition, as for him the apperceptive interrelation also belonged to the power of the real.

What he was looking for was to be found in summer 1969 at the posthumous publication of Marcel Duchamp's last work, *Etant Donnés,* in the Philadelphia Museum of Art. Duchamp, who died on 2 October 1968, had been working on this in secret from 1944/46 to 1966. Here the viewer as the voyeur of a staging is made into the addressee of the empathy of the artist-author. Thus Marcel Duchamp was recanting his own revolution, because here the absolute object is not satisfied with its own appearance without interest, but dialectically demands the self-reflection of the spectator's role from the viewer. This point of view, in terms of both space and content, is fixed by the author; in fact, the work is comprehensible only as a subjective assertion of a perspective proposition. After this experience, Duane Hanson sought to extend Marcel Duchamp's recourse to the personal consciousness of the viewer to the perspective of his judgement as well, and to extend physical space to cognitive space.

Duane Hanson's sculptures also greet their viewers exclusively in museums. It is firstly and solely the outstanding place that justifies them as objects to be observed because of its ability to furnish originally banal components of the reality of life with aesthetic validity. Duane Hanson's art figures, as duplicates of reality with the highest possible precision in terms of their mechanical rendering, and clad in all the original attributes of reality, do not (only) thrive artistically on the fact that they are indistinguishable from their own real presence, even though they perhaps embody the aporia of being and seeming more than all artefacts that have otherwise been created to the present day. It is only the museum as a location that conveys the critical element to them that goes beyond the anecdotal and the everyday, and translates their everyday vocabulary into the language of poetry; in the museum they escape from the folk misunderstanding of veristic waxworks in favour of the truth of the image. The museum as a hermetic counter-world creates the necessary space for Duane Hanson's sculptures, in that they, leaving the everyday world, turn their backs on the rules of that world. While in terms of time the real world has long destroyed all the former biographical certainties of their anecdotal average existences as tourists, sportsmen and women, or consumers, they are able to stand firm in the museum world and assimilate themselves into the category of the permanent, which is the only one for art.

But for the viewer, the two worlds present themselves directly together in the perception of their apparent being. This stimulates the viewer's aesthesia to the level of shock. Because together with art's assertion of truth, the two worlds confront him with the question of the power of reality as contraband in terms of content from an unexpected quarter and reach him with their moral appeal when he is defenceless, as it were, before he has become aware of the performative self-contradiction of the two worlds. He becomes a horrified opposite number when faced with the eerie reality of Duane Hanson's team of figures, all of them anonymous heroes of the normal conduct of life. He is suddenly horrified with himself, experiencing a shock of recognition as he senses his own social dangerousness and thus that he is in moral danger.

Johann-Karl Schmidt, Galerie der Stadt Stuttgart

HOW TO LOOK AT...
CHRISTINE BREYHAN

Although Duane Hanson's sculptures would probably not actually get lost in the crowd of their fellow creatures in a gathering of people, they might simply be accepted as a fact of social life. But when they are made to stand out in an exhibition venue, provided with an exclamation mark, as it were, viewers could be embarrassed by their conspicuous banality and not always be sure what to say about them.

What makes the group of people responding to Hanson's works different from the works themselves? There is a complex system of references and interplay between the appearance of these two categories. The similarity is amazing at first, but on closer examination it turns out to be merely schematic and defined by external characteristics. There is a similarity, but with whom does the viewer claim to have found it, and what criteria does he or she have for drawing a distinction? Although they are duplicates of living people, Hanson's works are not copies. On the contrary, he invents his figures. Even though he works on the basis of an existing basic social structure, these portrayals acquire their ability to convey an artistic message from their cleverly devised poses, the design elements that surround them, and their art-historical allusions, and become Hanson's creations. At first the viewer is not struck by the formal ideas and strict composition behind the figures portrayed, because he or she is concerned with their fate or their history. And the appropriate prehistories based on their role will exist, and they can be constantly rewritten. The more varied the audience, the more extensive will be the possibilities for response.

Hanson shows the disparity between being exposed and being lost, between feeling abandoned and feeling secure – the kind of experience that city-dwellers can have in a "lonely crowd". Observers and observed seem to become paralysed by the first surprise of confrontation in the art context. Are the works of art imitating their public, or is the public pretending to be works of art? Both sides pretend that they want to plunge into anonymity and being undefined. Where is the borderline at which the work of art no longer represents a certain individual in spite of all of its typical characteristics of a concrete human being? At what point does the figure stop representing its model and become a mere surrogate, a construct of artificial materials? In Hanson's work, the technique of total repetition becomes a style. The contradictory nature of the figures shows both in the apparent eternity of a single moment as presented, which has still cost the artist months of his time, and in the highly artificial technique, which is put at the service of copying nature perfectly. Even though the sculptures are the opposite of idealistic designs, viewers can succumb to the technical magic, which wants to triumph over living reality. Stimulated by Hanson's obsession with detail, viewers are tempted against their better knowledge to ascribe human qualities to these phantasms: feelings, breathing, movement, language, so that it is possible to follow a familiar pattern when reacting to them. But when does the doll stop being a doll and become a double?

The artist is playing with the disturbing effect on the viewer, who feels in the art context that he is directly confronting an individual of his own species. The feeling of insecurity is created by the ambiguity of the role images, the crude directness of the figures' trivial appearance, by their presentation, which amazes or alienates, because it is not linked with the exhibition venue in any way. The loss of living qualities in absolute paralysis shifts the figures, whose robust materials can outlast the viewer, close to still life. If this refers strikingly to the mortality of the models, time does still make its mark on the sculptures. People are aware in the meantime that the layer of paint will go grey, and although it reduces the destructive influence of light, it cannot prevent it altogether. The plastic materials become brittle with time because the solvents diffuse, so that the figures themselves are affected by the allusion to transience. This means that they shift even further into the sphere of larger-than-life *natures mortes*, permanently conjuring up a *memento mori*.

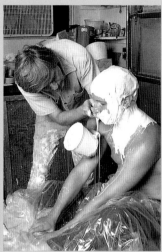

Duane Hanson with model for *Woman Reading Paperback*, c. 1978

Duane Hanson with model for *Jogger*, c. 1984

Visitors who come unprepared to Hanson's reconstruction of the American nightmare find it difficult to withdraw from this silent, endangered world, which seems to be dominated by being enslaved to death. But the sculptures are in the tradition of historical, life-size figures. If one disregards numerous other sculptural references, they can be seen in the same line of development as passion figures and figures of the saints – though the line is discontinuous. Other "relatives" of Hanson's polyester and fibreglass casts are the historical wax figures in anatomical museums and cabinets. Despite all their differences, they are linked by the fact that they are reconstructed on a scale of 1:1, and further by their faithful detail, their extroverted character, and their directness, which reveals a kind of interpretative naïveté. As well as their realistic quality, the anatomical wax models proved to be of high artistic calibre, although they were produced exclusively for the purpose of scientific study.

As in the case of models in waxworks, a particular role is underlined by the clothing in Hanson's case as well. In addition, he fixes their fate in the split quality of this role. Or is it the recipients' attitude of expectation that forces the artist to broaden his conception? Is Hanson recounting a story, or is he simply counting up? In any case he is particularly careful with the selection of accessories, which often seem worn and impoverished. They make it possible to take a sober look that records the staged sphere of the people presented. The interlinking of scrupulous artistic and technical execution and meticulously selected ready-mades emphasizes the realistic quality of the figures; at the same time the enhanced quality of the exhibition visitors' attention leads to a gradual distancing. Nevertheless there are constantly moments in which visitors want to make the sculptures capable of eyeing each other up or reflecting the intruders in their stage-like ambience. Their appearance has a ghostly quality about it, showing them as silent, paralysed, and sightless, and after a short time similarities and differences between the art product and the real person start to show up. But despite this, a vestige of shame is still felt among all the people who are so keen to have a look after they have mercilessly scrutinized the surface of the sculpture to see if there are any inadequacies. Hanson has built these discoveries into his figures, because this is what produces the demarcation that is needed for his sculptures to be appreciated as works of art. Their surface is both "skin" and a painted surface. For the attentive observer, this surface acquires an illusionistic dimension; in the specific situation in which the works are perceived, he recognizes the boundary in terms of likeness and creativity at which human duplicates and painting meet. This is the boundary between merely imitating nature and the work of art. Viewers pass it on a zigzag course. They recognize it, cross it, turn back, and want to deny it again when they see that reality is not surpassed by the exhibit. If they see through the aesthetic illusion, they join in Hanson's game at this point, without having to leave serious aspects out of account. Given that Hanson does not equate appearance and reality, but also pretends that he is making a distinction, the work of art gains an additional point of attraction for the person looking at it. For this reason the artist generally avoids making his "people" look directly into the viewers' eyes, as this is where they reveal their weakest point: the inanimate point that unmasks their artificial nature in the cruellest way, the dead point to which the viewers' distress is directly attached.

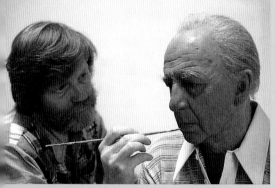

Duane Hanson with *Man on a Bench*, 1977

Where they expect to find light and life they encounter an impenetrable, dead area. The painted eye does not return the look that has been granted it. Even in a crush, in an anonymous state among unknown people, feelings can flash into life in a fraction of a second in the eyes of passers-by who have a markedly indifferent expression on their faces. The constant apathy of the works of art prevents any sense of strong connection, because no interpersonal traffic can be established.

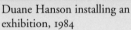

Duane Hanson installing an exhibition, 1984

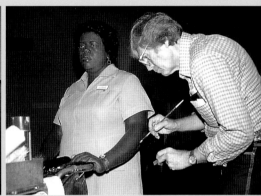

Duane Hanson with *Queenie*, 1980

There will be a significant number of viewers for whom the question of identifying with the sculptures will not arise, as social relationships with fellow human beings are frequently shaped by idealized models in the media. Common behaviour patterns derived from a shared environment are compared, but by no means do viewers want to recognize themselves in these figures. Certainly most exhibition visitors will not feel particularly inclined (if it were still possible) to offer themselves to Duane Hanson as models. For one thing, the procedure of making a duplicate directly from the body takes a lot of time and effort, and for another the question arises of whether one would want to put oneself through all this in order to see oneself later reproduced in perpetuity as a tourist, housewife, construction worker, or beer drinker. Do we want to see ourselves reduced to a single role until the materials disintegrate? Can't we take seeing the embodiment of our own emptiness, defeat, or weaknesses in the shadow of Hanson's presentations? Perhaps there is a fear that too serious a difference could yawn between ideas of one's own self and Hanson's depiction; perhaps it is the fear that the difference would not be large enough to exclude hypothetical notions of this kind. The dialogue situation that emerges for a model is not without some explosive quality. But Hanson's real models – many of them were his friends – may well have taken on the roles allotted to them willingly and perhaps proudly. Perhaps they were aware that the artist was concerned with the effect of non-identity for his stagings, which could have made them self-confident and impregnable. Perhaps it amused the female art critic to wear the mask of the woman at the checkout; the doctor may have felt that he was both suitable and appropriately dressed to be the sportsman. They will have seen their role as a role and their duplicate as a counter-figure.

Hanson's creations are clones that despite their stubborn assertions of reality are from a ghostly world that exists alongside the real world. These identical twins that wait on the spot as if thunderstruck stand in their physical presence for the obstinate defence of the copy against the aura of the original, the cliché against the individual.

As they get older, the question of identity will shift to the works of art themselves. Today's exhibition visitors apply other standards to Hanson's role allocations and interpret the symbols, which also determine our everyday culture, from different points of view. Does *Rita the Waitress*, who dates from 1975, look antiquated now? Is anyone at all in the new millennium still interested in the fate of the 1967 *Gangland Victim*? Who would still laugh about the impossible get-up of *Tourists II*, dating from 1988? From today's perspective the works of art reflect a specific way of looking at things, as though they intended to show a change of identity shifting

to the point of loss of identity. As status symbols and role attributes have changed, the artist would now depict the computer buff at a computer, the student not with a surfboard, but surfing the Internet, and the highly specialized researcher in the final stages of decoding the human genome. Or would he not put any trust in progress, which in the information age becomes obsolete even more quickly than fashion, and would he stay with his everyday figures with their simple activities? Perhaps his stage directions would shift more clearly to presenting inactivity: to people thinking, dozing, sitting around resignedly, tipsy people who have collapsed helplessly.

It is not the magnificent execution, which is anyway familiar from historical works of art, that might possibly inhibit viewers. Hanson's works go in the opposite direction. His exhibits are magnificent in their tastelessness and are more likely to shame in their vulgarisation. But, constantly magically attracted by the staging, the observers are painfully embarrassed, especially when they notice too late that they have succumbed to an ambivalent situation of personal privacy and publicly staged privacy. The viewer's look can tilt abruptly out of the hyperrealistic perspective, in other words the recipient's aesthetic experience is continued in everyday life, and it is not improbable that the recipients are taking on a role in the artist's screenplay against their own will. They become his accomplices and can catch themselves checking up on other visitors with their eyes as if they were sculptures. As ordinary people from the streets have now conquered the exhibition galleries as works of art, chance encounters in the street can seem like a continuation of the exhibition visit.

Since the time the sculptures were made, new criteria of perception and judgement have been formed. What is there to protect the figures from arbitrary or random statements if there are no culturally protected criteria? Can the works of art actually still be the same ones that they were at the time they were created, if they are for example torn out of their context years later, pleasingly arranged, and presented in European exhibition galleries? Of course this problem applies quite generally to any work of art. But the excerpt from the picture of society that Hanson draws is in a constant state of change and was out of date even in his lifetime. Hanson is stimulated by the state that people are in, which is something that lies beyond the current fashions in hairstyles, clothes, and utensils; and it is precisely through the break he shows between everyday worlds and concrete spheres of reality that he manages to shift his viewers into a state of hovering between reality and fiction. But the most disturbing aspect remains the absence of "real" humanity. And nevertheless that relationship of tension also keeps the works alive for the young audience of today, and it does it through the discrepancy of being similar but never exactly the same, varying and at the same time expecting people to accept repetition of something that is always the same, designing a unique life through standardisation. This can constantly bring the works of art up to date in the eyes of the spectators through the principle of adaptation to changed conditions of reception.

Certainly it is the figures themselves and their condition of isolation, advancing decrepitude, or sheer despair that will always be moving. In addition, the nature of an ambiguous mode of description protects Hanson's works from definitive patterns of meaning and admits ways of interpreting them that are always new. But despite their precisely allocated roles, the numerous aspects of their meaning, and their direct appeal the figures do not force themselves upon us; they maintain a strange quality of reserve that will guarantee them curiosity and the interest of the public.

Our understanding of reality has changed again in the age of digital images. Hanson's perfectionism, which brings real duplicates into being, contrasts with the virtual pictorial realities that can be seen at the touch of a button. But like these, Hanson is not creating copies,

but clichés of clichés, transfers of existing thought patterns. They drive the real, archetypal image to the utmost, but do not copy it. The artist walks the tightrope between psychograph and *déjà vu*. Within the oeuvre as a whole, the paralysis of gestures, body language, and the form of action makes a conclusive statement. The figures partly acquire mythical significance in their aura of cold and hopelessness, and represent a generally valid model of the human being. Thus the *Housepainter* of 1988, carrying his paint roller with an extension rod like a banner, is both a fiction of a person and of a representative of his profession. The figurative duplicate and the objects belonging to it indicate symbols of the world and connections in terms of the history of motifs.

In contrast with the exhibition, the postlude should be open to checking in reality. The differences between watching and action, representing and copying can be measured and compared. The viewer has scarcely accepted that reality is revealed in a refusal to act when he is compelled to discover that it consists only of a tissue of hypotheses and fictions.

Hanson's sculptures prove the false character of the real. Reality cannot be copied: according to Thomas Bernhard the original is always the fake. But what should we see as the original, the work of art or the model? In Duane Hanson's case the work of art even compels the viewer to resist being made part of the fiction.

Christine Breyhan, Art Historian, Bremen

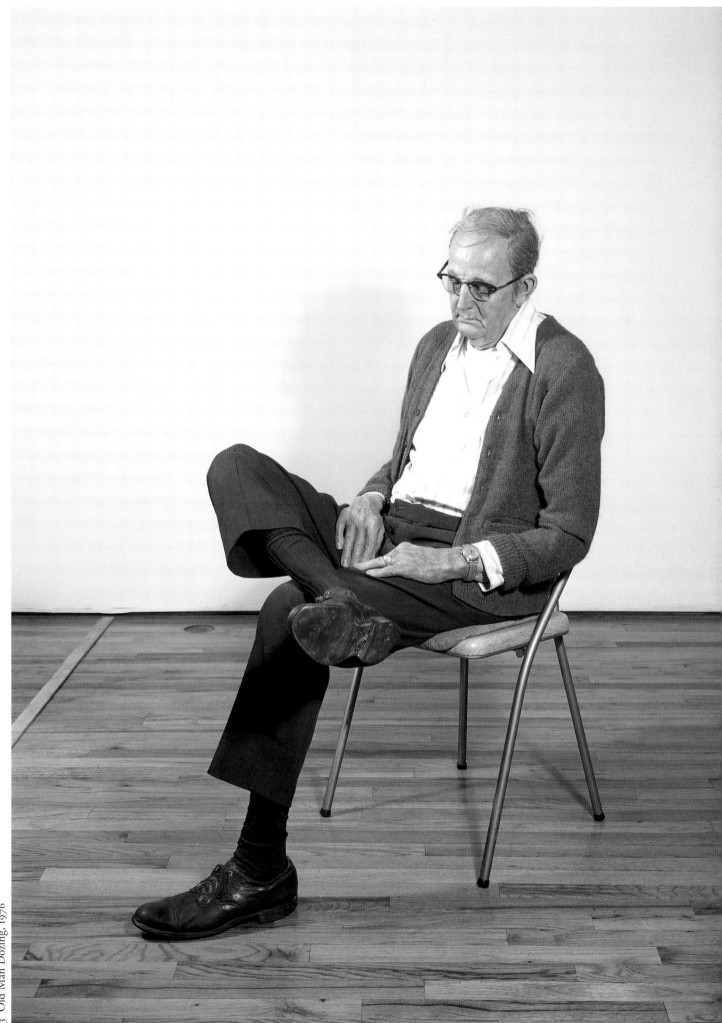

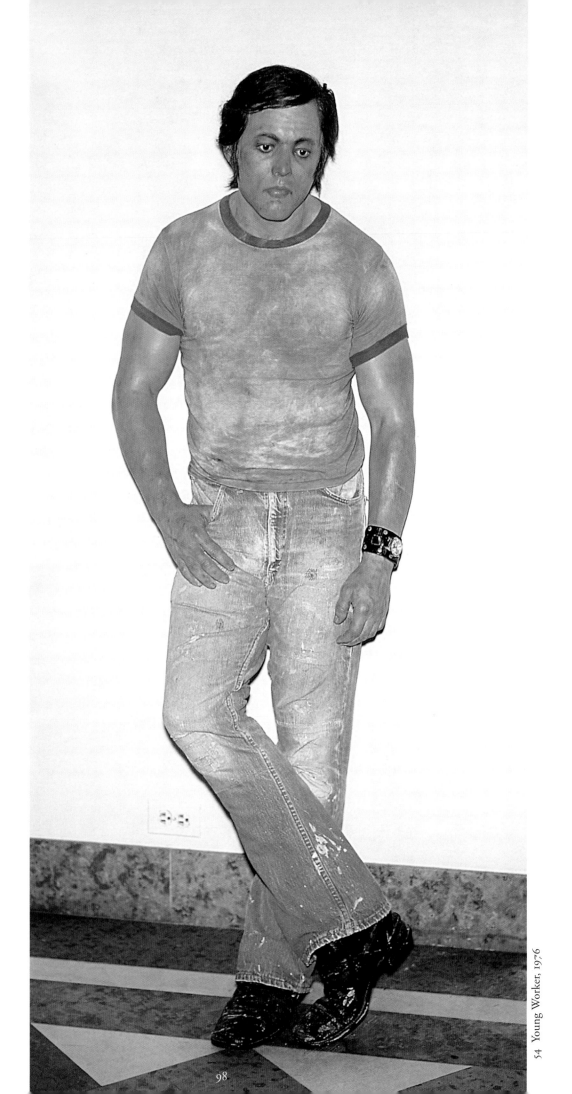

54 Young Worker, 1976

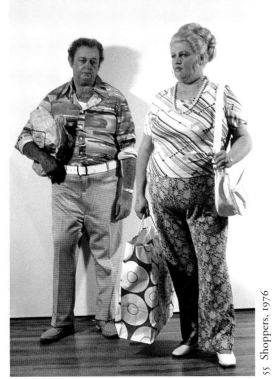

55 Shoppers, 1976

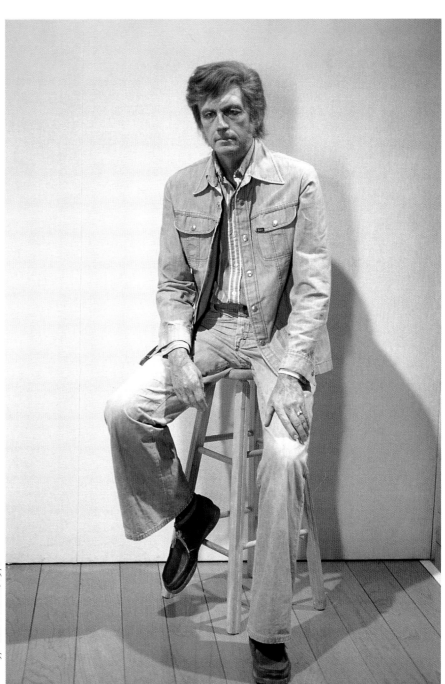

57 Self-Portrait, 1976

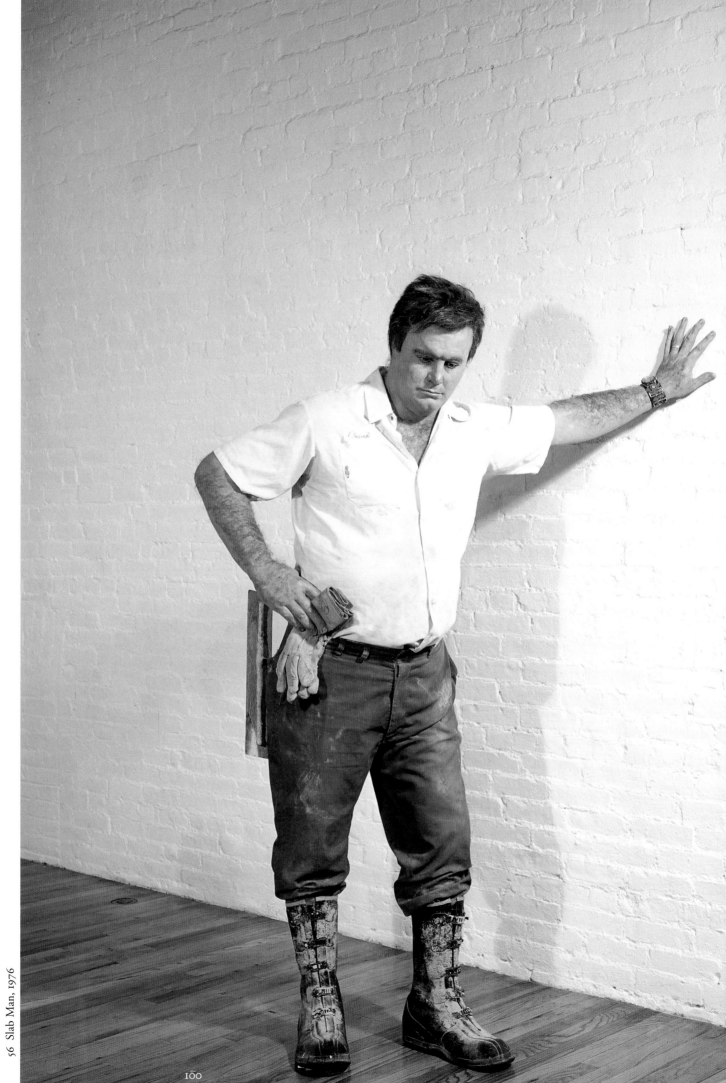

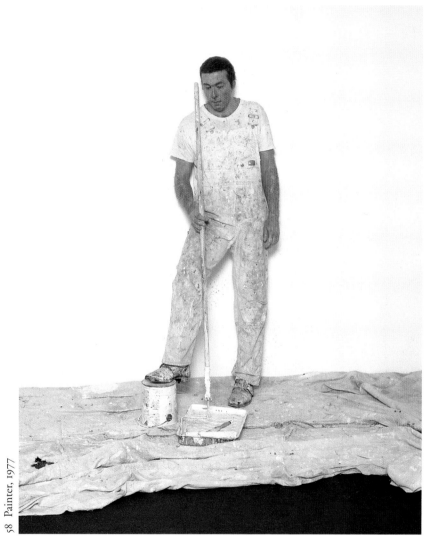

58 Painter, 1977

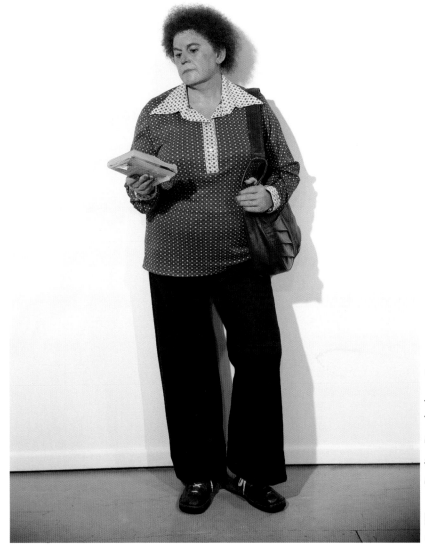

62 Woman Reading Paperback, 1978

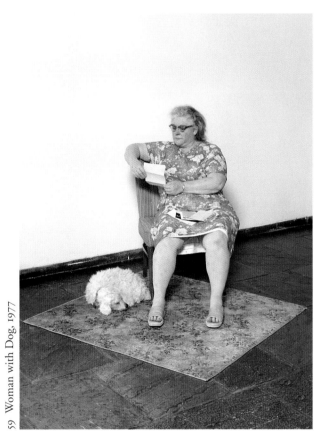

59 Woman with Dog, 1977

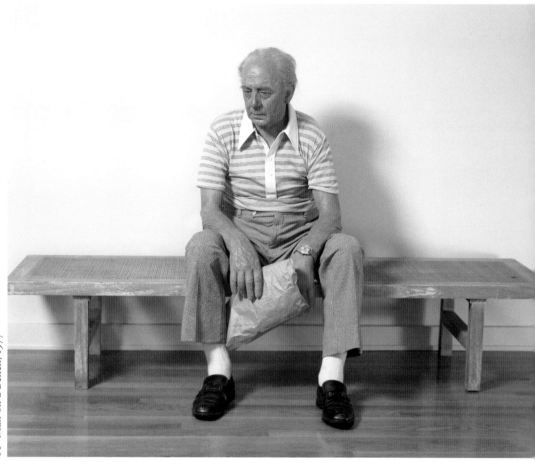

60 Man on a Bench, 1977

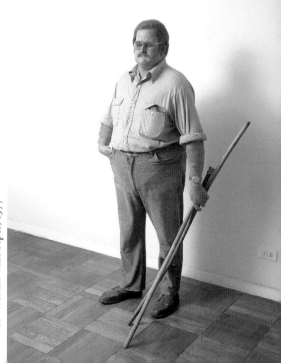

61 Worker with Pipes, 1977

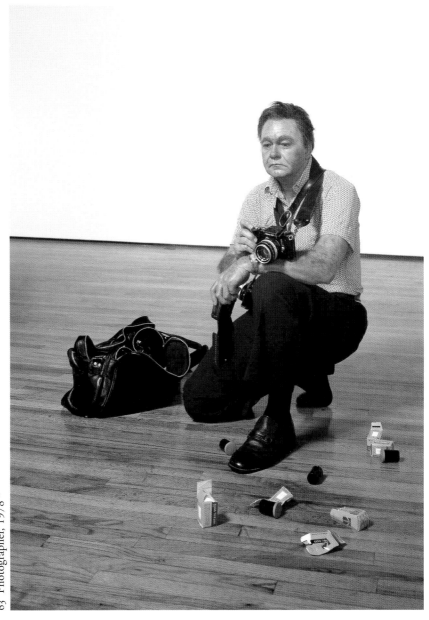

63 Photographer, 1978 *

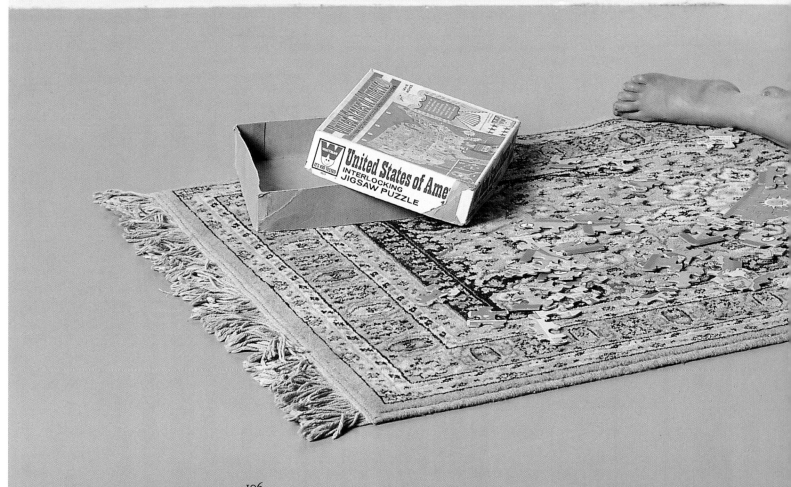

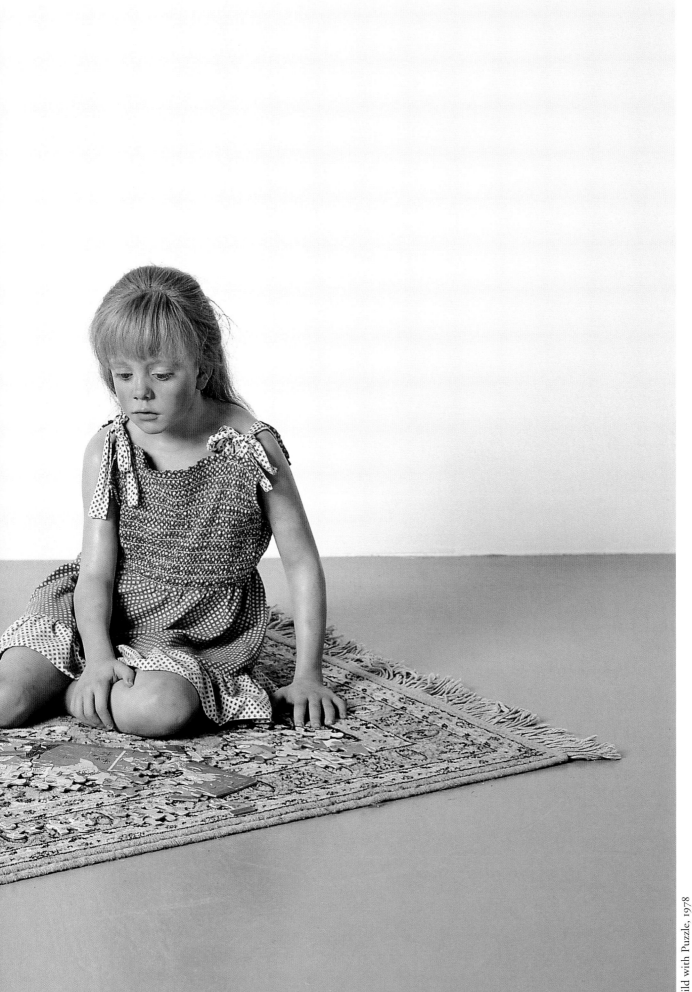

64 Child with Puzzle, 1978

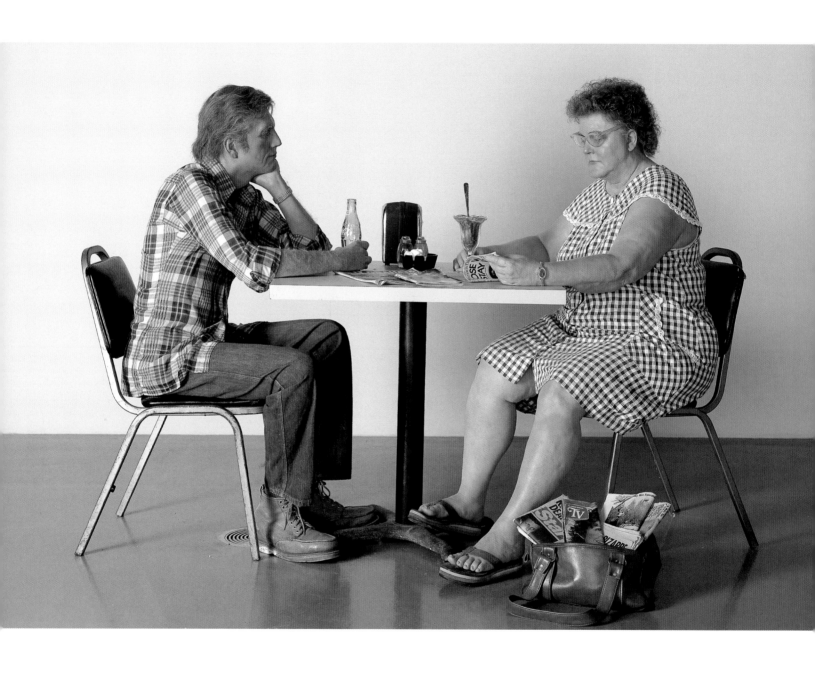

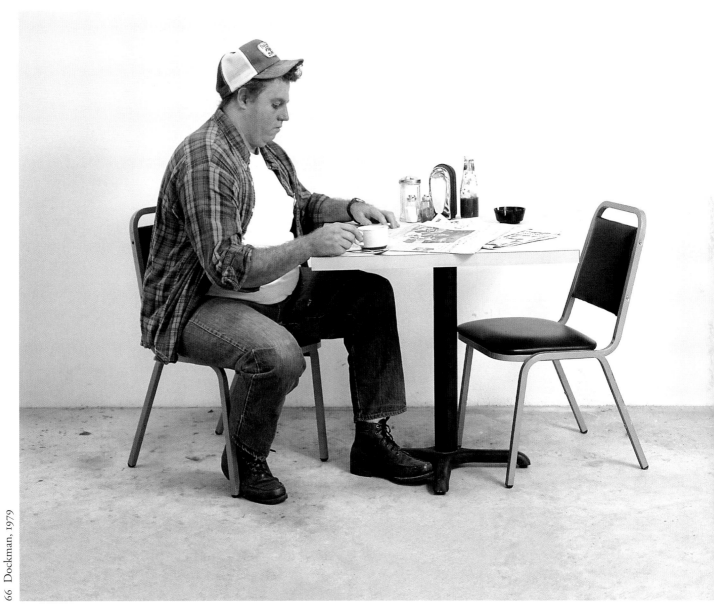

65 Self-Portrait with Model, 1979 *

66 Dockman, 1979

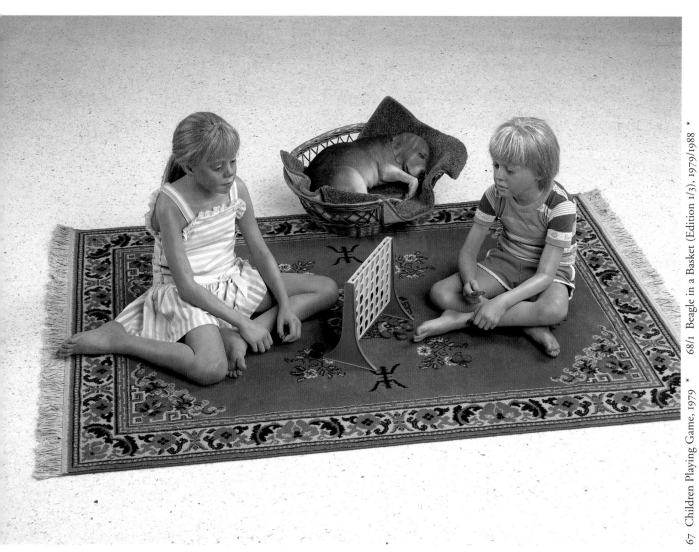

67 Children Playing Game, 1979 * 68/1 Beagle in a Basket (Edition 1/3), 1979/1988 *

69 Delivery Man, 1930 *

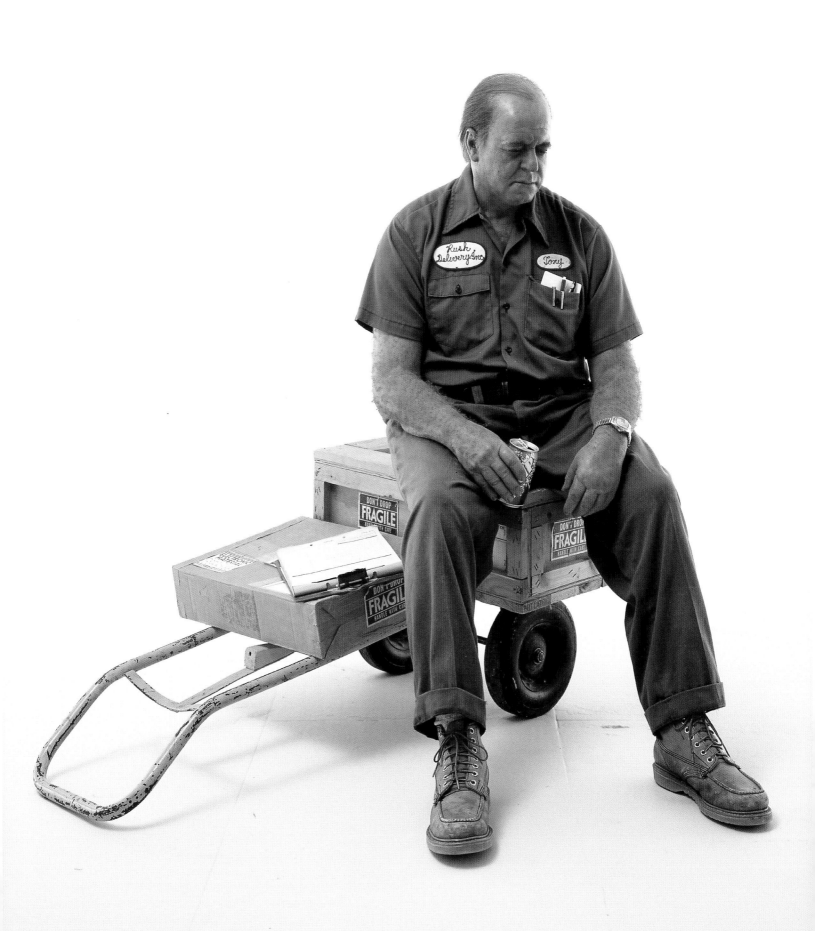

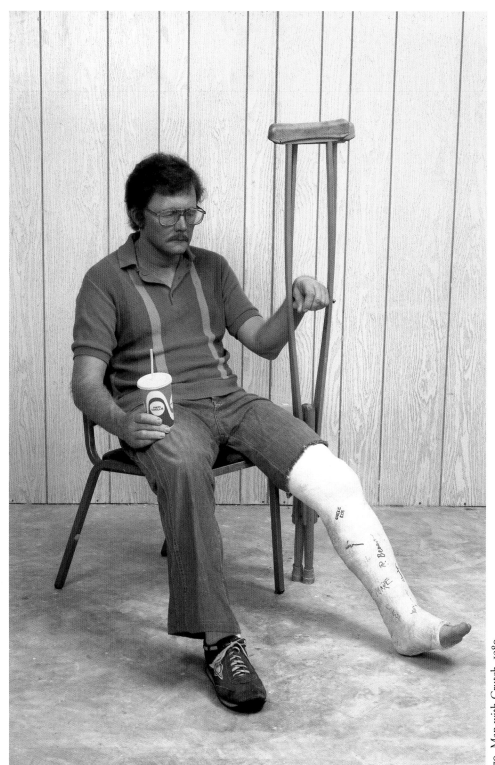

70 Man with Crutch, 1980

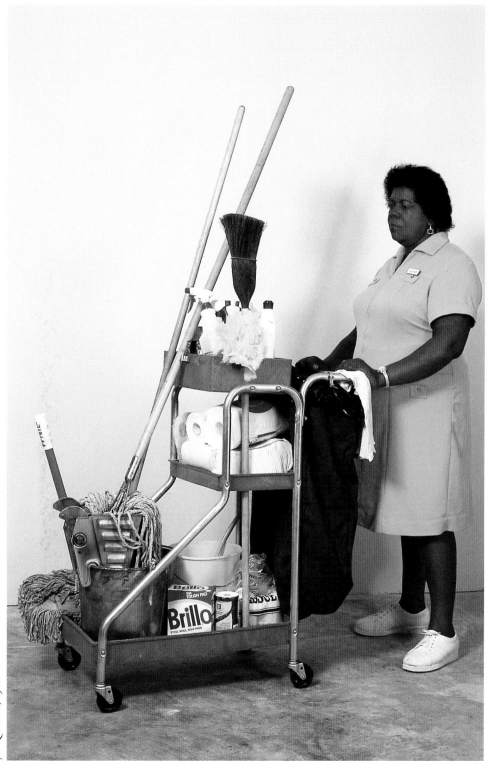

71 Queenie, 1980

73 Football Player, 1981

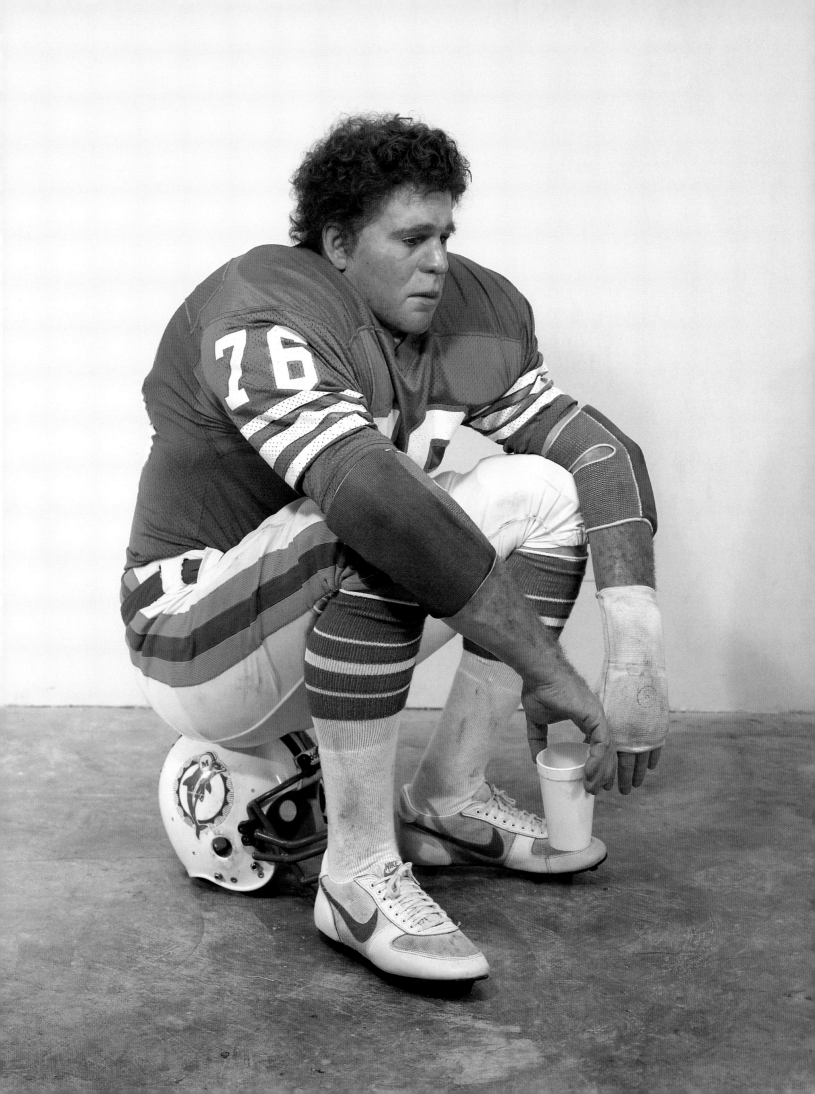

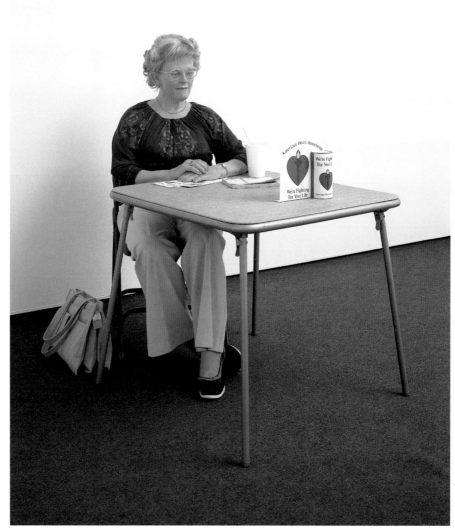

72 Fundraiser, 1980

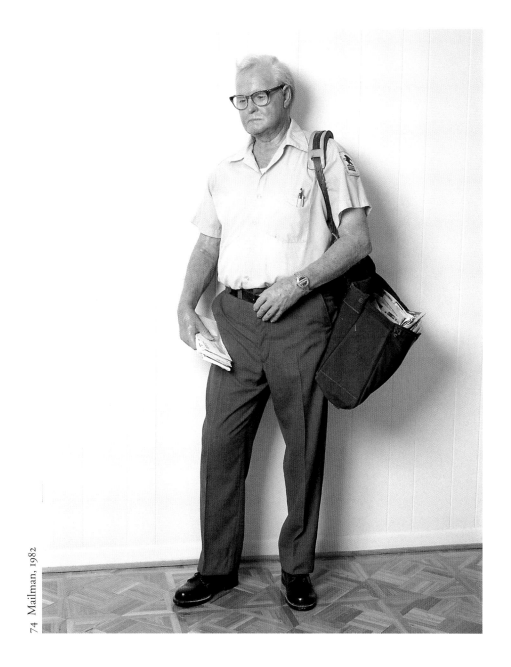

74 Mailman, 1982

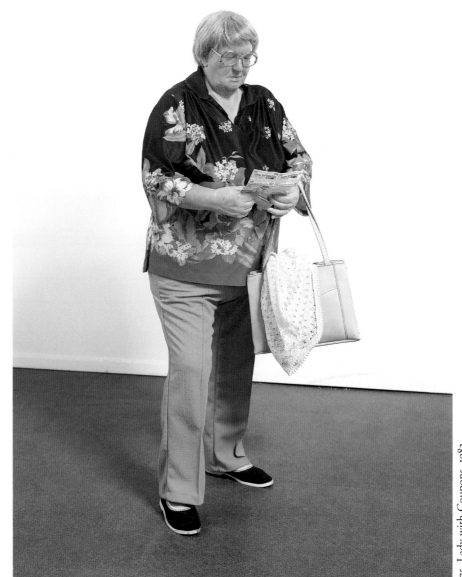

75 Lady with Coupons, 1982

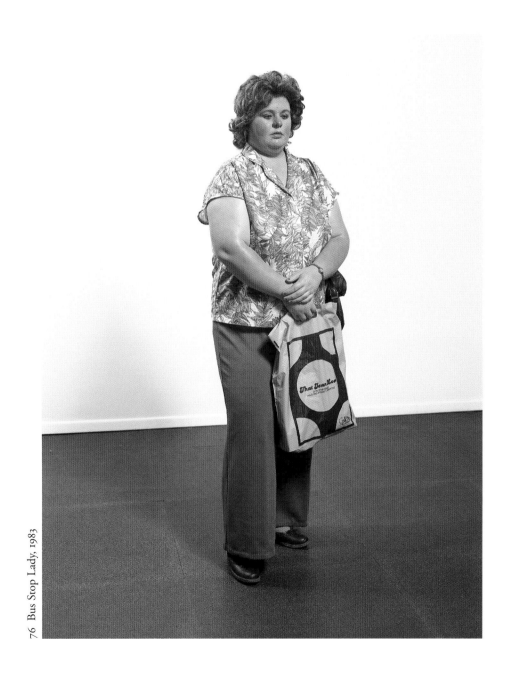

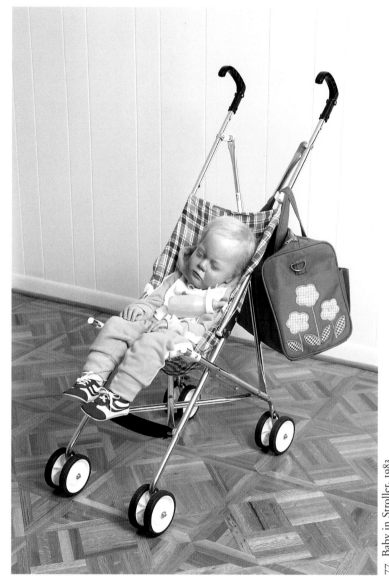

77 Baby in Stroller, 1983

78 Businessman Reading, 1983

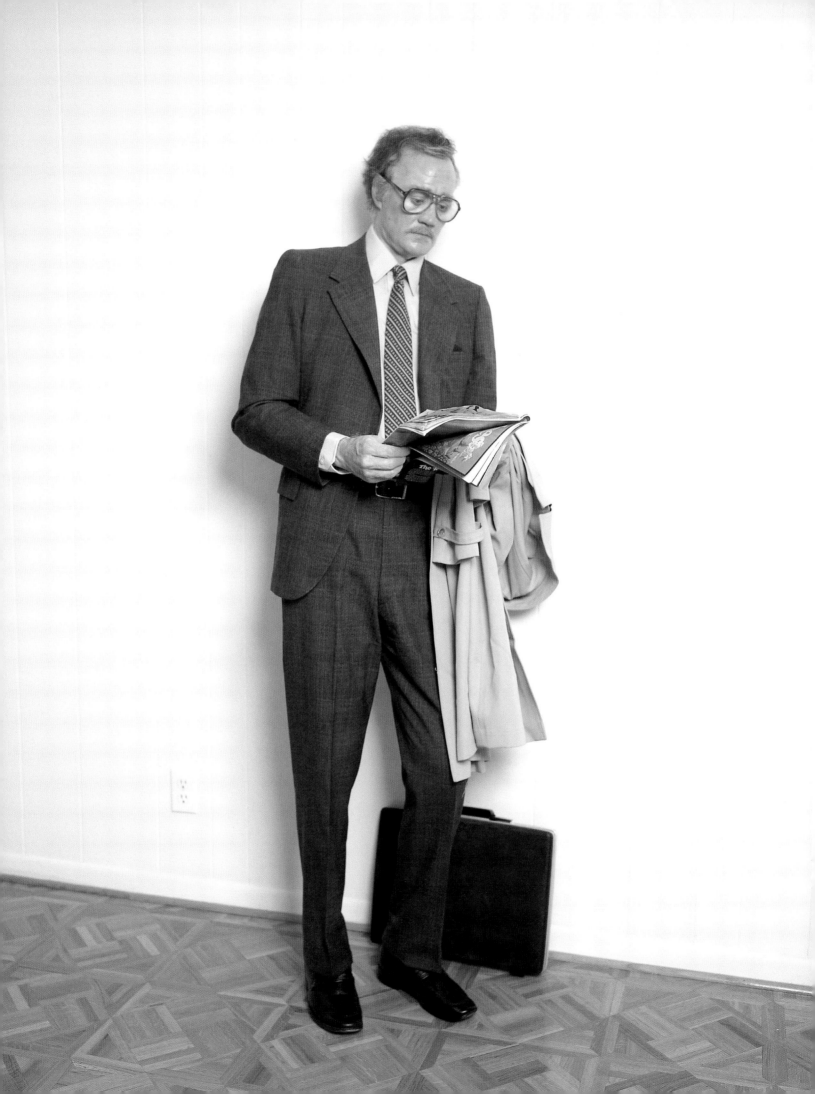

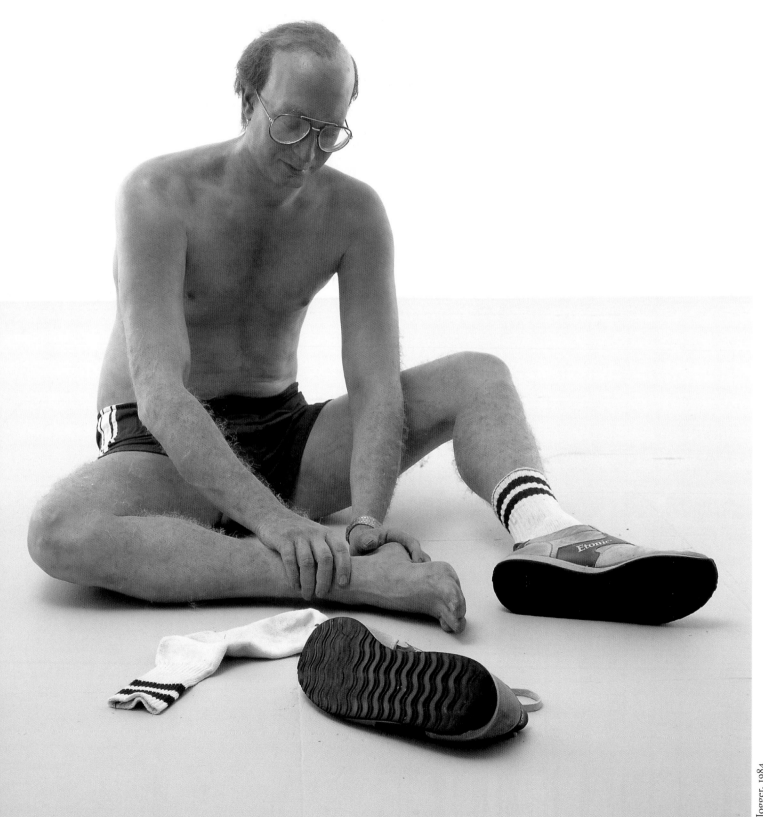

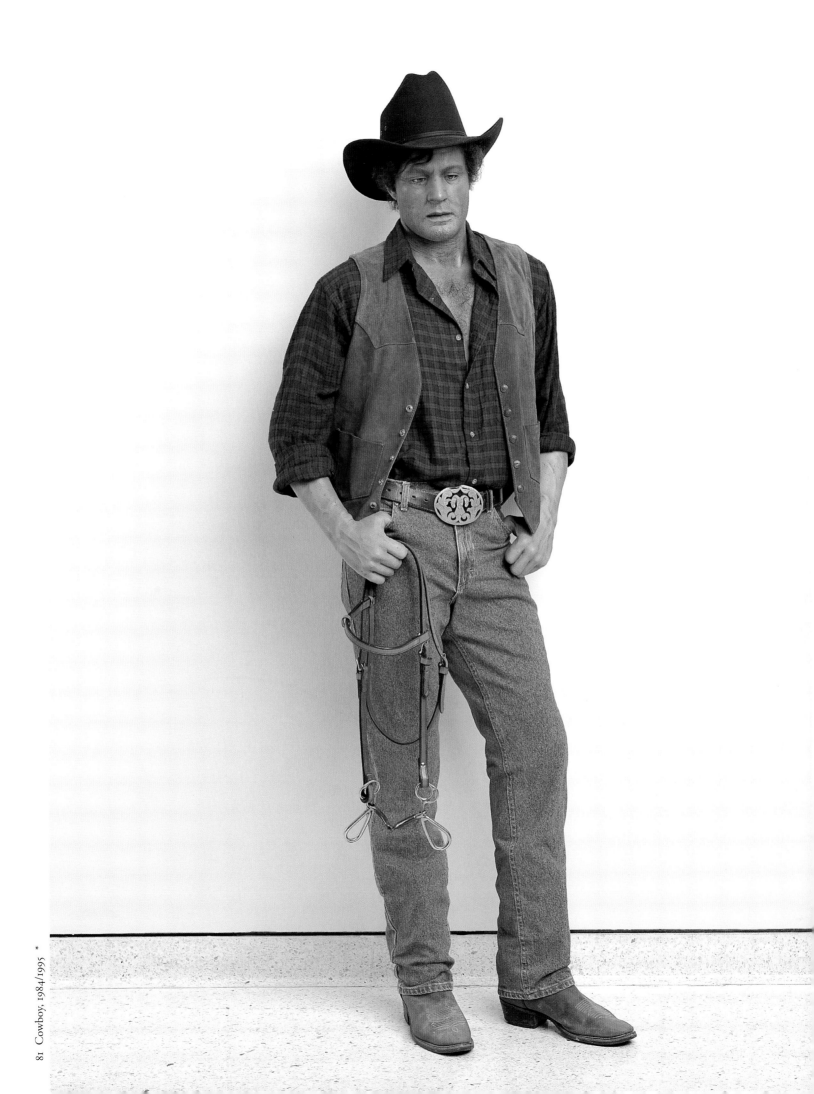

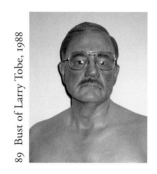

89 Bust of Larry Tobe, 1988

82 Female Bust, 1984

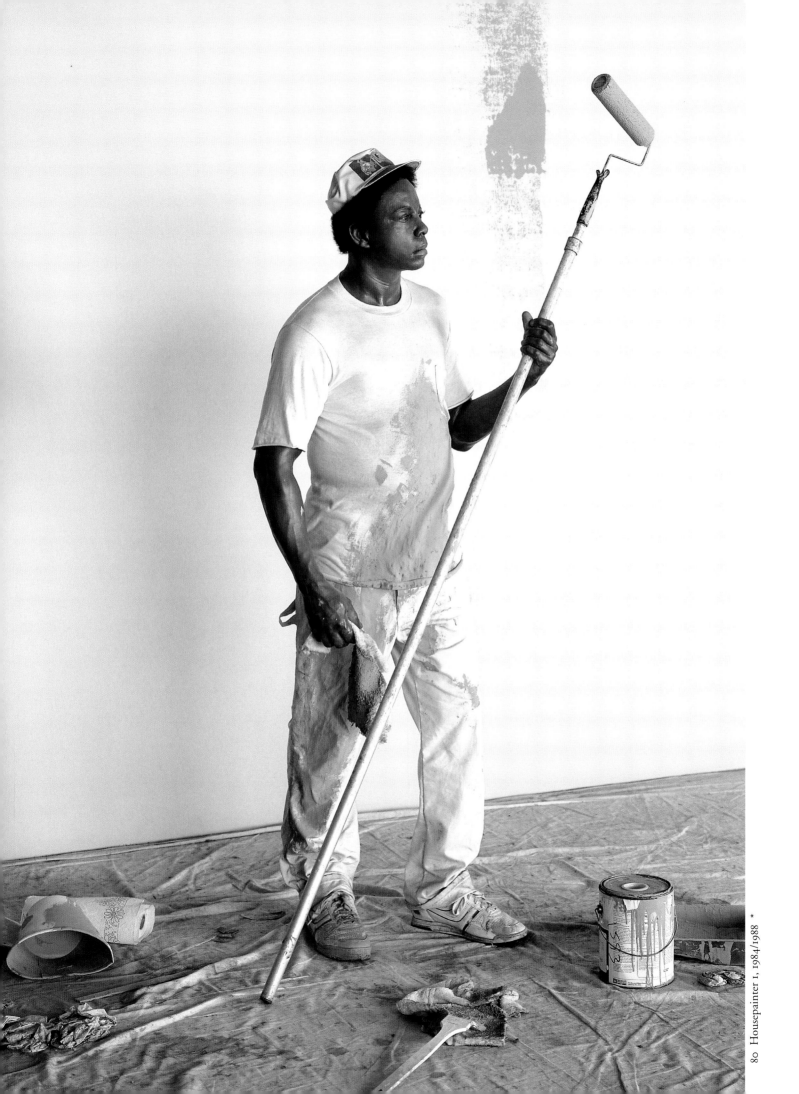

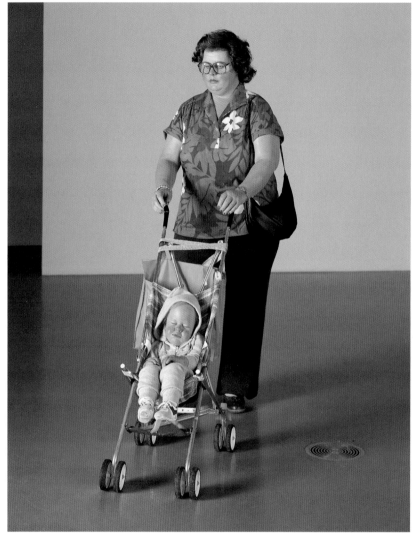

83 Woman with Child in Stroller, 1985

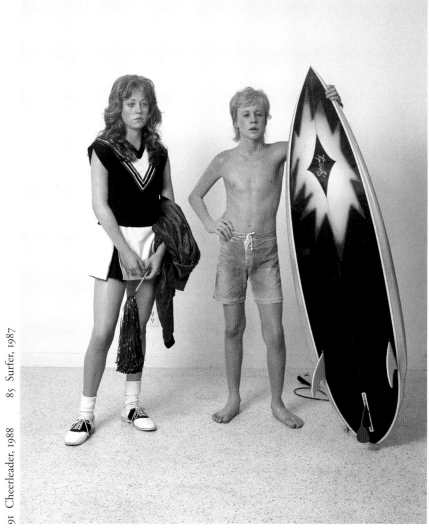

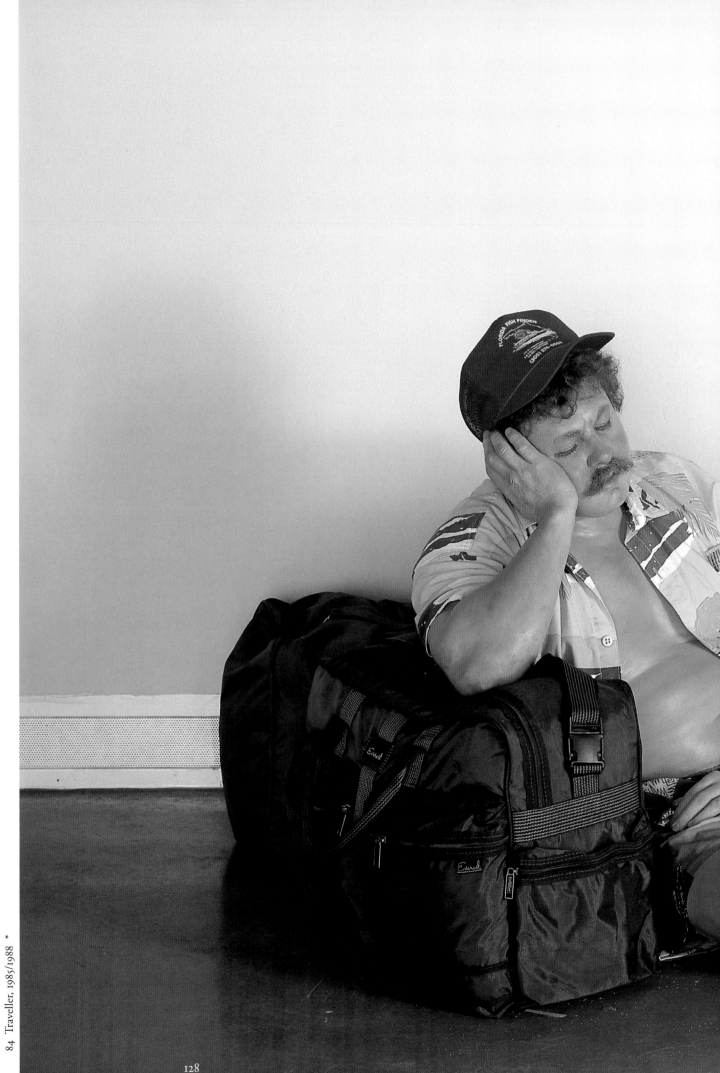

84 Traveller, 1985/1988 *

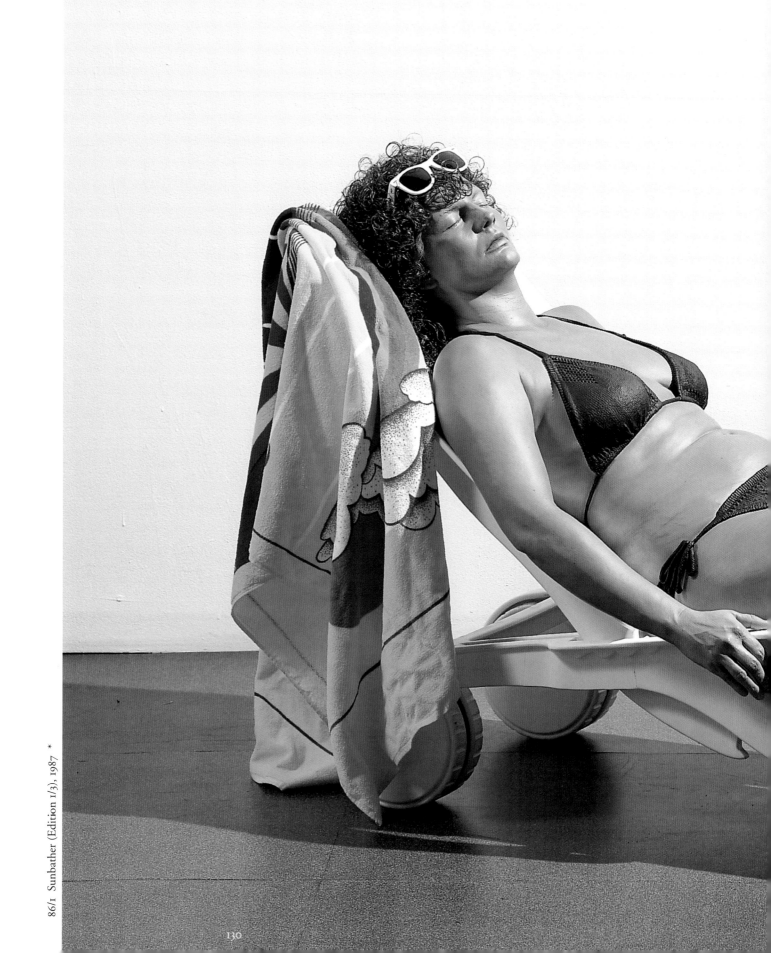

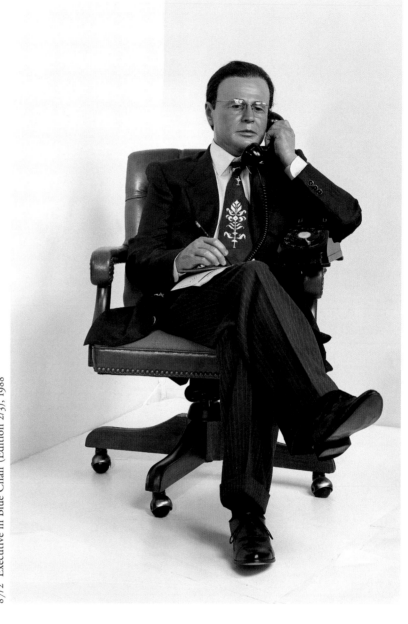

87/2 Executive in Blue Chair (Edition 2/3), 1988

88 Queenie II, 1988 *

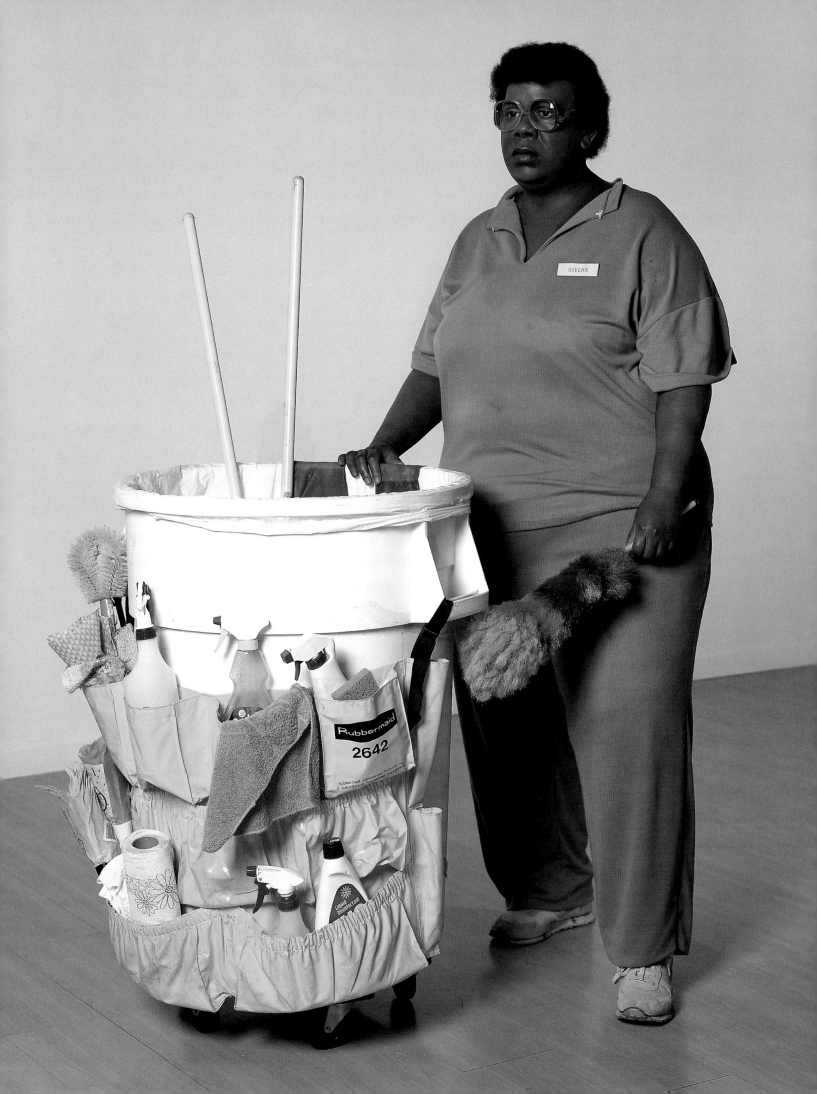

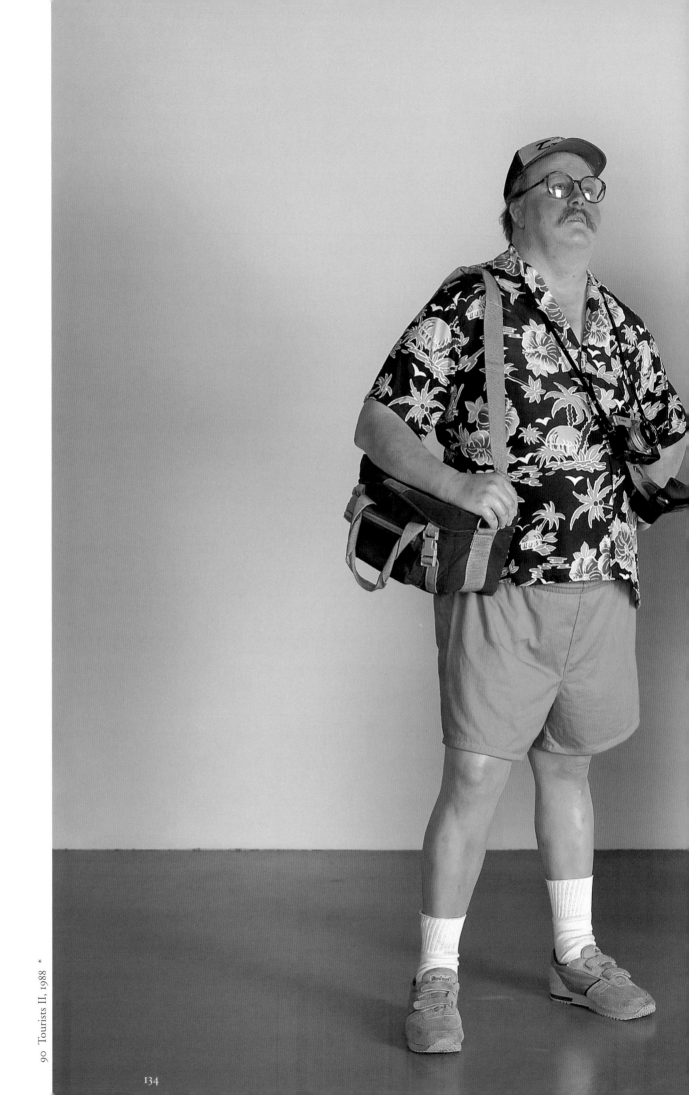

90 Tourists II, 1988 *

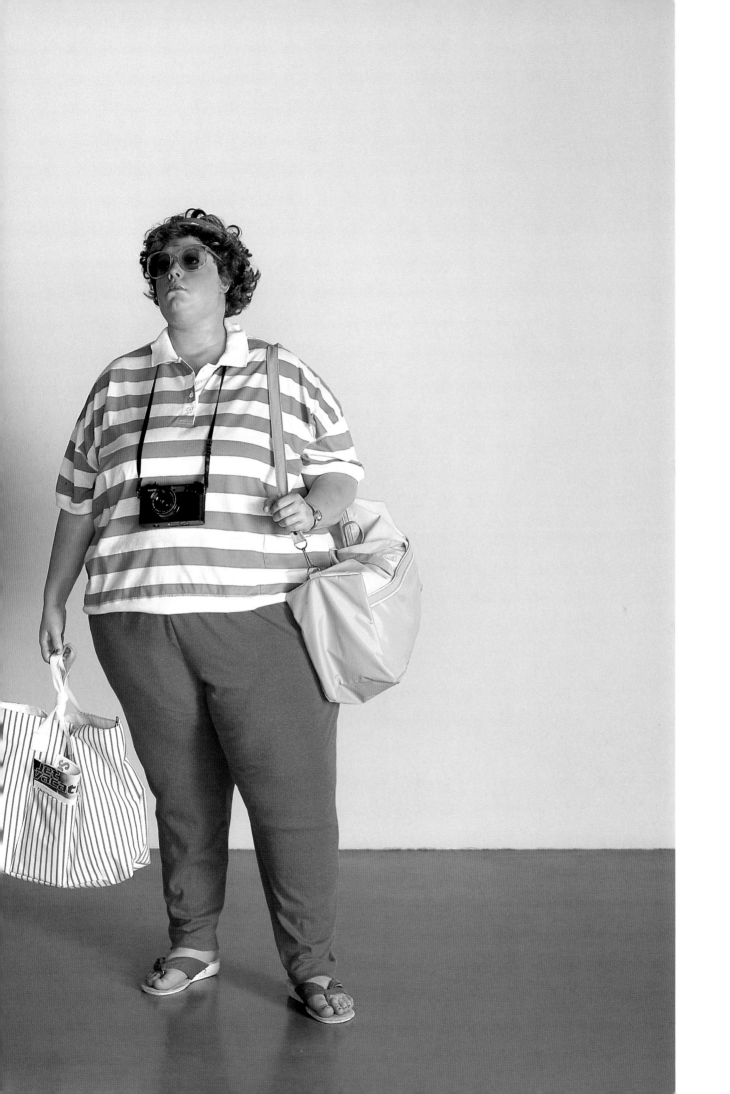

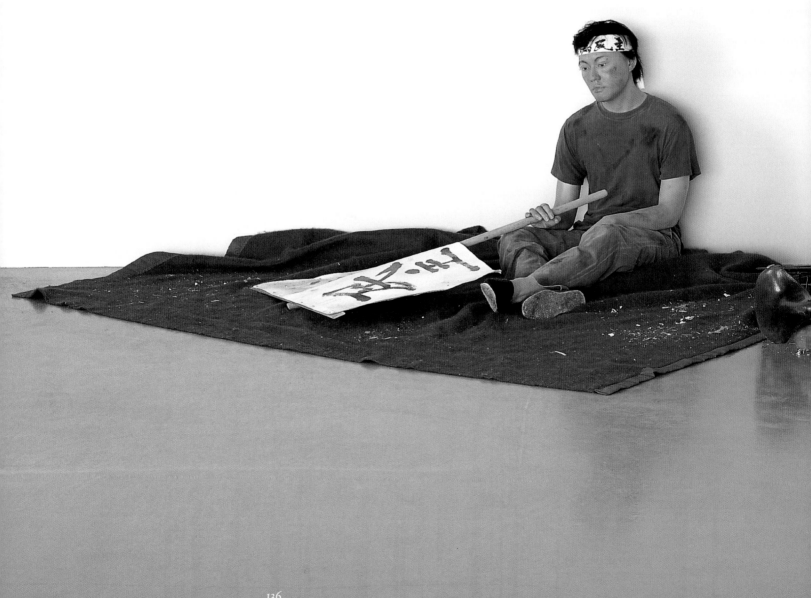

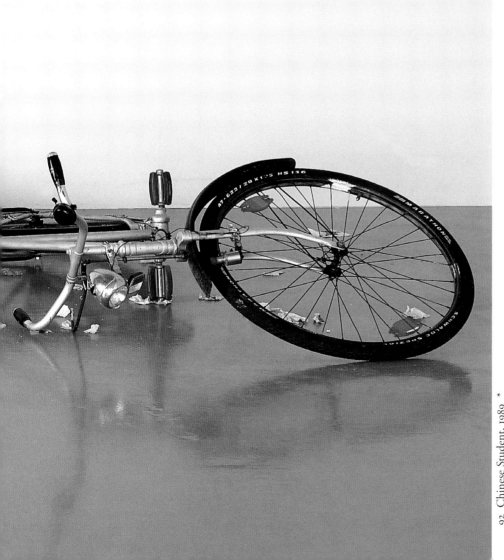

92 Chinese Student, 1989 *

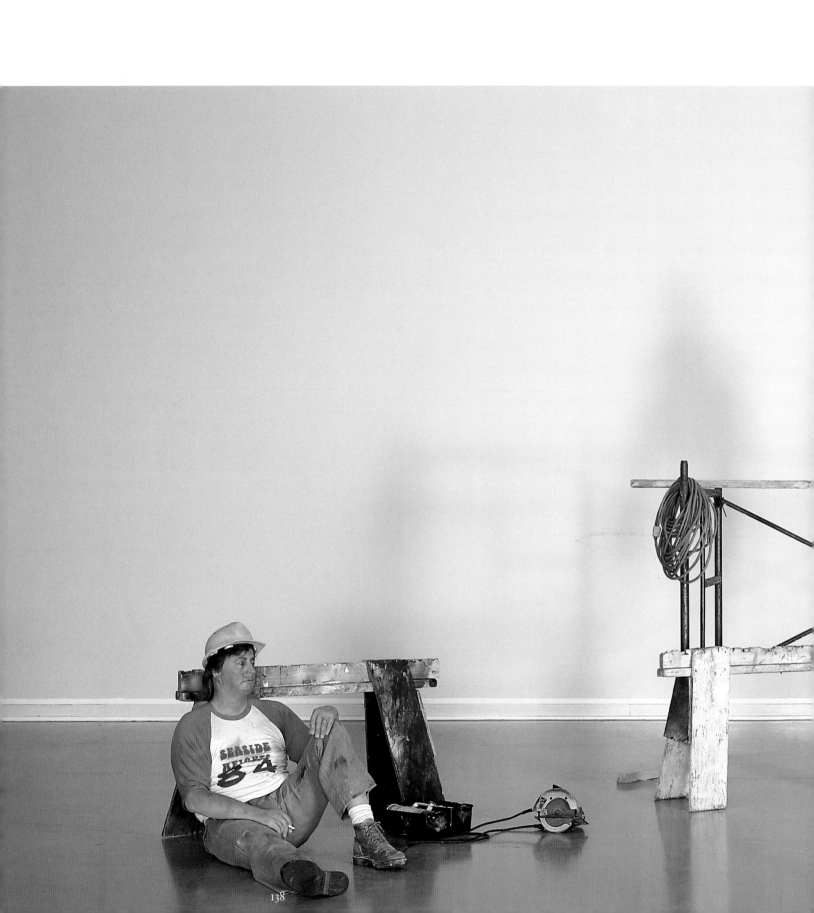

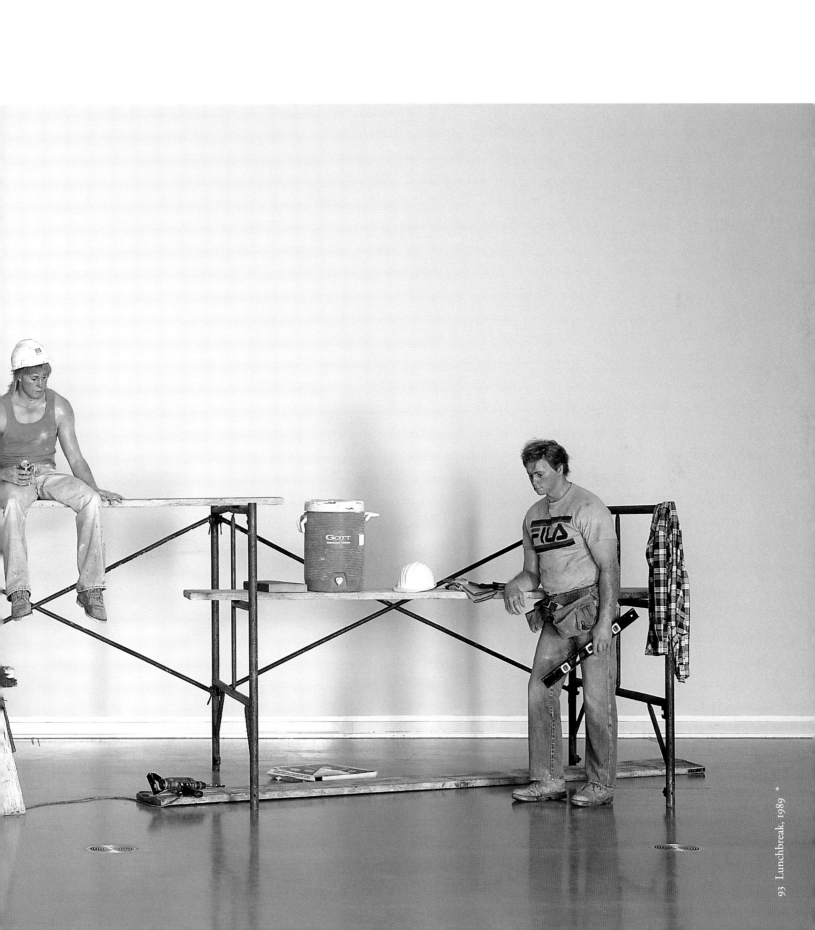

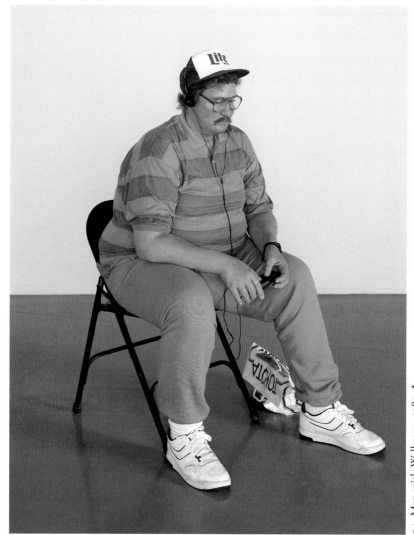

94 Man with Walkman, 1989 *

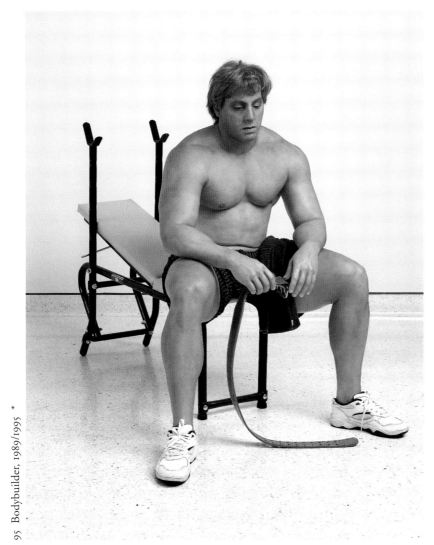

95 Bodybuilder, 1989/1995 *

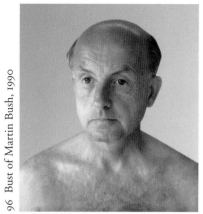

96 Bust of Martin Bush, 1990

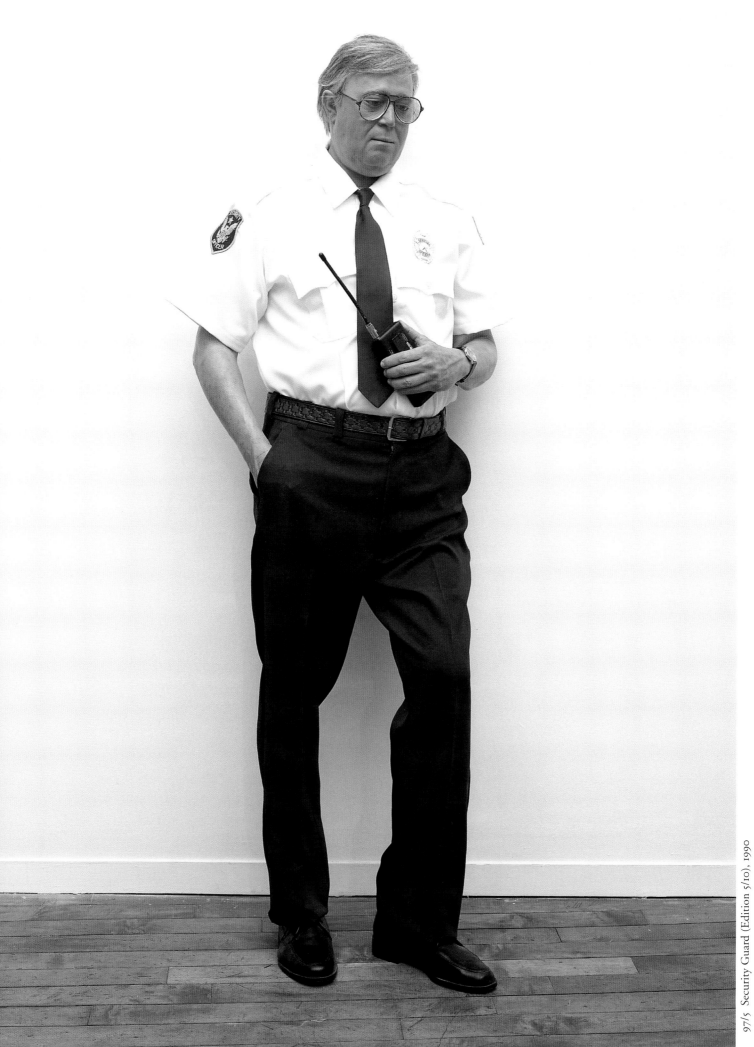

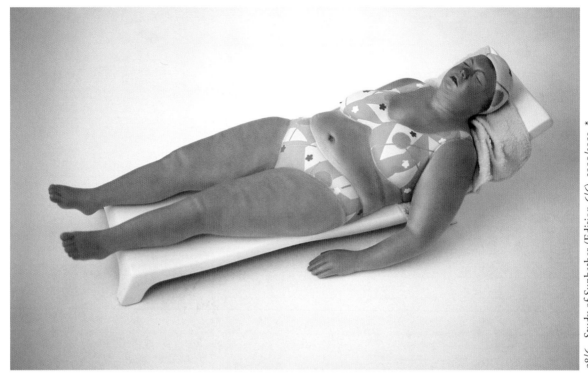

98/6 Study of Sunbather (Edition 6/6), 1990/1991 *

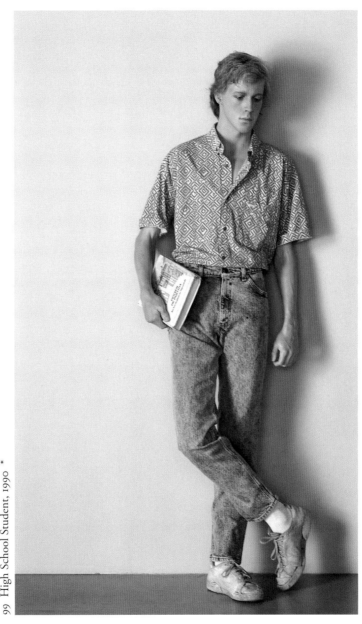

99 High School Student, 1990 *

101 Man with Camera, 1991 *

148

102 Homeless Person, 1991

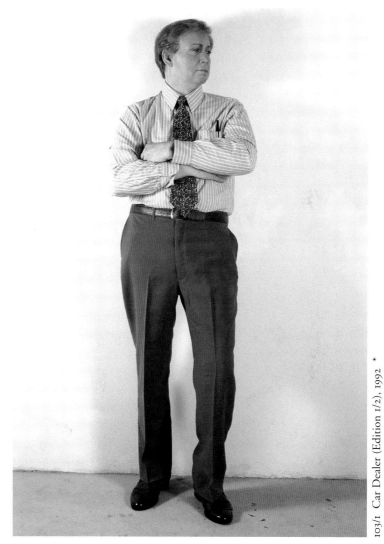

103/1 Car Dealer (Edition 1/2), 1992 *

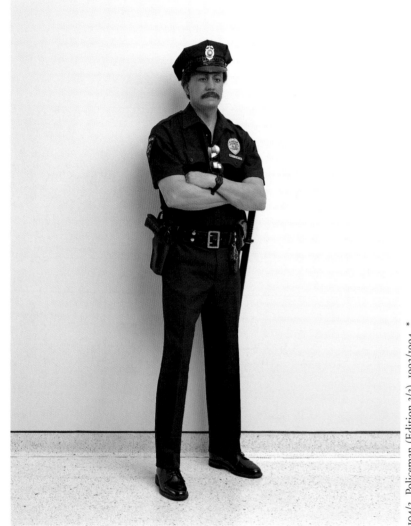

104/3 Policeman (Edition 3/3), 1992/1994 *

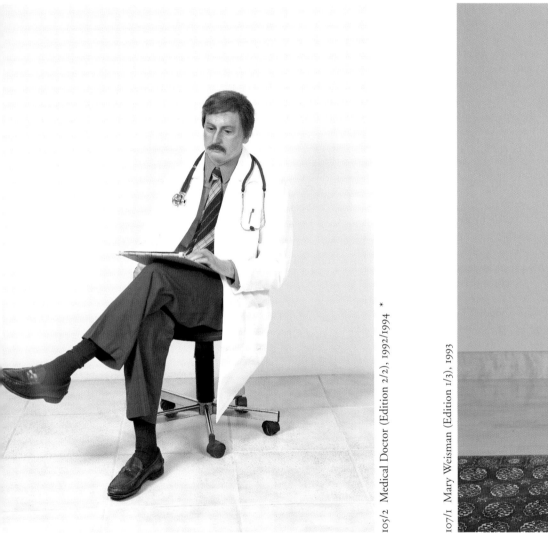

105/2 Medical Doctor (Edition 2/2), 1992/1994 *

107/1 Mary Weisman (Edition 1/3), 1993

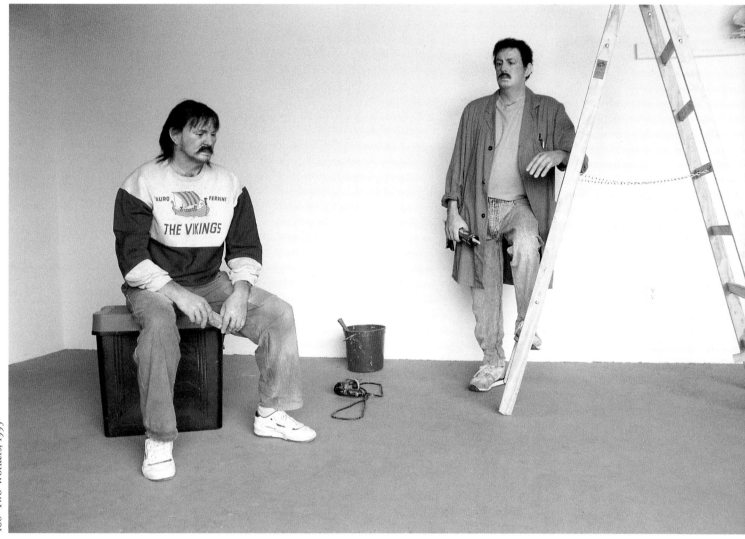

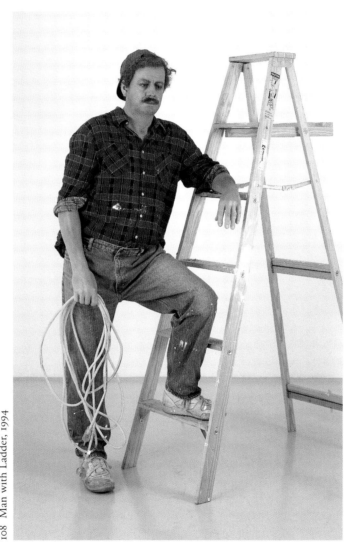

108 Man with Ladder, 1994

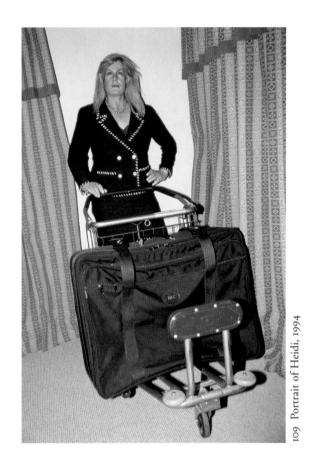

109 Portrait of Heidi, 1994

111/1 Female Bust (Edition 1/3), 1994

110 Portrait of Kim, 1994

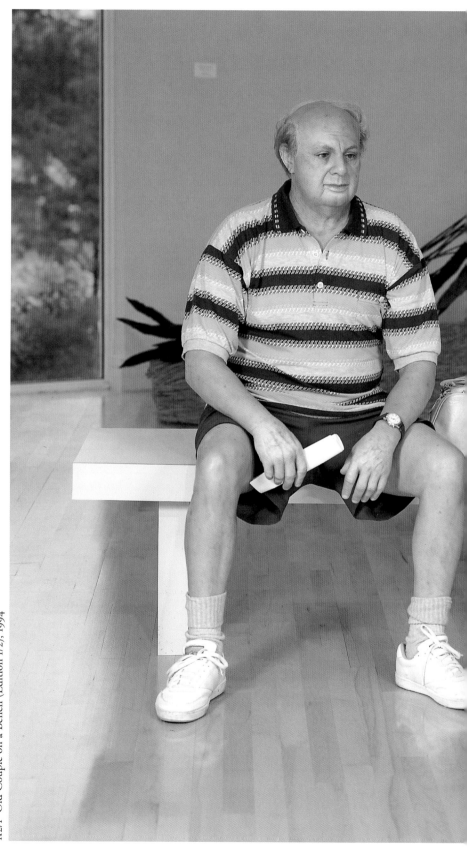

112/1 Old Couple on a Bench (Edition 1/2), 1994 *

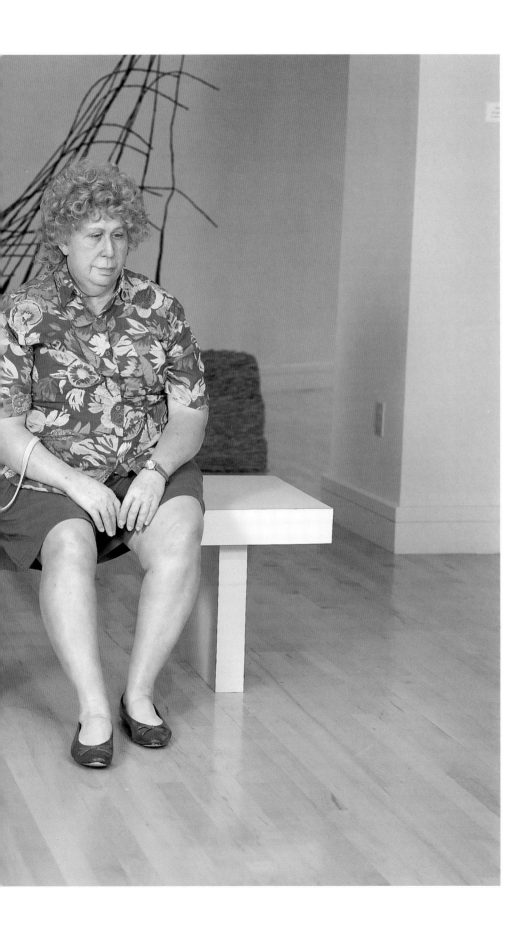

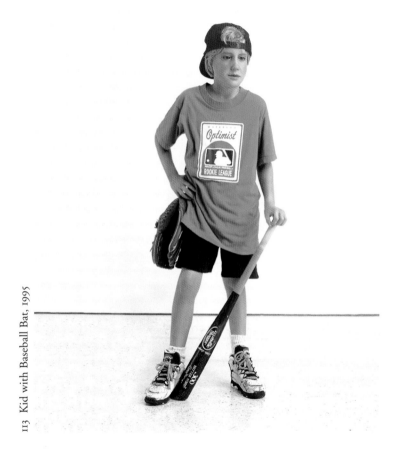

113 Kid with Baseball Bat, 1995

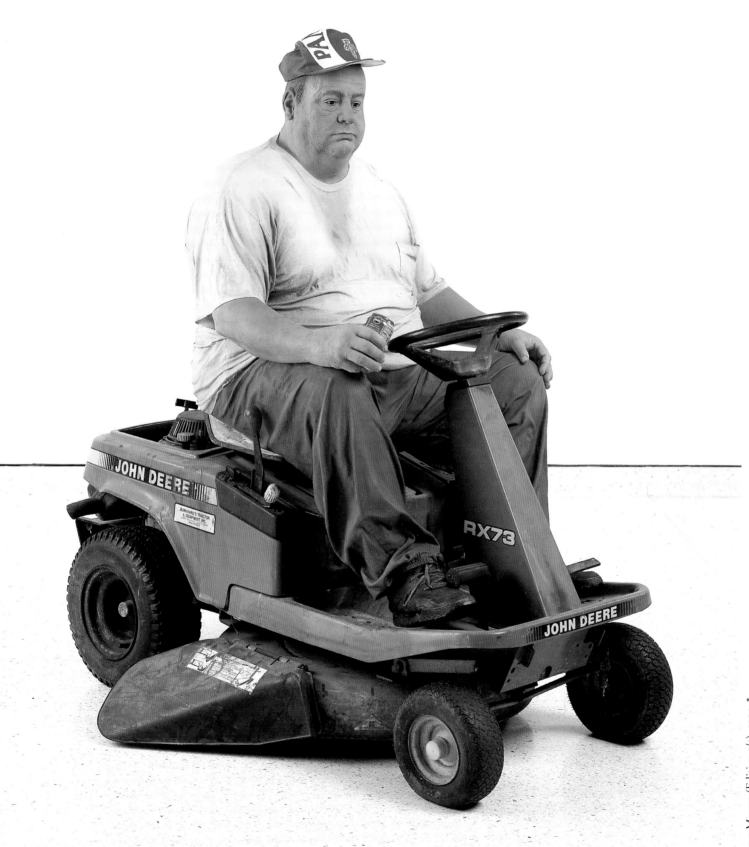

17 January 1925 Duane Hanson is born to the Swedish immigrants Dewey O. Hanson and Agnes Nelson Hanson in Alexandria, Minnesota, where his parents run a dairy farm.

1930 The family moves to Parkers Prairie, Minnesota.

1938 Hanson creates his first sculpture *Blue Boy*, based on the painting of the same name by the portraitist Thomas Gainsborough.

1941 First visit to an art museum on a trip to Minneapolis, Minnesota.

1943 Hanson enrols at Luther College in Decorah, Iowa.

1944 The family moves to Seattle, Washington, and Hanson switches to the University of Washington, where he specialises in art.

1945 Returns to St. Paul, Minnesota, where he lives with relatives and attends Macalester College. He again specialises in art. He makes friends with his teachers, the sculptors Alonzo Hauser and John Rood.

1946 Receives Bachelor of Arts degree from Macalester College.

1947 Continues his studies at the University of Minnesota.

* = Exhibition piece

All sculptures are life-size. Any exceptions are noted in this catalogue.

All titles, including the German ones, are original.

All editions not illustrated in the catalogue raisonné are to be found in the plates under the number cited.

Group Exhibition 1945
_Seattle Art Museum, Washington

Group Exhibition 1946
_Walker Art Center, Minneapolis, Minnesota

Group Exhibition 1948
_University of Minnesota, Minneapolis

1950 Enrols at Cranbrook Academy of Art in Bloomfield Hills, Michigan, where he now studies sculpture only.

1951 Receives Master of Fine Arts degree from Cranbrook Academy of Art. He meets the Swedish sculptor Carl Milles. Hanson teaches at Edgewood School in Greenwich, Connecticut, and marries Janice Roche.

Solo Exhibitions 1951
_Museum of Art, Cranbrook Academy of Art, Bloomfield Hills, Michigan

1952 Teaches at Wilton Junior High School in Wilton, Connecticut.

Solo Exhibition 1952
_Wilton Gallery, Connecticut

1953 First trip to Europe. He teaches art at American army schools, for four years in Munich and three years in Bremerhaven.

Solo Exhibition 1958
_Galerie Netzel, Worpswede, Germany

1959 He meets the German artist George Grygo in Bremerhaven. Grygo works in polyester resin and fiberglass, a technique that was unknown to Hanson at the time.

1961 Returns to the United States, where he settles in Atlanta, Georgia, and starts teaching again.

1963 Wins the Ella Lyman Cabot Trust Award. He receives two thousand dollars to conduct experiments with polyester resin.

Solo Exhibition 1967
_Wilhelm Lehmbruck Museum, Duisburg, Germany

Group Exhibition 1952
_Silver Mine Gallery, Wilton, Connecticut

1965 Hanson divorces his wife and moves to Miami, Florida, where he teaches art and sculpture at Miami Dade Community College. He undertakes a critical analysis of current evils in American society in his sculptures.

1967 Hanson produces his first life-size works in polyester resin and fiberglass. He receives an encouraging letter from the New York art dealer Ivan Karp.

1968 Marries Wesla Host. Ivan Karp visits Hanson's studio in Florida and offers him a one-man show in New York. Hanson receives the Florida State Fair Award of Merit – awarded by George Segal – for *Gangland Victim.*

The works *Motorcycle Accident* and *Gangland Victim* are removed from the exhibition in the Bicardi Museum in Miami, Florida, after heated debate.

1965

1 *
Abortion

Wood, cloth, plaster and mixed media
h 28 cm, w 64 cm, d 41 cm
Hanson Collection, Davie, Florida

1967

2
War

Polyester resin and fiberglass, polychromed in oil, mixed media, with accessories
Wilhelm Lehmbruck Museum, Duisburg, Germany

3 *
Motorcycle Accident

Polyester resin and fiberglass, polychromed in oil, mixed media, with accessories
Flick Collection

4 *
Gangland Victim

Polyester resin and fiberglass, polychromed in oil, mixed media, with accessories
The Art Museum @ Florida International University, Miami, Florida

5
Policeman and Rioter

Polyester resin and fiberglass, polychromed in oil, mixed media, with accessories
Flick Collection

6 *
Trash

Polyester resin and fiberglass, mixed media, with accessories
David Gossoff, Davie, Florida

1968

7
Football Players

Polyester resin and fiberglass, polychromed in oil, mixed media, with accessories
Museum moderner Kunst Stiftung Ludwig, Vienna

Group Exhibition 1967
_Hollywood Art Museum, Florida

Group Exhibitions 1968
_Florida State Fair Fine Arts
 Exhibit, Tampa, Florida
_Hollywood Art Museum, Florida
_Lowe Art Gallery, University of
 Miami, Florida
_Miami Art Center, Florida

1969 Moves to New York, where he takes a studio at 17 Bleecker Street.

1970 Everyday life in America gradually emerges as the focal point of his work. The figures created include housewives, tourists, and construction workers. Birth of daughter Maja.

Solo Exhibition 1970
_O. K. Harris Gallery, New York

1971 Hanson contracts cancer.

1969

8
Bowery Derelicts

Polyester resin and fiberglass, polychromed in oil, mixed media, with accessories
Neue Galerie, Aachen, Germany

1970

9
Supermarket Shopper

Polyester resin and fiberglass, polychromed in oil, mixed media, with accessories
Ludwig Forum für Internationale Kunst, Aachen, Germany

10
Bunny

Polyester resin and fiberglass, polychromed in oil, mixed media, with accessories
Monroe Meyerson, New York

11
Housewife

Polyester resin and fiberglass, polychromed in oil, mixed media, with accessories
Sammlung Onnasch, Neues Museum Weserburg, Bremen, Germany

12
Tourists

Polyester resin and fiberglass, polychromed in oil, mixed media, with accessories
National Galleries of Scotland, Edinburgh

13
Hard Hat

Polyester resin and fiberglass, polychromed in oil, mixed media, with accessories
Frances and Sydney Lewis, Richmond, Virginia

1971

14
Baton Twirler

Polyester resin and fiberglass, polychromed in oil, mixed media, with accessories
Galerie Thelen, Cologne

15
Rock Singer

Polyester resin and fiberglass, polychromed in oil, mixed media, with accessories
Jan Streep, Amsterdam

16
Woman Eating

Polyester resin and fiberglass, polychromed in oil, mixed media, with accessories
Mrs. Robert Mayer, Chicago, Illinois

Group Exhibition 1969
_*Human Concern/Personal Torment: The Grotesque in American Art*
Whitney Museum of American Art, New York

Group Exhibitions 1970
_*Figures/Environments*
Cincinnati Art Museum, Ohio
Dallas Museum of Fine Arts, Texas
Indianapolis Museum of Art, Indiana
Walker Art Center, Minneapolis, Minnesota
_*Klischee und Antiklischee*
Neue Galerie, Aachen, Germany

_*Painting and Sculpture Today*
O. K. Harris Gallery, New York
_*American Art since 1960*
Princeton University Art Museum, New Jersey
_*Sculpture Annual*
Whitney Museum of American Art, New York
_University Art Museum, Berkeley, California

Group Exhibitions 1971
_*Depth and Presence*
Corcoran Gallery of Art, Washington D.C.
_*Direction 3: Eight Artists*
Milwaukee Art Center, Wisconsin
_*Radical Realism*
Museum of Contemporary Art, Chicago, Illinois
_*New Realism and Old Realism*
Dannenberg Gallery and Roman Galleries, New York

1972 Takes part in *documenta 5* in Kassel. Hanson makes a breakthrough on to the international scene. He works in Cologne from June to September.

Solo Exhibitions 1972
_Galerie Onnasch, Cologne, Germany
_O. K. Harris Gallery, New York

1972

17
Sunbather

Polyester resin and fiberglass, polychromed in oil, mixed media, with accessories
Wadsworth Atheneum, Hartford, Connecticut

18
Businessman

Polyester resin and fiberglass, polychromed in oil, mixed media, with accessories
Virginia Museum of Fine Arts, Richmond, Virginia

19
Executive

Polyester resin and fiberglass, polychromed in oil, mixed media, with accessories
The Saatchi Gallery, London

20
Woman Cleaning Rug

Polyester resin and fiberglass, polychromed in oil, mixed media, with accessories
Hiroshima City Museum of Contemporary Art, Japan

21
Boxers

Polyester resin and fiberglass, polychromed in oil, mixed media, with accessories
Galerie des Quatre Mouvements, Paris

22
Seated Artist

Polyester resin and fiberglass, polychromed in oil, mixed media, with accessories
Byron Cohen, Kansas City, Missouri

23
Reclining Man Drinking

Polyester resin and fiberglass, polychromed in oil, mixed media, with accessories
Mrs. Morton Neumann, Chicago, Illinois

24 *
Lady with Shopping Bags

Polyester resin and fiberglass, polychromed in oil, mixed media, with accessories
Flick Collection

25
Artist with Ladder

Polyester resin and fiberglass, polychromed in oil, mixed media, with accessories
Bill Fromm, Barkley Evergreen & Partners, Kansas City, Missouri

26
Rocker

Polyester resin and fiberglass, polychromed in oil, mixed media, with accessories
Frederick R. Weisman Art Foundation, Los Angeles, California

27
Putzfrau

Polyester resin and fiberglass, polychromed in oil, mixed media, with accessories
Staatsgalerie Stuttgart, Germany

28
Maurer

Polyester resin and fiberglass, polychromed in oil, mixed media, with accessories
Sprengel Museum, Hannover, Germany

29
Lesender Mann

Polyester resin and fiberglass, polychromed in oil, mixed media, with accessories
Mr. and Mrs. George Meeker, Kansas City, Missouri

30
Sekretärin

Polyester resin and fiberglass, polychromed in oil, mixed media, with accessories
Foster Goldstrom, Dallas, Texas, and San Francisco, California

Group Exhibitions 1972
_*documenta 5*
 Kassel, Germany
_*Phases of New Realism*
 Lowe Museum of Art, University of Miami, Florida
_Galerie de Gestlo, Hamburg, Germany
_Galerie Schmela, Düsseldorf, Germany
_*Hyperréalistes américains*
 Galerie des Quatre Mouvements, Paris
_*Realism Now*
 New York Cultural Center, New York

_*Recent Figurative Sculpture*
 Fogg Museum, Harvard University, Boston, Massachusetts
_*Sharp-Focus Realism*
 Sidney Janis Gallery, New York

1973 Returns to Davie, Florida. Birth of his son Duane Jr.

1974 Hanson lives and works in Berlin for six months on a scholarship from the German Academic Exchange Service (DAAD). He receives the Art Institute of Chicago's Blair Award for *Woman Derelict*.

Solo Exhibitions 1974
_Neue Galerie, Aachen, Germany
_Württembergischer Kunstverein, Stuttgart, Germany
_Galerie de Gestlo, Hamburg, Germany
_Museum of Contemporary Art, Chicago, Illinois
_O. K. Harris Gallery, New York

1973

31
Dishwasher

Polyester resin and fiberglass, polychromed in oil, mixed media, with accessories
Ed Cauduro, Portland, Oregon

32
Janitor

Polyester resin and fiberglass, polychromed in oil, mixed media, with accessories
Milwaukee Art Museum, Wisconsin

33
Old Man Playing Solitaire

Polyester resin and fiberglass, polychromed in oil, mixed media, with accessories
William Jasper, Hewlett Harbor, New York

34
Woman with Suitcases

Polyester resin and fiberglass, polychromed in oil, mixed media, with accessories
Mrs. Morton Neumann, Chicago, Illinois

35
Florida Shopper

Polyester resin and fiberglass, polychromed in oil, mixed media, with accessories
Frederick R. Weisman Art Foundation, Los Angeles, California

36
Woman Derelict

Polyester resin and fiberglass, polychromed in oil, mixed media, with accessories
Centraal Museum Utrecht, Netherlands

37
Man in Chair with Beer

Polyester resin and fiberglass, polychromed in oil, mixed media, with accessories
Yale University Art Museum, New Haven, Connecticut

38
Young Shopper

Polyester resin and fiberglass, polychromed in oil, mixed media, with accessories
The Saatchi Gallery, London

1974

39
Man Leaning against Wall

Polyester resin and fiberglass, polychromed in oil, mixed media, with accessories
Mr. and Mrs. Burton Reiner, Bethesda, Maryland

40
Drug Addict

Polyester resin and fiberglass, polychromed in oil, mixed media, with accessories
Richard Brown Baker, New York

41
Seated Old Woman Shopper

Polyester resin and fiberglass, polychromed in oil, mixed media, with accessories
Mr. and Mrs. Burton Reiner, Bethesda, Maryland

42
Back Packer

Polyester resin and fiberglass, polychromed in oil, mixed media, with accessories
Location unknown

43
Woman with Laundry Basket

Polyester resin and fiberglass, polychromed in oil, mixed media, with accessories
Art Gallery of South Australia, Adelaide, Australia

44
Seated Child

Polyester resin and fiberglass, polychromed in oil, mixed media, with accessories
Museum Boijmans Van Beuningen, Rotterdam, Netherlands

45
Repairman

Polyester resin and fiberglass, polychromed in oil, mixed media, with accessories
Jeffrey C. Kasch, Milwaukee, Wisconsin

46
Woman with Purse

Polyester resin and fiberglass, polychromed in oil, mixed media, with accessories
Museum Ludwig, Cologne, Germany

Group Exhibitions 1973
_*American Sharp-Focus Realism*
 Galerie Löwenadler, Stockholm
_*Amerikansk Realism*
 Lunds Konsthall, Sweden
_*Amerikanste Realister*
 Randers Kunstmuseum, Denmark
_*Whitney Biennial*
 Whitney Museum of American Art, New York
_*Grands maîtres hyperréalistes américains*
 Galerie des Quatre Mouvements, Paris

_*Ekstrem Realisme*
 Groningen Museum, Netherlands
 Kunstmuseum Luzern, Switzerland
 Louisiana Museum of Modern Art, Humlebæk, Denmark
_*Hyperréalisme*
 Galerie Isy Brachot, Brussels
_*Radical Realists*
 Portland Center of the Visual Arts, Oregon
_*Mit Kamera, Pinsel und Spritzpistole*
 Städtische Kunsthalle, Recklinghausen, Germany

_*30 internationale Künstler in Berlin*
 DAAD, Berlin
_*The Super-Realist Vision*
 DeCordova Museum, Lincoln, Massachusetts

Group Exhibitions 1974
_*Agora 2*
 Palazzo Reale, Milan, Italy
_*Contemporary American Painting and Sculpture*
 Krannert Art Museum, Champaign, Illinois
_*Ars 74*
 Fine Arts Academy of Finland, Helsinki

_*Kijken naar de Werklijkheid*
 Museum Boijmans Van Beuningen, Rotterdam, Netherlands
_*Hyperréalistes américains/Réalistes européens*
 Centre National d'Art Contemporain, Paris
_*Edinburgh Festival*
 Scottish Art Council, Edinburgh
_*American Hyperrealist – European Realists*
 Arts Council, Serpentine Gallery, London
 Rotunda, Milan, Italy
_*Kunstverein Hannover, Germany*
_*Musée d'Art Moderne, Paris*

1975

1976

47
Bank Guard

Polyester resin and fiberglass,
polychromed in oil, mixed media,
with accessories
Max Palevsky, Malibu, California

48
Cement Worker

Polyester resin and fiberglass,
polychromed in oil, mixed media,
with accessories
Mr. and Mrs. Raymond
Zimmerman, Nashville, Tennessee

49 *
Rita the Waitress

Polyester resin and fiberglass,
polychromed in oil, mixed media,
with accessories
The Saatchi Gallery, London

50
Man with Hand Cart

Polyester resin and fiberglass,
polychromed in oil, mixed media,
with accessories
Frances and Sydney Lewis,
Richmond, Virginia

51
Museum Guard

Polyester resin and fiberglass,
polychromed in oil, mixed media,
with accessories
Nelson-Atkins Museum, Kansas
City, Missouri

52 *
Old Lady in Folding Chair

Polyester resin and fiberglass,
polychromed in oil, mixed media,
with accessories
Hanson Collection, Davie, Florida

53
Old Man Dozing

Polyvinyl, polychromed in oil,
mixed media, with accessories
Frederick R. Weisman Art
Foundation, Los Angeles, California

54
Young Worker

Polyester resin and fiberglass,
polychromed in oil, mixed media,
with accessories
Norton Gallery of Art, West Palm
Beach, Florida

55
Shoppers

Polyvinyl, polychromed in oil,
mixed media, with accessories
Mr. and Mrs. Jerome Nerman,
Kansas City, Missouri

56
Slab Man

Polyvinyl, polychromed in oil,
mixed media, with accessories
Lewis and Lynn Pollock, Lexington,
Massachusetts

57
Self-Portrait

Polyvinyl, polychromed in oil,
mixed media, with accessories
Harry Litwin, Wichita, Kansas

Solo Exhibitions 1977
_Virginia Museum of Fine Arts, Richmond, Virginia
_Colorado Springs Fine Arts Center, Colorado
_William Rockhill Nelson Gallery & Atkins Museum of Fine Arts, Kansas City, Missouri

_Portland Art Museum, Oregon
_University Art Museum, Berkeley, California
_Des Moines Art Center, Iowa

Solo Exhibition 1978
_Corcoran Gallery of Art, Washington, D.C.

1979 Granted the title Adjunct Professor of Art by the University of Miami, Florida, and the title Doctor of Humane Letters by the University of Fort Lauderdale, Florida.

Solo Exhibition 1979
_Whitney Museum of American Art, New York

1977

58
Painter

Polyvinyl, polychromed in oil, mixed media, with accessories
Belger Family, Kansas City, Missouri

59
Woman with Dog

Polyvinyl, polychromed in oil, mixed media, with accessories
Whitney Museum of American Art, New York

60
Man on a Bench

Polyvinyl, polychromed in oil, mixed media, with accessories
The Saatchi Gallery, London

61
Worker with Pipes

Polyvinyl, polychromed in oil, mixed media, with accessories
Lewis and Lynn Pollock, Lexington, Massachusetts

1978

62
Woman Reading Paperback

Polyvinyl, polychromed in oil, mixed media, with accessories
Joyce Bogart, Los Angeles, California

63 *
Photographer

Polyvinyl, polychromed in oil, mixed media, with accessories
The Saatchi Gallery, London

64
Child with Puzzle

Polyvinyl, polychromed in oil, mixed media, with accessories
Hanson Collection, Davie, Florida

1979

65 *
Self-Portrait with Model

Polyvinyl, polychromed in oil, mixed media, with accessories
Hanson Collection, Davie, Florida

66
Dockman

Polyvinyl, polychromed in oil, mixed media, with accessories
Yellow Freight Systems, Overland Park, Kansas

67 *
Children Playing Game

Polyvinyl, polychromed in oil, mixed media, with accessories
Hanson Collection, Davie, Florida

68
Beagle in a Basket

Polyvinyl, polychromed in oil, mixed media, with accessories
Hanson Collection, Davie, Florida

68/1 *
Beagle in a Basket
(Edition 1/3)
1979/1988
Bronze, polychromed in oil, mixed media, with accessories
Hanson Collection, Davie, Florida

68

Group Exhibitions 1977
_*Whitney Biennial*
Whitney Museum of American Art, New York
_*8 Contemporary American Realists*
Pennsylvania Academy of Fine Arts, Philadelphia, Pennsylvania
_*American Realists*
North Carolina Museum of Art, Raleigh, North Carolina
_*Kunst um 1970*
Sammlung Ludwig, Neue Galerie, Aachen, Germany

Group Exhibitions 1978
_*Musée National d'Art Moderne*, Centre Georges Pompidou, Paris
_*Matrix 40*
Wadsworth Atheneum, Hartford, Connecticut
_*Aspekte der 60er Jahre: Aus der Sammlung Reinhard Onnasch*
Nationalgalerie, Berlin

Group Exhibitions 1979
_*Figure of Five*
North Campus Gallery, Miami Dade Community College, Florida
_*Reality or Illusion*
Denver Art Museum, Colorado
Herbert F. Johnson Museum of Art, Cornell University, Ithaca, New York
Honolulu Academy of Fine Art, Hawaii
Oakland Museum, California
University of Southern California Art Galleries, Los Angeles, California
University Art Museum, University of Texas, Austin, Texas

Group Exhibitions 1980
_*Arts and Crafts Center*, Pittsburgh, Pennsylvania
_*Aspects of the Seventies – Directions on Realism*
Danforth Museum, Framingham, Massachusetts
_*Form and Figure*
Block Gallery, Northwestern University, Evanston, Illinois
Boise Gallery of Art, Idaho
Tyler Museum of Art, Texas
University Art Gallery, North Dakota
Museum of Art, Washington State University, Pullman, Washington

Solo Exhibitions 1980
_Jacksonville Art Museum, Florida
_O. K. Harris Gallery, New York

Solo Exhibitions 1981
_Loch Haven Art Center, Orlando,
Florida
_Lowe Art Museum, University of
Miami, Florida
_Norton Gallery and School of
Arts, West Palm Beach, Florida

1980 1981 1982

68/2
Beagle in a Basket
(Edition 2/3)
1979/1989
Bronze, polychromed in oil,
mixed media, with accessories
Private Collection

68/3
Beagle in a Basket
(Edition 3/3)
1979/1989
Bronze, polychromed in oil,
mixed media, with accessories
Dr. Andy Hirschl, Miami,
Florida

68/2

68/3

69 *
Delivery Man

Polyvinyl, polychromed in oil,
mixed media, with accessories
The Saatchi Gallery, London

70
Man with Crutch

Polyvinyl, polychromed in oil,
mixed media, with accessories
Gloria and Richard Manney,
Plantation, Florida

71
Queenie

Polyvinyl, polychromed in oil,
mixed media, with accessories
Marty Margulies, Miami, Florida

72
Fundraiser

Polyvinyl, polychromed in oil,
mixed media, with accessories
Hunter Museum, Chattanooga,
Tennessee

73
Football Player

Polyvinyl, polychromed in oil,
mixed media, with accessories
Lowe Art Museum, University of
Miami, Florida

74
Mailman

Polyvinyl, polychromed in oil,
mixed media, with accessories
Daniel Filipacchi, New York

75
Lady with Coupons

Polyvinyl, polychromed in oil,
mixed media, with accessories
Moore International Studio, Great
Neck, New York

_International Florida Artists
 Ringling Museum of Art, Sarasota,
 Florida
_Morton Neumann Collection
 National Gallery of Art,
 Washington D.C.
_Mysterious & Magical Realism
 Aldrich Museum of Contemporary
 Art, Ridgefield, Connecticut
_The Figurative Tradition and the
 Whitney Museum of American Art:
 Painting and Sculpture from the
 Permanent Collection
 Whitney Museum of American
 Art, New York

_The Lewis Contemporary Art Fund
 Collection
 Virginia Museum, Richmond,
 Virginia
_Rose 80
 National Gallery of Ireland and
 University College, Dublin

Group Exhibitions 1981
_Real, Really Real, Super Real
 Indianapolis Museum of Art,
 Indiana
 Museum of Art, Carnegie
 Institute, Pittsburgh, Pennsylvania
 San Antonio Museum of Art, San
 Antonio, Texas
 Tucson Museum of Art, Arizona
_Whitney Biennial Exhibition
 Whitney Museum of American
 Art, New York
_Contemporary American Realism
 since 1960
 Pennsylvania Academy of Fine
 Arts, Philadelphia, Pennsylvania
_International Florida Artists
 John and Mable Ringling Museum
 of Art, Sarasota, Florida

Group Exhibitions 1982
_Five in Florida
 North Miami Museum and Art
 Center, Florida
_Realist Exhibition
 Philadelphia Academy of Art,
 Pennsylvania
_Artists Speak for Peace
 Trinity Cathedral Hall, Miami,
 Florida
_Five Artists and the Figure
 Whitney Museum of American
 Art, Stamford, Connecticut
_Cranbrook U.S.A
 Cranbrook Academy of Art,
 Bloomfield Hills, Michigan

1983 Hanson receives the State of Florida's Ambassador of the Arts Award.

Solo Exhibition 1983
_West Palm Beach Library, Florida

1984 Produces first bronze sculptures.

Solo Exhibitions 1984
_Nagoya City Museum, Japan
_Niigata Isetan Art Hall, Japan
_Municipial Museum of Art, Osaka, Japan
_Isetan Museum, Tokyo

_Edwin A. Ulrich Museum of Art, Wichita State University, Kansas
_O. K. Harris Gallery, New York

1983

76
Bus Stop Lady

Polyvinyl, polychromed in oil, mixed media, with accessories
Sydney and Walda Bestoff Foundation, USA

77
Baby in Stroller

Polyvinyl, polychromed in oil, mixed media, with accessories
Dr. Ross Clarke, Hollywood, Florida

78
Businessman Reading

Polyvinyl, polychromed in oil, mixed media, with accessories
Gilbert and Lila Silverman, Southfield, Minnesota

1984

79
Jogger

Polyvinyl, polychromed in oil, mixed media, with accessories
The Saatchi Gallery, London

80 *
Housepainter I

1984/1988
Autobody filler, polychromed, mixed media, with accessories
Hanson Collection, Davie, Florida

> 80/1
> Custodian
> (Edition 1/3)
> 1984
> Bronze, polychromed, mixed media, with accessories
> Jules and Elaine Litvach, New York

80/2
Windowwasher
(Edition 2/3)
1984
Bronze, polychromed, mixed media, with accessories
Dick Anderson, Overland Park, Kansas

80/3
Housepainter II
(Edition 3/3)
1984
Bronze, polychromed, mixed media, with accessories
Charles Lindsay, Greenwich, Connecticut

81 *
Cowboy

1984/1995
Autobody filler, polychromed in oil, mixed media, with accessories
Hanson Collection, Davie, Florida

81/1
Rodeo Cowboy
(Edition 1/9)
1984
Bronze, polychromed in oil, mixed media, with accessories
Saul Brandman, Beverly Hills, California

81/2
Cowboy
(Edition 2/9)
1984/1985
Bronze, polychromed in oil, mixed media, with accessories
Albert Peskin, Los Angeles, California

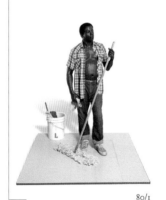

80/1

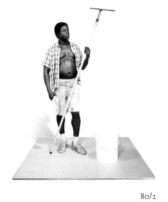

80/2

80/3

Group Exhibitions 1983
_Contemporary Trompe l'œil Painting and Sculpture
 Boise Gallery of Art, Idaho
 The Museum of Art, Washington State University, Pullman, Washington
 Bellevue Art Museum, Washington
 Salt Lake Art Center, Utah
 Laguna Beach Museum of Art, California
 Queens Museum, New York

_Icons of Contemporary Art
 Foster Goldstrom, Dallas, Texas
_American Super Realism from the Morton G. Neumann Family Collection
 Terra Museum of American Art, Evanston, Illinois
_Time Out: Sport and Leisure in America Today
 Tampa Museum, Florida
_Realism Now
 Museum of Modern Art, Saitama, Japan

Group Exhibitions 1984
_In Quest of Excellence
 Center for the Fine Arts, Miami, Florida
_O. K. Harris Artists
 Royal Palm Gallery, Palm Beach, Florida
_Image, Effigy, Form: Figurative Sculpture
 University Art Museum, California State University, Long Beach, California

_The Lewis and Clark Collection
 Portland Center of Visual Arts, Oregon
_Return of the Narrative
 Palm Springs Desert Museum, California
_Figurative Sculpture: Ten Artists/Two Decades
 University Art Museum, California State University, Long Beach, California

81/3
Cowboy
(Edition 3/9)
1984/1985
Bronze, polychromed in oil,
mixed media, with accessories
Charles B. Moss, Roxbury,
Connecticut

81/4
Fancy Dude Cowboy
(Edition 4/9)
1984/1986
Bronze, polychromed in oil,
mixed media, with accessories
Chris Skerik, Huntington
Beach, California

81/5
Cowpuncher
(Edition 5/9)
1984/1987
Bronze, polychromed in oil,
mixed media, with accessories
Nancy Magoon, Aspen,
Colorado

81/6
Cowboy
(Edition 6/9)
1984/1988
Bronze, polychromed in oil,
mixed media, with accessories
Joel and Joan Picket, Harrison,
New York

81/7
Cowboy
(Edition 7/9)
1984/1989
Bronze, polychromed in oil,
mixed media, with accessories
Location unknown

81/8
Cowboy with Hay
(Edition 8/9)
1984/1989
Bronze, polychromed in oil,
mixed media, with accessories
Shirlee Levin, Miami, Florida

81/9
Cowboy
(Edition 9/9)
1984/1991
Bronze, polychromed in oil,
mixed media, with accessories
A. Barry and Arlene Hirschfeld,
Denver, Colorado

82
Female Bust

Autobody filler, polychromed
in oil, mixed media
Mrs. Leon Steinman, New York

81/2

81/3

81/4

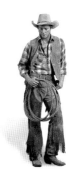
81/5

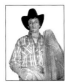
81/1

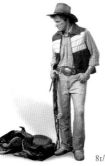
81/6

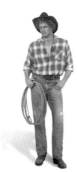
81/7

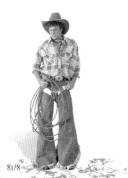
81/8

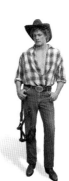
81/9

_Citywide Contemporary
 Sculpture Exhibition
 Toledo Museum of Art, Ohio
_American Art from the Frederick R.
 Weisman Foundation Collections
 San Francisco Art Institute,
 California
_Games of Deception: When Nothing
 Is as It Appears
 Artisan Space, Fashion Institute of
 Technology, New York

1985 Awarded the Florida Prize, worth ten thousand dollars, for outstanding work in the field of visual and performing arts.

Solo Exhibitions 1985
_Cranbrook Academy of Art, Bloomfield Hills, Michigan
_Macalester College, St. Paul, Minnesota

1986 Honoured by the King of Sweden on the occasion of an exhibition.

Solo Exhibition 1986
_Millesgården, Lidingö, Sweden

1987 Honoured by the announcement of a Duane Hanson Day in Broward County, Florida.

Solo Exhibitions 1987
_Ruin Stone Museum, Alexandria, Minnesota
_Swedish American Institute, Minneapolis, Minnesota

1985

83
Woman with Child in Stroller

Polyvinyl, polychromed in acrylic, mixed media, with accessories
The Saatchi Gallery, London

84 *
Traveller

1985/1988
Autobody filler, polychromed in oil, mixed media, with accessories
The Saatchi Gallery, London

84/1
Traveller
(Edition 1/4)
1985
Bronze, polychromed in oil, mixed media, with accessories
Orlando International Airport, Florida

84/2
Traveller
(Edition 2/4)
1985/1986
Bronze, polychromed in oil, mixed media, with accessories
Nathan Gantcher, Scarsdale, New York

84/3
Traveller
(Edition 3/4)
1985/1987
Bronze, polychromed in oil, mixed media, with accessories
Sammlung Charles O. Moss, Roxbury, Connecticut

84/4
Traveller
(Edition 4/4)
1985/1990
Bronze, polychromed in oil, mixed media, with accessories
Location unknown

1987

85
Surfer

Polyvinyl, polychromed in oil, mixed media, with accessories
Hanson Collection, Davie, Florida

86
Sunbather

1987/1995
Autobody filler, polychromed in oil, mixed media, with accessories
Hanson Collection, Davie, Florida

86/1 *
Sunbather
(Edition 1/3)
1987
Bronze, polychromed in oil, mixed media, with accessories
The Saatchi Gallery, London

86/2
Sunbather
(Edition 2/3)
1987/1988
Bronze, polychromed in oil, mixed media, with accessories
Nathan Gantcher, Scarsdale, New York

86/3
Sunbather
(Edition 3/3)
1987/1989
Bronze, polychromed in oil, mixed media, with accessories
Jeffrey Steiner, New York

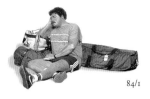
84/1

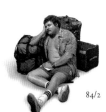
84/2

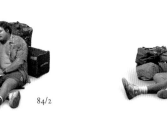
84/3

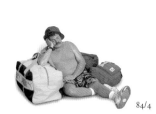
84/4

Group Exhibitions 1985
_Artist of O. K. Harris
Helander/Rubenstein Gallery, Palm Beach, Florida
_Fortissimo! Thirty Years of the Richard Brown Baker Collection of Contemporary Art
Museum of Art, Rhode Island School of Design, Providence, Rhode Island
San Diego Museum of Art, California
Portland Art Museum, Oregon
_Selected Works: The Frederick R. Weisman Foundation of Art
Art Center College of Design, Pasadena, California

_The Real Thing
North Miami Museum and Art Center, Florida
_Figure It out: Exploring the Figure in Contemporary Art
Laguna Gloria Art Museum, Austin, Texas
_Pop Art: 1955–1970
Art Gallery of New South Wales, Sydney, Australia
Queensland Art Gallery, Brisbane, Australia,
National Gallery of Victoria, Melbourne, Australia

Group Exhibitions 1986
_Figure as Subject: The Last Decade
The Whitney Museum of American Art at the Equitable Center, New York
_Michigan People: Photographs from People Magazine
Detroit Institute of Arts, Michigan
Millesgården, Lidingö, Sweden
_Boston Collects: Contemporary Painting and Sculpture
Museum of Fine Arts, Boston, Massachusetts
_New Work – New York
Helander Gallery, Palm Beach, Florida

Group Exhibitions 1987
_Florida Invitational, Part 1
O. K. South, South Miami, Florida
_Independence Sites: Sculpture for Public Spaces
Independence Mall, Philadelphia, Pennsylvania
_45th Annual Exhibition
Port of History Museum at Penn's Landing, Philadelphia, Pennsylvania
_Pop Art America Europa dalla Collezione Ludwig
Forte di Belvedere, Florence, Italy

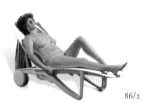

86/2

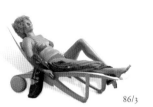

86/3

1988

87/1
Executive on Telephone
(Portrait of William Weisman)
(Edition 1/3)
Bronze, polychromed in oil, mixed media, with accessories
Frederick R. Weisman Art Foundation, Los Angeles, California

87/2
Executive in Blue Chair
(Portrait of William Weisman)
(Edition 2/3)
Bronze, polychromed in oil, mixed media, with accessories
Frederick R. Weisman Art Foundation, Los Angeles, California

87/3
Executive in Red Chair
(Portrait of William Weisman)
(Edition 3/3)
Bronze, polychromed in oil, mixed media, with accessories
Frederick R. Weisman Art Museum at the University of Minnesota, Wisconsin

88 *
Queenie II

Autobody filler, polychromed in oil, mixed media, with accessories
Hanson Collection, Davie, Florida

88/1
Queenie II
(Edition 1/1)
Bronze, polychromed in oil, mixed media, with accessories
The Saatchi Gallery, London

89
Bust of Larry Tobe

Autobody filler, polychromed in oil, mixed media
Mr. and Mrs. Larry Tobe, Tallahassee, Florida

90 *
Tourists II

Polyvinyl, polychromed in oil, mixed media, with accessories
The Saatchi Gallery, London

91
Cheerleader

Polyvinyl, polychromed in oil, mixed media, with accessories
Hanson Collection, Davie, Florida

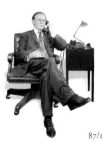

87/1

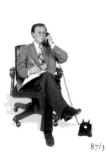

87/3

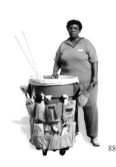

88/1

1989

92 *
Chinese Student

Autobody filler, polychromed in oil,
mixed media, with accessories
Hanson Collection, Davie, Florida

93 *
Lunchbreak

Polyvinyl, polychromed in oil,
mixed media, with accessories
Hanson Collection, Davie, Florida

94 *
Man with Walkman

Autobody filler, polychromed in oil,
mixed media, with accessories
Hanson Collection, Davie, Florida

94/1
Vendor with Walkman
(Edition 1/1)
1989/1990
Bronze, polychromed in oil,
mixed media, with accessories
Fort Lauderdale International
Airport, Florida

95 *
Bodybuilder

1989/1995
Autobody filler, polychromed in oil,
mixed media, with accessories
Hanson Collection, Davie, Florida

95/1
Bodybuilder
(Edition 1/3)
1989
Bronze, polychromed in oil,
mixed media, with accessories
Louis K. Adler, Houston, Texas

95/2
Bodybuilder
(Edition 2/3)
1989/1990
Bronze, polychromed in oil,
mixed media, with accessories
Hanson Collection, Davie,
Florida

95/3
Bodybuilder
(Edition 3/3)
1989/1992
Bronze, polychromed in oil,
mixed media, with accessories
Cranbrook Academy of Art,
Bloomfield Hills, Michigan

94/1

95/1

95/2

95/3

1990

96
Bust of Martin Bush

Bronze, polychromed, mixed media
Dr. Martin Bush, New York

97
Security Guard

Autobody filler, polychromed in oil,
mixed media, with accessories
Hanson Collection, Davie, Florida

97/1
Security Guard
(Edition 1/10)
1990
Bronze, polychromed in oil,
mixed media, with accessories
Location unknown

97/2
Security Guard
(Edition 2/10)
1990
Bronze, polychromed in oil,
mixed media, with accessories
Location unknown

_Brown University Art Museum,
 Providence, Rhode Island
_Kunsthalle Tübingen, Germany

97/3
Security Guard
(Edition 3/10)
1990
Bronze, polychromed in oil,
mixed media, with accessories
The Saatchi Gallery, London

97/4
Security Guard
(Edition 4/10)
1990
Bronze, polychromed in oil,
mixed media, with accessories
Location unknown

97/5
Security Guard
(Edition 5/10)
1990
Bronze, polychromed in oil,
mixed media, with accessories
Location unknown

97/6
Security Guard
(Edition 6/10)
1990
Bronze, polychromed in oil,
mixed media, with accessories
Location unknown

97/7
Security Guard
(Edition 7/10)
1990
Bronze, polychromed in oil,
mixed media, with accessories
Jeffrey Steiner, Fairchild Corp,
New York

97/8
Security Guard
(Edition 8/10)
1990
Bronze, polychromed in oil,
mixed media, with accessories
Daniel Filipacchi, New York

97/9
Security Guard
(Edition 9/10)
1990/1991
Bronze, polychromed in oil,
mixed media, with accessories
Location unknown

97/10
Security Guard
(Edition 10/10)
1990/1991
Bronze, polychromed in oil,
mixed media, with accessories
Private Collection

97

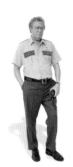

97/1

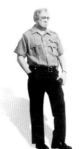

97/2

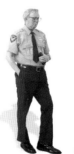

97/3

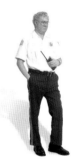

97/4

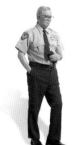

97/6

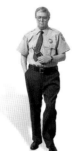

97/7

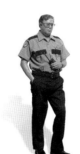

97/8

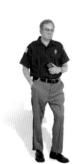

97/9

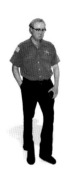

97/10

98/1
Study of Sunbather
(Edition 1/6)
1990
Bronze, polychromed in oil,
mixed media, with accessories
h 23 cm, w 66 cm, d 30 cm
Kresge Art Museum, East
Lansing, Michigan

98/2
Study of Sunbather
(Edition 2/6)
1990
Autobody filler, polychromed,
mixed media, with accessories
h 23 cm, w 66 cm, d 30 cm
Location unknown

98/3
Study of Sunbather
(Edition 3/6)
1990
Bronze, polychromed in oil,
mixed media, with accessories
h 23 cm, w 66 cm, d 30 cm
Dr. Arnold Berliner, Boca
Raton, Florida

98/4
Study of Sunbather
(Edition 4/6)
1990
Bronze, polychromed in oil,
mixed media, with accessories
h 23 cm, w 66 cm, d 30 cm
Location unknown

98/5
Study of Sunbather
(Edition 5/6)
1990
Bronze, polychromed in oil,
mixed media, with accessories
h 23 cm, w 66 cm, d 30 cm
Duane Hanson Jr., New York

98/6 *
Study of Sunbather
(Edition 6/6)
1990/1991
Bronze, polychromed in acrylic,
mixed media, with accessories
h 23 cm, w 66 cm, d 30 cm
Tin Ly, Fort Lauderdale, Florida

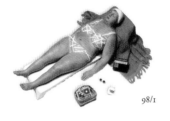

98/1

98/2

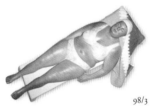

98/3

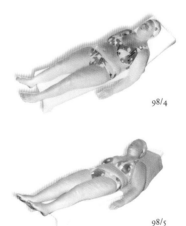

98/4

98/5

99 *
High School Student

Autobody filler, polychromed in oil,
mixed media, with accessories
Hanson Collection, Davie, Florida

99/1
High School Student
(Edition 1/2)
Bronze, polychromed in oil,
mixed media, with accessories
Flint Institute of Art, Michigan

99/2
High School Student
(Edition 2/2)
Bronze, polychromed in oil,
mixed media, with accessories
Hanson Collection, Davie,
Florida

99/1

99/2

100 *
Flea Market Lady

Autobody filler, polychromed in oil,
mixed media, with accessories
Hanson Collection, Davie, Florida

 100/1
 Flea Market Lady
 (Edition 1/4)
 1990
 Bronze, polychromed in oil,
 mixed media, with accessories
 Hanson Collection, Davie,
 Florida

 100/2
 Flea Market Lady
 (Edition 2/4)
 1990/1991
 Bronze, polychromed in oil,
 mixed media, with accessories
 Raymond Zimmerman,
 Nashville, Tennessee

 100/3
 Flea Market Lady
 (Edition 3/4)
 1990/1991
 Bronze, polychromed in oil,
 mixed media, with accessories
 Martin Gecht, Palm Beach,
 Florida

100/4
Flea Market Lady
(Edition 4/4)
1990/1994
Bronze, polychromed in oil,
mixed media, with accessories
The Saatchi Gallery, London

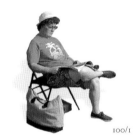

100/1

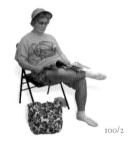

100/2

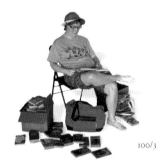

100/3

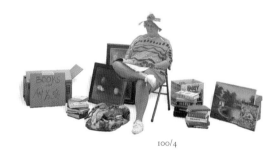

100/4

Solo Exhibitions 1991
_Josef-Haubrich-Kunsthalle,
 Cologne, Germany
_Kunstverein Hamburg, Germany
_Gallery of Art, Jackson County
 Community College, Overland
 Park, Kansas

_Florida State University Gallery
 and Museum, Tallahassee, Florida
_Haus am Waldsee, Berlin

<u>1992</u> Admitted to the Florida
Artists' Hall of Fame.

Solo Exhibitions 1992
_Neue Galerie der Stadt Linz,
 Wolfgang-Gurlitt-Museum,
 Austria
_KunstHaus Wien, Vienna
_Galerie Neuendorf, Frankfurt am
 Main, Germany
_Helander Gallery, New York

1991

101 *
Man with Camera

Autobody filler, polychromed in oil,
mixed media, with accessories
Hanson Collection, Davie, Florida

101/1
Man with Camera
(Edition 1/3)
Bronze, polychromed in oil,
mixed media, with accessories
Hanson Collection, Davie,
Florida

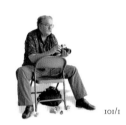

101/1

101/2
Man with Camera
(Edition 2/3)
Bronze, polychromed in oil,
mixed media, with accessories
Heidrun Eckes-Chantré, Palm
Beach, Florida

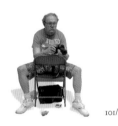

101/2

101/3
Man with Camera
(Edition 3/3)
Bronze, polychromed in oil,
mixed media, with accessories
Sassower Family Collection, USA

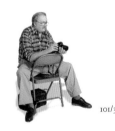

101/3

102
Homeless Person

Autobody filler, polychromed in oil,
mixed media, with accessories
Hannes von Gösseln

1992

103
Car Dealer

Autobody filler, polychromed in oil,
mixed media, with accessories
Kemper Museum of Contemporary
Art and Design, Kansas City,
Missouri

103/1 *
Car Dealer
(Edition 1/2)
Bronze, polychromed in oil,
mixed media, with accessories
Hanson Collection, Davie,
Florida

103/2
Car Dealer
(Edition 2/2)
Bronze, polychromed in oil,
mixed media, with accessories
Location unknown

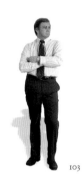

103

Group Exhibition 1991
_La Sculpture Contemporaine
 après 1970
 Fondation Daniel Templon,
 Fréjus, France

Group Exhibition 1992
_In Search of Sunsets:
 The Persistence of Imagery in
 American Art
 Tacoma Art Museum,
 Washington

104
Policeman

Autobody filler, polychromed in oil,
mixed media, with accessories
Location unknown

104/1
Policeman
(Edition 1/3)
1992/1993
Bronze, polychromed in oil,
mixed media, with accessories
Location unknown

104/2
Policeman
(Edition 2/3)
1992/1994
Bronze, polychromed in oil,
mixed media, with accessories
Gerard Cafesjian, USA

104/3 *
Policeman
(Edition 3/3)
1992/1994
Bronze, polychromed in oil,
mixed media, with accessories
Hanson Collection, Davie,
Florida

105
Medical Doctor

1992/1993
Autobody filler, polychromed in oil,
mixed media, with accessories
Dr. Craig Hanson, Seattle,
Washington

105/1
Medical Doctor
(Edition 1/2)
1992
Bronze, polychromed in oil,
mixed media, with accessories
Location unknown

105/2 *
Medical Doctor
(Edition 2/2)
1992/1994
Bronze, polychromed in oil,
mixed media, with accessories
Hanson Collection, Davie,
Florida

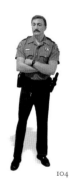
104

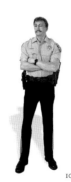
104/1

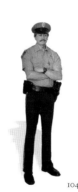
104/2

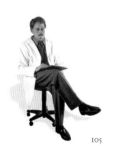
105

Solo Exhibition 1993
_Eve Mannes Gallery, Atlanta,
 Georgia

Solo Exhibitions 1994
_The Montreal Museum of Fine
 Arts, Canada
_Modern Museum of Fort Worth,
 Texas

1993

106
Two Workers

Bronze, polychromed in oil, mixed
media, with accessories
Stiftung Haus der Geschichte,
Bonn, Germany

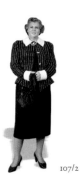

107/2

107/3

107/1
Mary Weisman
(Edition 1/3)
1993
Bronze, polychromed in oil,
mixed media, with accessories
Frederick R. Weisman Art
Museum at the University
of Minnesota, Wisconsin

107/2
Mary Weisman
(Edition 2/3)
1993/1994
Bronze, polychromed in oil,
mixed media, with accessories
Frederick R. Weisman Art
Foundation, Los Angeles,
California

107/3
Mary Weisman
(Edition 3/3)
1993/1994
Bronze, polychromed in oil,
mixed media, with accessories
Frederick R. Weisman Art
Foundation, Los Angeles,
California

1994

108
Man with Ladder

Autobody filler, polychromed in oil,
mixed media, with accessories
Don Fisher, GAP, San Francisco,
California

109
Portrait of Heidi

Autobody filler, polychromed in oil,
mixed media, with accessories
Heidrun Eckes-Chantré, Palm
Beach, Florida

110
Portrait of Kim

Autobody filler, polychromed in oil,
mixed media, with accessories
Heidrun Eckes-Chantré, Palm
Beach, Florida

111/1
Female Bust
(Edition 1/3)
Bronze, polychromed in oil,
mixed media
Duane Hanson Jr., New York

111/2
Female Bust
(Edition 2/3)
Bronze, polychromed in oil,
mixed media
Tin Ly, Fort Lauderdale, Florida

111/3
Female Bust
(Edition 3/3)
Bronze, polychromed in oil,
mixed media
Sammlung Luis Montoya, Palm
Beach, Florida

111/2 111/3

Group Exhibition 1994
_Columbia Museum of Art,
 Missouri

112
<u>Old Couple on a Bench</u>

Autobody filler, polychromed,
mixed media, with accessories
The Saatchi Gallery, London

112/1 *
<u>Old Couple on a Bench</u>
(Edition 1/2)
1994
Bronze, polychromed, mixed
media, with accessories
Hanson Collection, Davie,
Florida

112/2
<u>Old Couple on a Bench</u>
(Edition 2/2)
1994/1995
Bronze, polychromed, mixed
media, with accessories
Palm Springs Desert Museum,
California

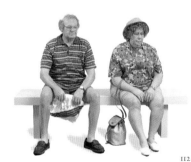

112

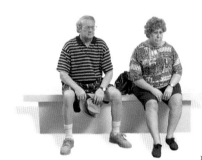

112/2

1995 Awarded a Doctorate of Fine Arts by Luther College, Decorah, Iowa, and Macalester College in St. Paul, Minnesota.

Solo Exhibitions 1995
_Diamaru Museum of Art, Tokyo
_Genichiro-Inkuma Museum of Contemporary Art, Kagawa, Japan
_Kintetsu Museum of Art, Osaka, Japan

6 January 1996 Duane Hanson dies of cancer in Boca Raton, Florida.

Solo Exhibition 1997
_Saatchi Gallery, London

113
Kid with Baseball Bat

Autobody filler, polychromed, mixed media, with accessories
Hanson Collection, Davie, Florida

114
Man on a Mower

Autobody filler, polychromed, with mower
Hanson Collection, Davie, Florida

114/1 *
Man on a Mower
(Edition 1/3)
Bronze, polychromed, with mower
Hanson Collection, Davie, Florida

114/2
Man on a Mower
(Edition 2/3)
Bronze, polychromed, with mower
Hanson Collection, Davie, Florida

114/3
Man on a Mower
(Edition 3/3)
Bronze, polychromed, with mower
Hanson Collection, Davie, Florida

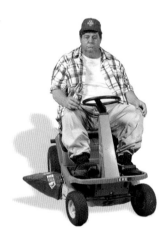
114

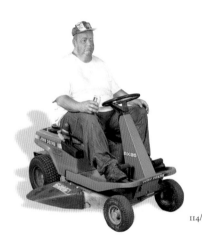
114/2

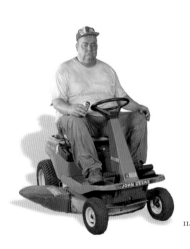
114/3

Group Exhibitions 1995
_Biennale de sculpture
 Monte Carlo, Monaco
_Armutszeugnisse
 Fritz-Hüser-Institut,
 Museum am Ostwall,
 Dortmund, Germany

Group Exhibitions 1996
_The Human Body in
 Contemporary American Sculpture
 Gagosian Gallery, New York
_Homeland of the Imagination: The
 Southern Presence in 20th Century
 Art
 Olympics Show, Atlanta, Georgia

Group Exhibition 1998
_Selection from Frederick
 R. Weisman Collection
 Pepperdine University, Malibu,
 California

Group Exhibitions 1999
_Constructing Realities
 Brigham Young Museum of Art,
 Provo, Utah
_The American Century: Art and
 Culture 1900–2000
 Whitney Museum of American
 Art, New York
_Three Realist Sculptors
 Nassau County Museum of Art,
 Roslyn Harbor, New York

Solo Exhibitions 1998
_Museum of Art, Fort Lauderdale, Florida
_Flint Institute of Arts, Michigan
_Oglethorpe University Museum, Atlanta, Georgia
_Whitney Museum of American Art, New York
_Ballroom, Royal Festival Hall, London

Solo Exhibition 1999
_Memphis Brooks Museum of Art, Tennessee

Solo Exhibition 2000
_Palm Springs Desert Museum, California

Solo Exhibitions 2001
_San Jose Museum, California
_Nevada Museum of Art, Reno, Nevada
_Portland Art Museum, Oregon
_Schirn Kunsthalle, Frankfurt am Main, Germany

Solo Exhibitions 2002
_Galerie der Stadt Stuttgart, Germany
_Padiglione d'Arte Contemporanea, Milan, Italy
_Kunsthal Rotterdam, Netherlands
_National Galleries of Scotland, Edinburgh
_Kunsthaus Zürich

Group Exhibitions 2000
_Cast of Characters: Figurative Sculpture
 Albuquerque Museum, New Mexico
_The Intuitive Eye: Selections from the Frederick R. Weismann Collection
 Fashion Institute of Design and Merchandising, Los Angeles, California
_Aichi Prefectural Museum of Art, Nagoya, Japan

_Let's Entertain
 Walker Art Center, Minneapolis, Minnesota
 Portland Art Museum, Oregon
 Musée National d'Art Moderne, Centre Georges Pompidou, Paris
 Museo Rufino Tamayo, Mexico City
 Miami Art Museum, Florida

Group Exhibitions 2001
_A Century of the American Dream: The Sparkle of the "American Way" of Life
 Hyogo Prefectural Museum of Modern Art, Kobe, Japan
_Bellevue Museum, Seattle, Washington
_I Am A Camera
 The Saatchi Gallery, London
_Hounds in Leash
 Albuquerque Museum, New Mexico
_The Human Figure
 Arken Museum for Moderne Kunst, Copenhagen

_Pageant of the Masters
 Irvine Bowl Park, Laguna Beach, California

A Century of American Dream. The Sparkle of the "American Way" of Life. Exh. cat. Archi Prefectual Museum of Art, Nagoya, 2000.

A Gallery Tour. Exh. cat. Milwaukee Art Center 1974.

Abadie, Daniel, *L'Hyperréalisme américain.* Paris 1975.

Agora 2. Exh. cat. Musée d'Art Moderne, Strasbourg, 1974.

Albright, Thomas, *Art in the San Francisco Bay Area: 1945–1980.* Berkeley 1985.

American Art since 1960. Exh. cat. Art Museum, Princeton University, 1970.

American Sharp Focus Realism. Exh. cat. Galerie Löwenadler, Stockholm, 1973.

American Super Realism from the Morton G. Neumann Family Collection. Exh. cat. Terra Museum of American Art, Evanston, 1983.

Amerikanske Realister. Exh. cat. Randers Kunstmuseum 1973.

Armutszeugnisse. Die Darstellung der Armut in der Kunst des 20. Jahrhunderts. Ed. Andrea Zupanic, Fritz-Hüser-Institut, Museum am Ostwall, Dortmund, Berlin 1995.

Ars 74. Exh. cat. Art Museum of the Ateneum, Fine Arts Academy of Finland, Helsinki, 1974.

Art Around 1970. Exh. cat. Sammlung Ludwig, Aachen, 1977.

Art in Evolution. Exh. cat. Xerox Corporation, Rochester, 1973.

Art in the Environment. Exh. cat. Boca Raton Museum of Art 1986.

Artists Speak for Peace. Exh. cat. Trinity Cathedral Hall, Miami, 1982.

Ashton, Dore, *American Art since 1945.* New York 1982.

Aspects of the 70's – Directions in Realism. Exh. cat. Danforth Museum of Art, Framingham, 1980.

Aspekte der 60er Jahre: aus der Sammlung Reinhard Onnasch. Exh. cat. Nationalgalerie, Berlin, 1978.

Battock, Gregory, *Super Realism. A Critical Anthology.* New York 1975.

Beyond the Horizon. Festival of Arts and Pageant of the Masters 2001, Laguna Beach, 2001.

Blum, Paul von, *The Critical Vision.* Boston 1982.

Boston Collects Contemporary Painting & Sculpture. Exh. cat. Museum of Fine Arts, Boston, 1986.

Breyhan, Christine, *Duane Hanson. Housewife. Triumph der Künstlichkeit.* Ostfildern-Ruit 2000.

Brown, Milton W., *American Art.* New York 1979.

Bush, Martin H., *Duane Hanson.* Exh. cat. Edwin A. Ulrich Museum of Art, Wichita, 1976.

– *Sculptures by Duane Hanson.* Edwin A. Ulrich Museum of Art, Wichita, 1985.

Bush, Martin H. and Sumio Kuwabara. *Hyper-Realist Sculptures of Duane Hanson,* Isetan Museum of Art, Tokyo, 1984.

Bush, Martin H. and Thomas Buchsteiner, *Duane Hanson. Skulpturen.* Stuttgart 1990.

Cast of Characters. Figurative Sculptures. Exh. cat. Albuquerque Museum 2000.

Chase, Linda, *Les Hyperréalistes américains.* Paris 1973.

– *Hyperrealism.* New York 1975.

Citywide Contemporary Sculpture Exhibition. Exh. cat. Toledo Museum of Art 1984.

Contemporary American Art. Exh. cat. Whitney Museum of American Art, New York, 1973.

Contemporary American Painting and Sculpture. Exh. cat. Krannert Art Museum, Champaign, 1974.

Contemporary Sculpture from the Martin Z. Margulies Collection. Exh. cat. Grove Isle, Coconut Grove, 1986.

Contemporary Trompe l'œil Painting and Sculpture. Exh. cat. Boise Gallery of Art 1983.

Depth and Presence. Exh. cat. Corcoran Gallery of Art, Washington D.C., 1971.

Documenta 5. Exh. cat. Kassel, 1972.

30 internationale Künstler in Berlin. Exh. cat. DAAD, Berlin, 1973.

Duane Hanson. Ed. Württembergischer Kunstverein Stuttgart, Neue Galerie Aachen, Akademie der Künste, Stuttgart 1974.

Duane Hanson. Exh. cat. Onnasch Galerie, Cologne, 1972.

Duane Hanson. Exh. cat. Louisiana Museum of Modern Art, Humlebæk, 1975.

Duane Hanson. Exh. cat. The Saatchi Gallery, London, 1997.

Duane Hanson. Exh. cat. O. K. Harris Gallery, New York, 1974.

Duane Hanson. Exh. cat. Montreal Museum of Fine Arts 1994.

Duane Hanson. A Survey of his Work from the '30s to the '90s. Exh. cat. Museum of Art, Fort Lauderdale, 1998.

Duane Hanson. Sculptures. Exh. cat. Johnson Community College, Cultural Education, Overland Park, 1991.

Duane Hanson. Skulpturen/Sculptures. Exh. cat. Galerie Neuendorf, Frankfurt a. M., 1992.

Duane Hanson: The New Objectivity. Exh. cat. Florida State University Gallery & Museum, Tallahassee, 1991.

Duane Hanson. Virtual Reality. Exh. cat. Palm Springs Desert Museum 2000.

Eight Artists. Exh. cat. Milwaukee Art Center 1971.

Eight Contemporary American Realists. Exh. cat. Pennsylvania Academy of the Fine Arts, Philadelphia, 1977.

Figurative Sculpture. Ten Artists/Two Decades. Exh. cat. University Art Museum, California State University, Long Beach, 1984.

Figure of Five. Exh. cat. North Campus Gallery, Miami Dade Community College, 1979.

Figures-Environments. Exh. cat. Walker Art Center, Minneapolis, 1970.

Five Artists and the Figure. Duane Hanson. Exh. cat. Whitney Museum of American Art, New York, 1982.

Fleming, William, *Arts and Ideas.* New York 1980.

Fortissimo! Thirty Years from the Richard Brown Baker Collection of Contemporary Art. Exh. cat. Museum of Art, Rhode Island School of Design, Providence, 1985.

Frederick R. Weisman Foundation of Art. Los Angeles 1985.

Gilbert, Rita and Albert Knopf, *Living with Art.* New York 1985.

Goodyear, Frank H., *Contemporary American Realism since 1960.* New York 1981.

Handbook. Whitney Museum of American Art, New York 2001.

Handbuch Museum Ludwig. Cologne 1979.

Hartt, Frederick, *Art. A History of Painting. Sculpture. Architecture.* Vol. 2, New York 1976.

Hills Patricia and Roberta K. Tarbell, *The Figurative Tradition and the Whitney Museum of American Art. Paintings and Sculptures from the Permanent Collection.* Exh. cat. Whitney Museum of American Art, New York, 1980.

Homeland of the Imagination: The Southern Presence in the 20th Century Art. Exh. cat. Atlanta, 1996.

Human Concern – Personal Torment: The Grotesque in American Art. Ed. Robert Doty, Whitney Museum of American Art, New York 1969.

Hunter, Sam, *American Art of the 20th Century.* New York 1972.

Hunter, Sam and John Jacobus, *Modern Art.* New York 1976.

Hyperréalistes américains. Exh. cat. Galerie des Quatre Mouvements, Paris, 1972.

Hyperréalistes américains – réalistes européens, Exh. cat. Centre National d'Art Contemporain, Paris, 1974.

Icons of Contemporary Art. Exh. cat. Foster Goldstrom Gallery, Dallas, 1983.

Image. Effigy. Form. Figurative Sculpture. Exh. cat. University Art Museum, California State University, Long Beach, 1984.

In Search of Sunsets. Images of the American West 1850 to Present. Exh. cat. Tacoma Art Museum 1992.

Iperrealisti americani. Exh. cat. Galleria La Medusa, Rome, 1973.

Johnson, Ellen H., *American Artists on Art.* New York 1982.

– *Modern Art and the Object.* New York 1976.

July August '74. Exh. cat. Museum of Contemporary Art, Chicago, 1974.

Kijken naar de Werkijkheid. Exh. cat. Museum Boijmans Van Beuningen, Rotterdam, 1974.

Klischee und Antiklischee. Exh. cat. Neue Galerie Aachen 1970.

Kresge Art Museum Bulletin. Michigan State University, Lansing 1999.

Kultermann, Udo, *New Realism*. New York 1972.

– *Radikaler Realismus*. Tübingen 1972.

Kunst nach Wirklichkeit. Ein neuer Realismus in Amerika und Europa. Exh. cat. Kunstverein Hannover 1973.

La Sculpture Contemporaine après 1970. Exh. cat. Foundation Daniel Templon, Fréjus, 1991.

Let's Entertain. Life's Guilty Pleasures. Exh. cat. Walker Art Center, Minneapolis, 2000.

Levin, Gail, *Edward Hopper. The Art and the Artist*. New York 1980.

Liebelt, Udo, *Lebenszeichen: Botschaft der Bilder. Wirklichkeit und Lebensverständnis in der modernen Kunst*. Hanover 1983.

Lindey, Christine, *Superrealist Painting and Sculpture*. New York 1980.

Lipman, Jean and Helen M. Franc, *Bright Stars. American Painting and Sculpture since 1776*. New York 1976.

Livingstone, Marco, *Pop Art. A Continuing History*. London 1990.

Lucie-Smith, Edward, *Late Modern. The Visual Arts Since 1945*. New York 1976.

– *Super Realism*. Oxford 1979.

– *Art in the Seventies*. Ithaca 1980.

– *Art Now*. New York 1981.

– *American Art Now*. New York 1985.

– *American Realism*. London 1994.

Ludwig Collection. The Artist Exhibited. Exh. cat. Neue Galerie Aachen 1977.

Mathzy, François, *American Realism*. New York 1978.

Mennesket (The Human Body). Exh. cat. Arken Museum for Moderne Kunst, Copenhagen, 2000.

Mit Kamera. Pinsel und Spritzpistole: realistische Kunst in unserer Zeit. Exh. cat. Städtische Kunsthalle Recklinghausen 1973.

Montagna, Lino, *Iperralisti americani realisti europei*. Milan 1974.

Naylor, Colin and Genesis P. Orride, *Contemporary Artists*. New York 1977.

1977 Biennial Exhibition. Exh. cat. Whitney Museum of American Art, New York, 1977.

New Photo Realism. Exh. cat. Wadsworth Atheneum, Hartford, 1974.

New Realism and Old Realism. Exh. cat. Danenberg and Roman Contemporaries, New York, 1971.

Newman, Thelma R., *Plastics as Sculptures*. Radnor 1974.

Painting and Sculpture Today. Exh. cat. Indianapolis Museum of Art 1970.

Phases of New Realism. Exh. cat. Lowe Art Museum, University of Miami, 1972.

Photo Realism. Exh. cat. Serpentine Gallery, London, 1973.

Pop Art 1955–1970. Exh. cat. The Museum of Modern Art, New York, 1985.

Popper, Frank, *Art – Action and Participation*. New York 1975.

Radical Realism. Exh. cat. Museum of Contemporary Art, Chicago, 1971.

Radical Realists. Exh. cat. Portland Center for the Visual Arts 1973.

Real People. Sculpture by Duane Hanson. Exh. cat. Museum of Art, Fort Lauderdale, 1988.

Realism Now. Exh. cat. Museum of Modern Art, Saitama, 1983.

Realism Realisme. Exh. cat. Rothmans of Pall Mall 1978.

Realismus und Realität. Exh. cat. Kunsthalle Darmstadt 1975.

Restany, Pierre, *Plastics in Arts*. New York 1974.

Return of the Narrative. Exh. cat. Palm Springs Desert Museum 1984.

Richardson, John Adkins, *Art. The Way It Is*. New York 1974.

Rose, Barbara, *American Art since 1945*. New York 1975.

Rose '80. National Gallery of Ireland and University College, Dublin 1980.

Rosenberg, Harold, *Art on the Edge*. New York 1975.

– *The De-Definition of Art*. New York 1972.

Roukes, Nicholas, *Sculpture in Plastics*. New York 1978.

Sager, Peter, *Neue Formen des Realismus*. Cologne 1972.

Sandler, Irving, *American Art of the 1960s*. New York 1988.

Scene of the Crime. Exh. cat. UCLA at the Armand Hammer Museum of Art and Cultural Center, Los Angeles, 1996.

Schade, Virtus, *Moder Med Kunstneke I Weekendavisen*. Copenhagen 1977.

Schwartz, Barry, *The New Humanism*. New York 1974.

Sculpture Annual. Exh. cat. Whitney Museum of American Art, New York, 1970.

Selected Works of the Frederick R. Weisman Foundation. Los Angeles 1989.

Sharp Focus Realism. Exh. cat. Sidney Janis Gallery, New York, 1972.

She'll Never Change. She's One of Duane Hanson's Sculptures. Exh. cat. Museum of Fine Arts, Montreal, 1994.

7 Realists. Exh. cat. Yale University Art Gallery, New Haven, 1974.

Southern Monumental Exhibition. Exh. cat. Memphis State University Gallery 1981.

Stein, Harvey and Cornell Capa, *Artists Observed. Photographs by Harvey Stein*. New York 1986.

Taylor, Joshua C., *America as Art*. Washington D.C. 1976.

– *The Fine Arts in America*. Chicago 1979.

The Lewis Contemporary Art Fund Collection, Virginia Museum of Fine Arts. Richmond 1980.

The Morton G. Neumann Collection, National Gallery of Art. Washington D.C. 1980.

The Real and Ideal in Figurative Sculpture. Exh. cat. Museum of Contemporary Art, Chicago, 1974.

The Super-Realist Vision. Exh. cat. DeCordova Museum, Lincoln, 1973.

Time out. Sport and Leisure in America Today. Exh. cat. Tampa Museum of Art 1983.

Varnedoe, Kirk, *Duane Hanson*. New York 1985.

– *Duane Hanson*. Exh. cat. Jacksonville Art Museum 1981.

Walker, John A., *Art since Pop*. London 1975.

Wilmerding, John, *American Art*. New York 1976.

10 Jahre Berliner Künstlerprogramm. Exh. cat. DAAD, Berlin, 1975.

Alioto, Suzanne, "Is It Human or Hanson's?" *The Miami Herald*, 18 April 1982.

– "A Critic's Notebook". *Minneapolis Star*, 20 May 1970.

Altman, Peter, "Walker Art Show Can Be Read as Theatre". *Minneapolis Star*, 20 May 1970.

Auer, James, "It's Just a Mask". *Milwaukee Journal*, 18 April 1976.

Backers-Clement, Catherine, "L'Impossible real ou le leurre en vente". *L'Art Vivant*, 3/1973.

Bass, Ruth, "Duane Hanson". *ARTnews*, 11/1995.

Beckelmann, Jürgen, "Schock des Über-Natürlichen". *Spandauer Volksblatt*, 23 January 1975.

– "Zwischen Schock und Chic". *Erlanger Tagblatt*, 29 January 1975.

Behrens, David, "Who Are These People Anyways?" *The Newsday Magazine*, 14 March 1982.

Bentzon, Niels Viggo, "Supermarkedet". *Politiken*, 20 January 1979.

Berstein, Helen, "Hanson's Art Is of People, for People". *Palm Beach Daily News*, 26 March 1981.

Bloomfield, Arthur, "Art Exhibit Captures a Century of Torment". *San Francisco Examiner*, 26 January 1970.

Bongartz, R., "It's the Real Thing". *Horizon*, 9/1977.

Borgeaud, Bernard, "Hyperréalisme américain". *Pariscope*, 25 October 1972.

Bouyeure, Claude, "Le Regard froid". *Gulliver*, 12/1972.

Bower, Nellie, "Sculpture's Rejection Went a Long Way". *The Miami News*, 26 June 1968.

Bowman, Pierre, "Is That for Real?" *Honolulu Advertiser*, 7 April 1980.

Bush, Martin H., "Martin Bush Interviews Duane Hanson". *Art International*, 9/1977.

Canaday, John, "Art: The Old French Garde Is Revised". *The New York Times*, 23 October 1971.

– "John Canaday on Art". *New Republic*, 8 April 1978.

– "Odd Things to Worry about, Ethics". *The New York Times*, 7 June 1970.

– "Then and Now and Blood and Catsup". *The New York Times*, 26 October 1969.

Chase, Linda and Ted Mc Burnett, "The Verist Sculptors: 2 Interviews". *Art in America*, 11/1972.

Clair, Jean, "Situation des réalismes". *L'Art Vivant*, 4/1974.

Clurman, Irene, "Artist Creates Work from People He Finds". *Rocky Mountain News*, 16 September 1977.

Constable, Rosalind, "Mademoiselle Tussaud's Waxworks – Are They Really Art?" *Smithsonian*, 5/1974.

– "New Realism in Sculpture: Look Alive". *Saturday Review*, 22 April 1970.

Corbino, Marcia, "Duane Hanson's Polymer People". *Sarasota Herald Tribune*, 7 September 1980.

Cornelius, Else, "Kuinder er ikke hvad de har vaeret". *Frederiksborg Amts Avis*, 2 April 1975.

Cosford, Bill, "Arts Were Seen but Not Heard". *The Miami Herald*, 28 April 1983.

Dannecker, Hermann von, "Die lebensechten Plastiken des Duane Hanson". *Mannheimer Morgen*, 25 October 1974.

– "Hanson's lebensechte Plastiken". *Generalanzeiger Bonn*, 9 November 1974.

– "Kunst oder Panoptikum?" *Darmstädter Echo*, 18 October 1974.

– "Randfiguren der Gesellschaft". *Main-Post Würzburg*, 26 October 1974.

Davis, Douglas, "Art Is Necessary – Or Is It?" *Newsweek*, 17 July 1972.

– "Nosing out Reality". *Newsweek*, 14 August 1972.

– "Soho in New York". *Newsweek*, 16 February 1970.

Davis, Miller, "Davie's Hanson Sculpts the Way He Sees It". *Western News*, 24 May 1973.

Del Guercio, Antonio, "Iperrealismo tra 'pop' e informale". *Rinoseite*, 23 February 1973.

Deroudille, René, "Réalistes et hyperréalistes". *Derrière heure Lyonnaise*, 31 March 1974.

Diehl, Carol, "Reviews". *ARTnews*, 1 January 1993.

Diemer, Karl, "Putzfrauen im Kunstverein: Die Neue mit dem Schwamm". *Stuttgarter Nachrichten*, 27 September 1974.

Dobbs, Lillian, "Miami's 1980–81 Art Scene a Visual Feast". *The Miami News*, 19 September 1980.

– "Reality Is Art in Hansons Sculptures". *The Miami News*, 9 January 1981.

Donnell-Kotrozo, Carol, "Material Illusion: On the Issue of Ersatz objects", *Arts Magazine*, 3/1984.

Dorfles, Gillo, "Vitalita del negativo". *Art International*, 20 April 1971.

Dunlop, Beth, "Hanson's Real People". *The Miami Herald*, 11 January 1981.

Elboger, Paul, "Die Homunculi". *Schweizer Rundschau*, 5 December 1977.

Fedorka, Cindy, "Art Presentation to Open Center". *Sun-Tattler*, 1 November 1975.

Felter, John, "Arts Chronicle". *Gazette Telegraph*, 17 September 1977.

Ferber, Elfriede, "Wie bei den Wachsfiguren". *Reutlinger General-Anzeiger*, 16 October 1974.

Fisher, Alice, "The Real Thing". *Broward Life*, 6/1974.

Flanagan, Barbara, "Grisly Art Leads to Own Show". *Minneapolis Star*, 19 May 1970.

– "80-Year-Old Owes the Shape of His Fame to Sculptor Son". *Minneapolis Star*, 19 June 1979.

Foster, Alice, "Hanson the Humanist". *Sun-Tattler*, 29 August 1979.

– "He's Cast His Mold for the World to See". *The Miami Herald*, 14 December 1975.

– "Sculptor's Work 'Moves' Fast". *The Miami Herald*, 15 February 1976.

Frankenstein, Alfred, "Black Rock, Beams and Bones". *San Francisco Examiner*, 7 February 1971.

– "The Incredible Realism of Hanson's Humans". *San Francisco Chronicle*, 3 April 1977.

Gardner, James, "Still Lives". *National Review*, 8 February 1999.

Genauer, Emily, "The Spring Scene". *The International Herald Tribune*, 9 January 1978.

Gilbert-Rolfe, Jeremy, "Reviews". *Artforum*, 4/1974.

Glueck, Grace, "Look Who's at the Whitney". *The New York Times*, 10 February 1978.

Goodman, Cynthia, "Eight Contemporary American Realists". *Arts Magazine*, 1/1978.

Göpfert, Peter Hans, "Bilder von Bildern von Bildern". *Giessener Anzeiger*, 29 January 1975.

– "David wird ordinär". *Darmstädter Echo*, 28 January 1975.

– "David wird ordinär – Menschen wie du und ich in Gips". *Wiesbadener Kurier*, 30 January 1975.

– "Der 'schöne' David in Polyester und Fiberglas". *Neue Osnabrücker Zeitung*, 27 January 1975, and *Ostfriesische Nachrichten*, 28 January 1975.

Greenwood, Michael, "Current Representational Art. Five Other Visions: Duane Hanson and Joseph Raffael". *Arts Canada*, 12/1976.

Grover, J. Z., "Show in Hansonville". *Twin Cities Reader*, 6 September 1995.

Haacke, Lorraine, "Duane Hanson's Life-like Art". *Dallas Times Herald*, 2 April 1976.

Haikara, Jason, "Statues of 'Ordinary People' at Lowe". *The Miami Hurricane*, 16 January 1981.

Hand, Judson, "The New Realism. Bigger than Life and Realer than Life". *New York Sunday News*, 11 July 1972.

Hand, Judson, "The People's Realist". *Sunday Daily News Magazine*, 5 February 1978.

Hanson, Duane, "Which One Is a Real Person?" *New Florida*, 10/1981.

– "Presenting Duane Hanson". *Art in America*, 9/1970.

Hayt, Elizabeth, "In an Era of Humanoid Art. A Forerunner Finds a Place". *The New York Times*, 13 December 1998.

Hecht, Axel, "Wo bitte sitzt die echte Frau?" *Stern,* 49/1974.

Heidelberg, Paul, "I Was a Duane Hanson Model. A Sculptor's Muse Faces Some Thoroughly Modern Indignities". *Art & Antiques,* 1/1993.

Hennemann-Bayer, E., "Hautnahe Realität – Kunst oder Panoptikum?" *Alb-Bote Waldshut,* 25 October 1974.

Henry, Gerrit, "Close Encounters with Ourselves". *ARTnews,* 4/1978.

– "The Soho Body Snatcher". *ARTnews,* 3/1972.

Henry, Jean, "An Interview with Contemporary American Super-realist-Sculptor Duane Hanson". *Essays in Arts and Sciences,* 5/1983.

Hjort, Øystein, "Almindelige 1974 – mennesker". *Information Copenhagen,* 1 April 1974.

– "Kunstmiljøet i Rhinlandet". *Louisiana Revy,* 2/1973.

Horsley, Carter B., "A 'Maverick' Builder Tries to Be Different". *The New York Times,* 17 October 1971.

Houle, Alain, "Duane Hanson ou la rencontre du troisième type". *Lectures,* 4/1994.

Hurlburt, Roger, "Everyday People Are Immortalized in Hanson's Unnerving Sculptures". *Fort Lauderdale News and Sun-Sentinel,* 5 April 1981.

Jarmush, Ann, "Realism. Past and Present". *ARTnews,* 11/1977.

Jesperen, Gunnar, "Forbrugsmennesket haengs ud (og up)". *Berlingske Tidende,* 23 March 1975.

Jones, Will, "After Last Night". *Minneapolis Tribune,* 18 May 1970.

Kahlcke, Wolfgang, "Nicht ohne weiteres als Kunst erkennbar". *Die Welt,* 8 August 1974.

Key, Donald, "New Realism Movement Is Growing with Images Too Clear for Comfort". *Milwaukee Journal,* 4 July 1971.

Kimmelmann, Michael, "Duane Hanson, 70, Sculptor of Super-realistic Figures, Dies". *The New York Times,* 10 January 1996.

King, Larry, "A Wonderful Evening with the Witty Walter O". *The Miami Herald,* 18 March 1970.

Kipphoff, Petra, "Sein und Schein". *Die Zeit,* 7 February 1975.

Kirwin, Liza, "Notice of Oral Interview". *Archives of American Art Journal,* 3/1989.

Kissel, Howard, "Duane Hanson. Sculpture without Pedestal". *Women's Wear Daily,* 10 February 1978.

Kohen, Helen L., "Five Views of Humanity". *The Miami Herald,* 21 October 1979.

– "Museum Show Offers a Provocative Mix". *The Miami Herald,* 4 April 1982.

– "When Art and Life Meet Head on". *The Miami Herald,* 11 January 1981.

Kritzman, Larry, "Fragments. Incompletion and Discontinuity". *New York Literary Forum,* 8/1981.

Kroll, Jack, "The Arts in America". *Newsweek,* 24 December 1973.

– "The Arts in America". *Newsweek,* 11 February 1974.

Kuspit, Donald B., "Duane Hanson's American Inferno". *Art in America,* 11/1976.

La Mosa, Rina G., "Nel vuoto di einozioni". *Sette Giorni,* 18 February 1973.

Lerman, Leo, "Sharp-Focus Realism". *Mademoiselle,* 3/1972.

Leveque, Jean-Jacques, "L'Hyperréalisme ou le retour aux origines". *Nouvelles Littéraire,* 16 October 1972.

Levi, Dean, "Real Man Not Real". *Richmond News Leader,* 8 July 1972.

Levin, Kim, "The Ersatz Object". *Arts Magazine,* 2/1974.

Levisetti, Katharine, "Look Again – They're Sculptures". *Chicago-Style – Chicago Today,* 28 June 1974.

Liegeois, Jean-Paul, "Pour copie conforme". *L'Unité,* 3/1974.

Linder, Gisela, "Duane Hanson's konservierte Mitmenschen". *Schwäbische Zeitung,* 3 October 1974.

Lista, Giovanni, "Iperrealisti americani". *NAC,* 12/1972.

Lucie-Smith, Edward, "The Neutral Style". *Art and Artists,* 8/1975.

Lusk, Alison Pierce, "Mute Figures Have Eerie Quality". *Gazette Telegraph,* 8 September 1977.

Mack, Stan, "Mack". *Esquire,* 14 March 1978.

Mahoney, Larry, "Comment '69 Is Art – But It's also Protest". *The Miami Herald,* 11 February 1969.

Masheck, Joseph, "Verist Sculpture. Hanson and De Andrea". *Art in America,* 11/1972.

Mathews, Margaret, "Duane Hanson. Super Realism". *American Artist,* 9/1981.

Maus, Sibylle, "Eine ganz unheimliche Gaudi". *Stuttgarter Nachrichten,* 9 November 1974.

May, Steven, "Reviews". *ARTnews,* 2 February 1999.

Menna, Filiberto, "Paradosso dell'iperrealismo". *Il Mattino,* 6 February 1973.

Michael, Jan, "Hanson's Humans". *Esquire,* 3/1976.

Michel, Jacques, "La 'Mondialisation' de l'hyperréalisme". *Le Monde,* 2/1974.

Miller, Donald, "Notes and Nuances: On Sculptor Duane Hanson, Watercolorist Chen Chi". *Pittsburgh Post Gazette,* 2 July 1980.

Morgan, Robert C., "Duane Hanson's Documentary Sculpture". *USA Today,* 3/1982.

Morrin, Peter, "Review – Duane Hanson". *Art Papers,* 3/1981.

Morrison, Don, "Books and the Arts". *Minneapolis Star,* 15 May 1970.

Morschel, Jürgen, "Abgesang auf den Neuen Realismus". *Süddeutsche Zeitung,* 14 January 1974.

Moulin, Raoul-Jean, "Les Hyperréalistes américains et la neutralisation du réel". *L'Humanité,* 15 March 1974.

Murphy, Richard, "European Pleasures". *Horizon,* 7/1977.

Murray, Frank, "Tragic Sculpture Gains Prize but Banned as Too Gruesome". *Statesman,* 18 June 1968.

– "Violent Sculpture Wins. Removed from Exhibit". *Sioux Falls Argus-Leader,* 18 June 1968.

Nemser, Cindy, "Sculpture and the New Realism". *Arts Magazine,* 4/1970.

Nikolajsen, Ejgil, "Skal vi sluga kamelen?" *Berlingske Tidende,* 10 February 1973.

O'Doherty, Brian, "Inside the White Cube". *Artforum,* 2/1972.

– "The Eye and the Spectator". *Artforum,* 4/1976.

Ohff, Heinz, "Vier Realitäten – vier Realisten". *Der Tagesspiegel,* 19 January 1975.

Ohlig, Adelheid, "Vietnam – Plastik". *Südwestpresse,* 18 September 1973.

Osterwold, Tilman, "Duane Hanson". *Louisiana Revy* 1–6/1975.

Parks, Cynthia, "Guest of Honor Didn't Bat an Eye". *The Florida Times-Union,* 8 December 1980.

Paul, Boris, "The Freedom of Art Battles Censorship". *Sunday Sun and Independent,* 23 June 1968.

Perrault, John, "Art: That Time Again". *Village Voice,* 24 December 1970.

– "Waiting for the Eighties". *Soho Arts,* 16 February 1978.

Pfetzing, W. and P. Kerner, "Eine Kaffeekanne gießt sich selber Kaffee ein". *Kultur im Bild,* 1 July 1972.

Picard, Lil, "Alphabet aus Menschenleibern". *Die Welt,* 8 January 1970.

Pierre, José, "L'Hyperpuritanisme". *La Quinzaine Litteraire,* 15 March 1974.

Puvogel, Renate, "Hansons Figuren sind erschreckend echt". *Aachener Zeitung,* 23 November 1974.

Raft, Scott, "Davie Sculptor's Realism Gets Him in, out of Shows". *The Broward Times,* 12 August 1979.

Reno, Doris, "Taste Marks Sculptors of Florida Annual". *The Miami Herald,* 30 October 1966.

Richard, Paul, "Contemporary Art Shrinking". *The Washington Post,* 5 May 1971.

– "Mind Meets Spirit: Psychiatrists Ponder". *The Miami Herald,* 29 June 1971.

Roberts, Elizabeth Kendrick, "Duane Hanson". *Art Voices,* 1/1978.

Romdahl, Margareta, "Hon lever ju!". *Dagens Nyheter,* 26 March 1975.

Rosenberg, Harold, "The Art World: Reality Again". *The New Yorker,* 5 February 1972.

Roud, Richard, "The Objects of the Exercise". *Arts Guardian,* 29 April 1974.

Rubenstein, Betty, "Hanson's Sculpture Shockingly Realistic". *Tallahassee Democrat,* 7 April 1983.

Russell, Candice, "Is it Live… Or Is It Hanson". *Sky Magazine,* 7/1984.

Russell, John, "Art: Effigies of Humanity". *The New York Times,* 10 February 1978.

Rutherford, Kay, "Style". *Chicago Sun-Times,* 9 June 1971.

Saltz, Jerry, "Duane Hanson at Helander". *Art in America,* 1/1993.

Savage, Jim, "Sculpture 'Too Grisly', Banned from Exhibit". *The Miami Herald,* 18 June 1968.

Schade, Virtus, "Han har lavet debatskulptur, men det begyndte med Victoria". *Weekend-avisen – Berlingske Aften,* 26 July 1974.

Scherzer, Joachim, "Zwischen Typisierung und Individualtiät". *Deutsche Post,* 5 August 1975.

Schjeldahl, Peter, "Still Lives". *The New Yorker,* 11 January 1999.

Schneider, Pièrre, "Hyperréalistes américains". *L'Express,* 4 March 1974.

Schudel, Matt, "Mr. Hanson's Neighborhood". *Sun Sentinel,* 18 December 1988.

Schulze, Franz, "American Art: Old Wine in New Bottles?" *Chicago Daily News,* 15 June 1974.

Schwan, Gary, "The Real Duane Hanson". *The Post,* 2 April 1981.

Schwartz, Barbara, "Letter from New York". *Craft Horizons,* 4/1972.

Schwartz, Estelle, "They Know What They Like". *Cue,* 10/1977.

Shirey, David L., "Figures Cast by Hanson Are Shown Downtown". *The New York Times,* 29 January 1972.

– "Horror Show". *Newsweek,* 3 November 1969.

– "A Hollywood Coup". *The Miami Herald,* 16 December 1975.

– "Don't Eat before You Visit Lowe". *The Miami Herald,* 16 February 1969.

– "Exhibits Represent Mixed Bag". *The Miami Herald,* 16 March 1969.

– "Florida Artists Lead the Field". *The Miami Herald,* 9 December 1969.

– "Former Art Prof's Fiberglass Work in Whitney Show". *The Miami Herald,* 27 December 1970.

– "Miamians in N. Y. – Where Art Action Is". *The Miami Herald,* 8 July 1973.

Smith, Roberta, "Tenderly Replicating the Banal". *The New York Times,* 18 December 1998.

Snider, Fran, "'Live' Art Presented in Protest". *The Miami Herald,* 2 February 1968.

– "Lively Arts World Invades Hollywood". *The Miami Herald,* 4 February 1968.

– "The Seven Lively Arts Festival Gets Dose of Knock-Out Drops". *The Miami Herald,* 5 February 1968.

Steele, Mike, "Walker Exhibit Is Perplexing". *Minneapolis Tribune,* 31 March 1970.

Steen, Alex, "De skal op til eksamen i kunst". *Ekstra Bladet,* 22 March 1975.

– "Ham kan damerne ikke lide". *Lørdags Ekstra,* 20 July 1974.

Steward, Frank, "Playing Games With Perception". *The Star Bulletin,* 6 April 1980.

Talley, Dan R., "Duane Hanson: in the Flesh". *Art Papers,* 3/1981.

Teyssedere, Bernard, "Plus vrai que nature". *Le Nouvel Observateur,* 25 February 1974.

Thornton, Linda R., "Hanson's Realistic Sculptures Startle and Amaze Public". *Coral Gables Sun Reporter,* 15 January 1981.

Trucchi, Lorenza, "Iperrealisti americani alla Medusa". *Momento-sera,* 9 February 1973.

Tuby, Heidi S., "Realism – Artist Duane Hanson's Creations Startle". *Boca Raton News,* 31 March 1981.

Varnedoe, Kirk, "Duane Hanson: Retrospective and Recent Work". *Arts Magazine,* 1/1975.

Wasserman, Emily, "New York Reviews". *Artforum,* 3/1970.

Wells, Ken, "Sculptor Has No Statue of Limitation in Effort to Mold Modern Everyman". *The Miami Herald,* 29 March 1981.

Williams, Kathy, "Duane Hanson – Artist Creates Realistic Illusions". *The Evening News,* 27 March 1981.

Willis, Will, "Corpse Livens Art Festival". *The Miami Herald,* 10 April 1967.

Wilson, William, "Realism: All in the 'I' of the Beholder". *The Los Angeles Times,* 21 October 1979.

Wolfert, Leo, "Arts". *People,* 6 March 1978.

Wolff, Millie, "Sculptor Says His Unsmiling Figures Reflect Unpleasant Realities of Life". *Palm Beach Daily News,* 1 April 1981.

Wurster, Reinhold, "Alltägliches wird zum Horror-Trip". *Schwäbisches Tagblatt,* 25 October 1974.

"Fall Collection Now at Lowe". *The Miami Herald,* 12 November 1967.

"Lively Arts World Invades Hollywood". *The Miami Herald,* 4 February 1968

"Prize Sculpture Banned". *Cincinnati Enquirer,* 18 June 1968.

"Sculpture of Violence Banned". *St. Paul Pioneer Press,* 18 June 1968.

"Thrown out". *Minneapolis Journal,* 19 June 1968.

"Violent Sculpture Barred from Exhibit". *Pittsburgh Press,* 11 July 1968.

"Kunst – New York". *Der Spiegel,* 9 March 1970.

"Human Form Is Art Show Theme". *Minneapolis Tribune,* 10 March 1970.

"Die Kunst". *Twen,* 4/1970.

"Portrait of the Artist as a Wet Hen". *Esquire,* 4/1970.

"Presenting Duane Hanson". *Art in America,* 9/1970.

"Casual Comparisons". *Art in America,* 1/1971.

"A Sense of Violence". *Village Voice,* 23 September 1971.

"Mensch im Modell". *Stuttgarter Zeitung,* 5 October 1971.

"Documenta 5". *Magazin Kunst* 7-9/1972.

"Besser sehen durch Documenta". *Die Zeit,* 4 August 1972.

"Ein Warenhaus für Wirklichkeit mit Selbstbedienung". *Stern,* 27 August 1972.

"Homemaker". *Generalanzeiger Bonn,* 30 September 1972.

"Lebensgroße Wachsfiguren". *Frankfurter Allgemeine Zeitung,* 18 October 1972.

"Welches ist die falsche Frau?" *Quer durch Köln,* 28 October 1972.

"Le réalisme et son avenir". *Le Figaro,* 7 November 1972.

"A Parigi iperrealismo e astrazione assoluta". *Il Giorno,* 24 December 1972.

"Handgranaten durften Zoll nicht passieren". *Duisburger Stadtanzeiger,* 27 January 1973.

"Museum kauft den 'Krieg' von Duane Hanson". *Duisburger Stadtanzeiger,* 27 January 1973.

"Am Tag der offiziellen Beendigung". *Düsseldorfer Nachrichten,* 28 January 1973.

"Hansons ungeschönte Wirklichkeit". *Nürnberger Zeitung,* 29 January 1973.

"Radikaler Realismus". *Westfälische Nachrichten,* 31 January 1973.

"Duane Hanson: Vietnam Piece". *Mannheimer Morgen,* 2 February 1973.

"'Krieg' heißt die Plastik des Amerikaners Duane Hanson". *Deutsche Volkszeitung,* 8 February 1973.

"Riproduce la vita di ogni giorno la nuova pittura americana". *Avanti!,* 8 February 1973.

"War 1967". *Die Welt,* 8 February 1973.

"Duane Hanson. Amerikanischer Hyperrealist". *Südwest-Presse,* 9 February 1973.

"Iperrealisti americani". *La Settimana a Roma,* 15 February 1973.

"Vietnam Piece". *Süddeutsche Zeitung,* 4 June 1973.

"Abgesang auf den Neuen Realismus". *Süddeutsche Zeitung,* 14 January 1974.

"La Mondialisation de l'hyperréalisme". *Le Monde,* 21 February 1974.

"Pas tristes ces cires!". *Minute,* 27 March 1974.

"Plus vrais que nature". *Lui,* 3/1974.

"The Above Underground". *Horizon,* 4/1974.

"Duane Hansons konservierte Mitmenschen". *Schwäbische Zeitung,* 3 October 1974.

"Unbehaglicher Kontakt mit der hautnahen Wirklichkeit". *Nürnberger Zeitung,* 9 October 1974.

"Extrem realistisch". *Pforzheimer Zeitung,* 18 October 1974.

"Kunst oder Panoptikum". *Darmstädter Echo,* 18 October 1974.

"Iperrealisti americani a Milano". *La Nazione,* 21 October 1974.

"Adelaide Buys $ 10,000 Horror". *Sunday Telegraph Australia,* 10 November 1974.

"Schock und Mitleid". *Frankfurter Allgemeine Zeitung,* 31 December 1974.

"U.S.-Bildhauer in der Akademie". *Berliner Morgenpost,* 18 January 1975.

"Zwischenstation Berlin". *Spandauer Volksblatt,* 19 January 1975.

"Duane Hanson på Louisiana". *Helsingborgs Dagblad,* 22 March 1975.

"Moderne kunst der ogsa er for børene". *Roskilde Tidende,* 26 March 1975.

"Som I Et Spejl". *Information,* 1 April 1975.

"Tredimensionella Snapshots". *Helsingborgs Dagblad,* 1 April 1975.

"Hardhat 1970". *News Canada,* 4–5/1975.

"No, It's Not". *The Miami Herald,* 3 August 1975.

"Zwischen Typisierung und Individualität". *Deutsche Post,* 5 August 1975.

"Den pedantiske virkelighed". *Berlingske Tidende,* 9/1975.

"Is He – Or Isn't He?" *Palm Beach Daily News,* 11 February 1976.

"Latest Craze of the Well-to-Do". *National Enquirer,* 3 April 1976.

"Sculptor Duane Hanson's Work". *Arizona Daily Star,* 14 April 1976.

"Look, and then Look Again … It's Duane Hanson". *The Miami Herald,* 12 September 1976.

"Hanson's Realism Can Fool You". *Wichita Sun,* 6 October 1976.

"Is Anyone Here for Real?" *The Washington Post,* 15 January 1977.

"Sculpture of the Super-Real". *The Des Moines Register,* 24 January 1977.

"Realistic Sculptures Trick the Viewer". *San Jose Mercury,* 6 March 1977.

"Ripped out of Context". *Sacramento Bee,* 3 April 1977.

"Sculpture Communication". *San Jose News,* 6 May 1977.

"Sculptures Touch Museum Visitors". *Oregonian,* 13 May 1977.

"Hanson Sculptures Art Museum Sensation". *Oregon Journal,* 16 June 1977.

"I Am almost a Camera". *The Australian,* 27 July 1977.

"Reporter Can't Sit Still for Sake of Art". *Kansas City Star,* 30 July 1977.

"Excuse Me Sir … Sir?" *Sun Showcase,* 28 August 1977.

"Realists at the Academy". *Philadelphia Daily News,* 16 September 1977.

"Academy Hosts Realist Exhibit". *Philadelphia Inquirer,* 17 September 1977.

"Hanson Obtains a New Realism with Sculptures". *Morning News,* 21 September 1977.

"Real Art". *Philadelphia Inquirer,* 25 September 1977.

"Hanson Lets His People Speak for Themselves". *Richmond Times-Dispatch,* 14 October 1977.

"She's the Fake Real Person". *Richmond News Leader,* 10 November 1977.

"Duane Hanson's Doubletake Is Not for Real". *Washington (D.C.) Star,* 14 December 1977.

"A Family Portrait?" *The Miami Herald,* 8 February 1978.

"Hanson and De Kooning on Exhibition". *The International Herald Tribune,* 10 February 1978.

"Sculpture That Talks". *New York Post,* 11 February 1978.

"Duane Hanson: He Casts Life into Sculpture". *Daily Record,* 12 February 1978.

"Realism's New Look". *Newsweek,* 13 March 1978.

"Duane Hanson's World of Lifelike Creatures". *Pennysaver,* 15 March 1978.

"Corcoran Gallery Exhibit". *Art International,* 3/1978.

"Duane Hanson Confounded by Ivan Karp". *Interview,* 3/1978.

"Future Subjunctive". *Horizon,* 3/1978.

"Go Ahead and Stare – It's Art". *Florida Accent Magazine, Tampa Tribune,* 2 April 1978.

"Silent Terror Amerikanischer Realisten". *Frankfurter Allgemeine Zeitung,* 5 April 1978.

"John Canaday on Art". *New Republic,* 8 April 1978.

"Will the Real Duane Hanson Please Stand up". *Fort Lauderdale News,* 16 April 1978.

"Hartford's Peculiar Friends". *Hartford Advocate,* 17 May 1978.

"A Plastic Look". *Falcon Times,* 10 October 1979.

"Remember the Couple We Met …" *Wichita Eagle Beacon,* 27 November 1979.

"First Outing since the Break". *The Miami Herald,* 18 January 1980.

"It Snows in Ft. Lauderdale". *Fort Lauderdale Magazine,* 1/1980.

"Form and Figure". *Daily Northwestern,* 9 May 1980

"Sculpture Is on Display". *News-Banner,* 17 June 1980.

"'Form and Figure' Opens 1980–81 Museum Season". *The Pullman Herald,* 10 September 1980.

"Five Figure Artists Exhibit Creations". *Daily Evergreen,* 19 September 1980.

"Real People?" *The Florida Times-Union Jacksonville Journal,* 30 November 1980.

"Art Benefit Comes Alive". *The Florida Times-Union Jacksonville Journal,* 8 December 1980.

"Duane Hanson". *Jacksonville Art Museum Newsletter,* 12/1980.

"Surrealist People". *Miami,* 1/1981.

"Hanson Sculptures". *Inside SEMC,* 1/2, 1981.

"Statue Ask". *The Miami Herald,* 5 February 1981.

"Norton to Exhibit Duane Hanson Sculptures". *Sunshine,* 2/1981.

"Life-like Sculpture on Exhibit at Norton Gallery". *The Daily Journal,* 10 March 1981.

"Norton Gallery to Exhibit Duane Hanson Sculptures". *Entertainment,* 20 March 1981.

"Norton Gallery". *Here Magazine,* 21 March 1981.

"Exhibits". *The Post,* 22 March 1981.

"Sculptures on Display". *The Post and the Evening Times,* 27 March 1981.

"Seeing Is Believing or Is It? … at Norton Gallery". *Daily Palm Beacher,* 28/29 March 1981.

"Hanson's Sculptures Invite Double Takes". *Palm Beach Daily News,* 3/1981.

"Norton Gallery Exhibits Duane Hanson Sculptures". *Travel Host,* 3/1981.

"Hanson's People Are Works of Art". *Palm Beach Chronicle,* 1–7 April 1981.

"Those Shoppers Are No Dummies". *North County News,* 4 April 1981.

"The Local Favourite". *Star,* 17 October 1982.

"Wirklich und wahrhaftig. Anmerkung zum Werk von Duane Hanson". *Museen der Stadt Köln,* Bulletin 6, 1982.

"Duane Hanson". *USA Today Magazine,* 5/1999.

Photo Credits Plates

Dean Burton
No. 88

Roy G. Crogan
Nos. 52, 105/2, 112/1, 114, 114/1,
114/2, 114/3

D. James Dee
Nos. 61, 75, 76, 80/1, 80/3, 81/3,
81/5, 81/6, 84/2, 84/3, 86/1, 86/2,
86/3, 95/1, 97/5, 97/6, 97/7, 97/8

Alan Ginsburg, Hamburg
Nos. 5, 11, 64, 65, 81/8, 83, 90,
92, 94, 99, 100, 101

Eric Pollitzer, New York
Nos. 4, 53, 62

Jerry Thompson
No. 59

Photo Credits Text Illustrations

Gerhard Heidersberger
(Duane Hanson, *Blue Boy*): p. 70
George Hixson (Edward Kienholz):
p. 84
Nathan Rabin, New York
(George Segal): p. 83
Rheinisches Bildarchiv, Köln
(Robert Rauschenberg): p. 83
Courtesy Tate Gallery, London
(Carl Andre): p. 84
Stephen White (Jake und Dinos
Chapman, Marc Quinn, Gavin Turk):
pp. 84-85

Any person claiming to hold the
copyright for illustrations that have
not been identified should contact
Hatje Cantz Publishers.

Acknowledgement

The Art Museum @ Florida International
University, Miami / Bernd Barde /
Christoph Becker / Kristine Bell /
Anja Breloh / Christine Breyhan /
Richard Calvocorasse / Christie's, New
York / Annette Crandall / Heidrun
Eckes-Chantré / Wilhelm Etzel / Maria
Teresa Fiorio / Flick Collection / Galerie
der Stadt Stuttgart / David Gossoff /
Isabell Greschat / Karin Grüning /
Duane Hanson Jr. / Maja Hanson /
Wesla Hanson / Keith Hartley /
Markus Hartmann / Katja Hilbig /
Ines Höll / Nigel Hurst / Martin Keaney /
Kuhn & Bülow, Berlin / Kunsthal
Rotterdam / Kunsthaus Zürich /
L2M3 Kommunikations Design,
Stuttgart / Sascha Lobe / Tin Ly /
Lucia Matino / Rüdiger Mayer /
Momart, London / National Galleries of
Scotland, Edinburgh / Karin Osbahr /
Padiglione d'Arte Contemporanea,
Milan / Palm Springs Desert
Museum / Wim Pijbes / Katherine Plake
Hough / Portland Art Museum /
Repromayer, Reutlingen / Alex Ritter /
Ali Rosenbaum, / Charles Saatchi /
Schenker Art Cargo, Stuttgart /
Schirn Kunsthalle, Frankfurt a. M. /
Johann-Karl Schmidt /
Hellmut Seemann / Wim van Sinderen /
Barry S. Sparkman / Donald Urquhart /
Cliff Vernon / Zwirner & Wirth,
New York

Editor
Thomas Buchsteiner, Otto Letze

Editing
Daniela Ginten, Nicole Tonnier,
Martina Fauser, Jochen Schönfeld,
Jochen Hetterich

Copy Editing
Fiona Elliott, Tas Skorupa

Translations
Michael Robinson, Tas Skorupa

Graphic Design
Sascha Lobe, L2M3
Kommunikations Design, Stuttgart

Reproductions
Repromayer, Reutlingen

Printed by
Dr. Cantz'sche Druckerei,
Ostfildern-Ruit

Published by
Hatje Cantz Publishers
Senefelderstraße 12
D-73760 Ostfildern-Ruit
Germany
Tel. 0711 / 4 40 50
Fax 0711 / 4 40 52 20
Internet: www.hatjecantz.de

ISBN 3-7757-9093-4 (English Edition)
ISBN 3-7757-9092-6 (German Edition)

Printed in Germany

Distribution in the U.S.
D.A.P., Distributed Art Publishers, Inc.
155 Avenue of the Americas,
Second Floor
New York, N.Y. 10013-1507
Tel.: 1-212- 6 27 19 99
Fax: 1-212-6 27 94 84

Die Deutsche Bibliothek -
CIP-Einheitsaufnahme
Duane Hanson : More than reality /
[Ed.: Thomas Buchsteiner ; Otto Letze.
Transl.: Michael Robinson ; Tas
Skorupa]. - Ostfildern-Ruit :
Hatje Cantz, 2001
 Dt. Ausg. u. d. T.: Duane Hanson
 ISBN 3-7757-9093-4

Exhibition Conception and
Tour Organization
Institut für Kulturaustausch, Tübingen

Project Manager
Daniela Ginten

Cover and illustrations on opening and
final pages are details from:
Queenie II, 1988 (no. 88)
Tourists II, 1988 (no. 90)
Museum Guard, 1975 (no. 51)
Slab Man, 1976 (no. 56)
Football Player, 1981 (no. 73)
Housewife, 1970 (no. 11)
Self-Portrait with Model, 1979 (no. 65)

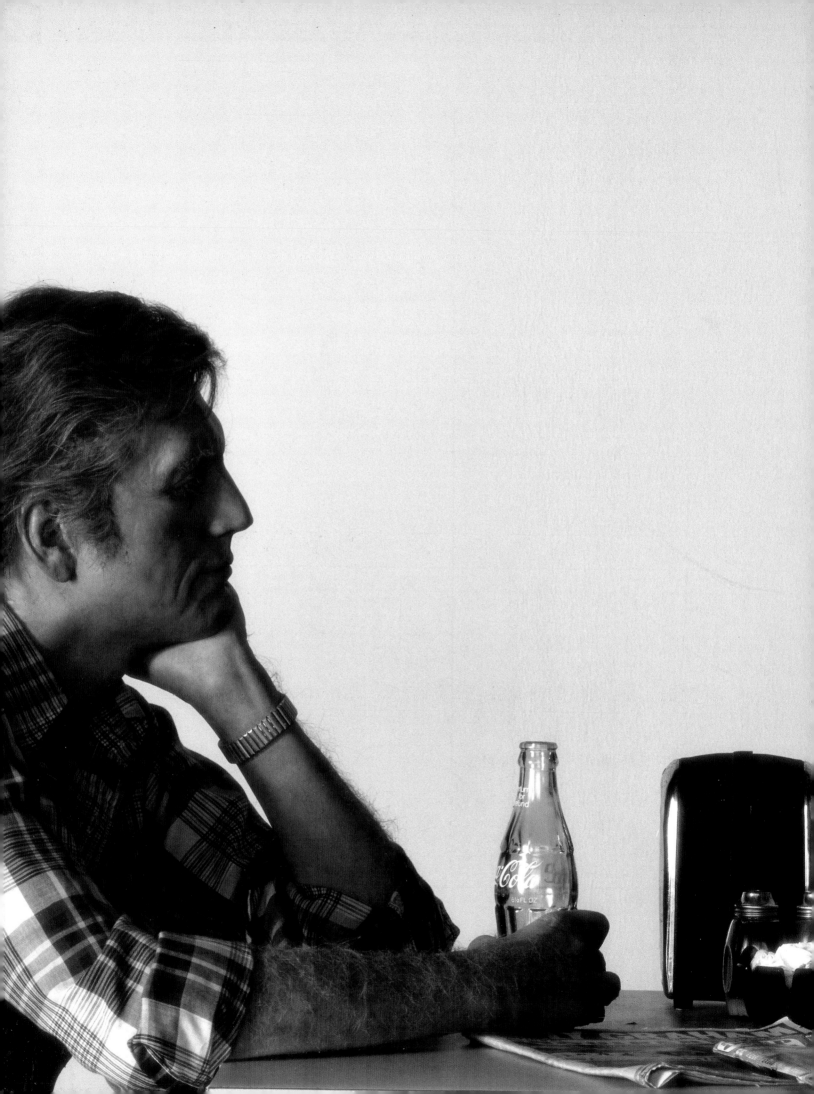